THE COLOR OF DANCE

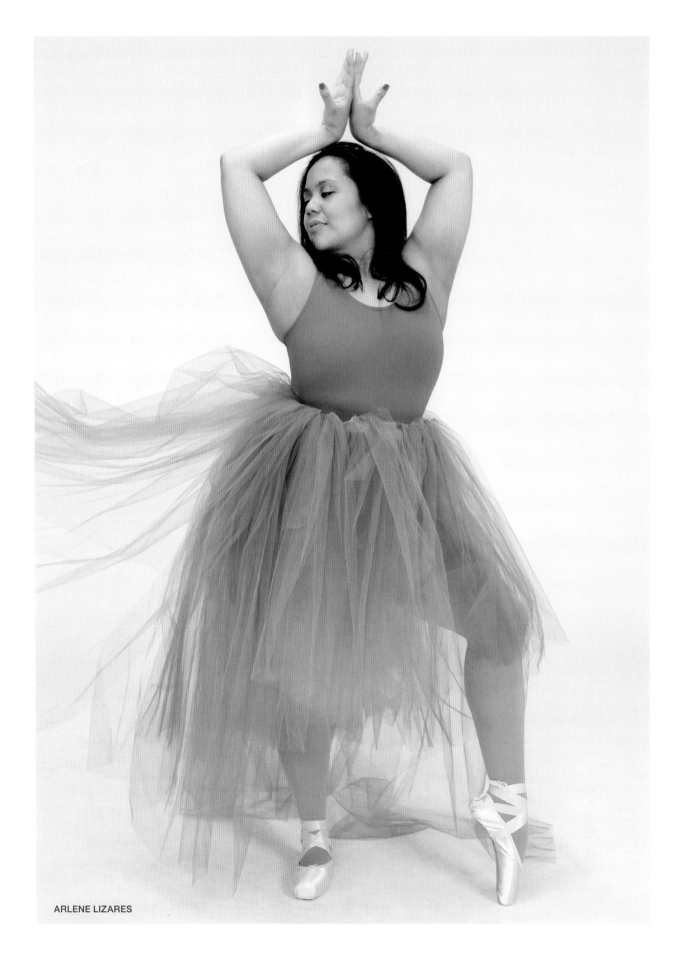

ARLENE LIZARES

THE COLOR OF DANCE

A CELEBRATION OF DIVERSITY AND INCLUSION IN THE WORLD OF BALLET

TAKIYAH WALLACE-McMILLIAN
Founder of Brown Girls Do Ballet

BLACK DOG
& LEVENTHAL
PUBLISHERS
NEW YORK

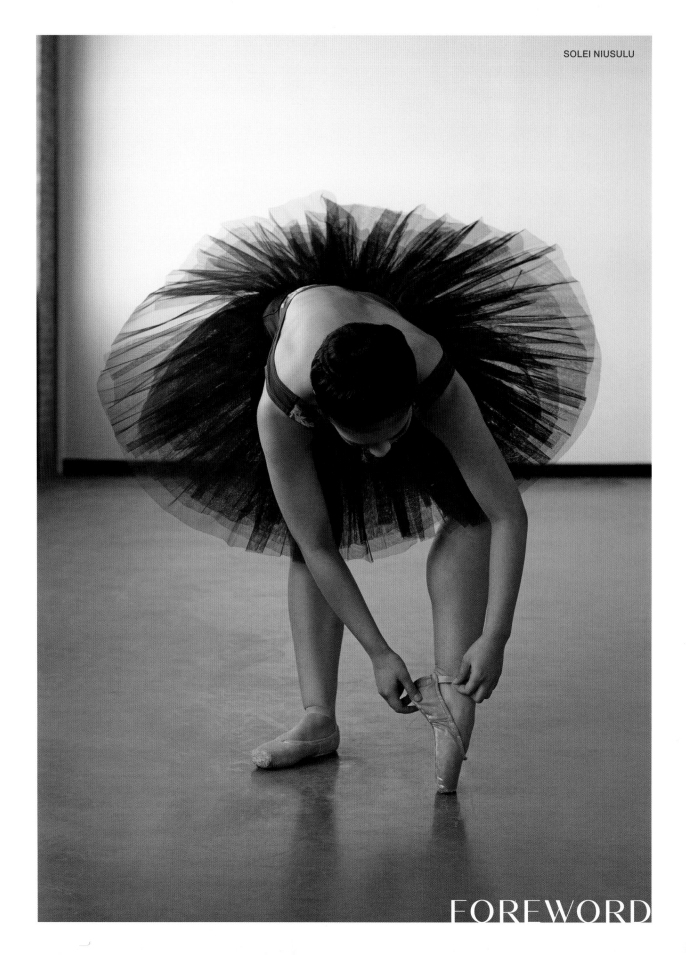

FOREWORD

I mages have power, and what we don't see often speaks volumes more than what we do.

During my time as the only woman of color with the New York City Ballet, I craved more positive images that represented me as a ballerina. Images demonstrating to the world and myself that I belonged.

I remember I did come upon one image of a Black ballerina while I was the only Black female training in the School of American Ballet's advanced division in the mid-1990s. It empowered me. It was a subtle reminder that I belonged, and that what appeared to be the impossible was indeed a real possibility. Reflecting on this image led me on my own journey in 2011, when I created The Swan Dreams Project, which began with the use of imagery. While The Swan Dreams Project uses the art of ballet to speak to issues that extend beyond the ballet world, I also deeply understand the need for dancers of color to see themselves in this art form. I understand because I've been there. I was starving for these images during my career, and I always saw the sparkle in a young dancer of color's eyes whenever we would meet. The beautiful awakening in another who had never stepped foot in a ballet class nor had imagined ever doing so, but who, upon seeing me in my full ballet attire, would transform in front of my eyes. As if they had just discovered a hidden door and I handed them the key.

It goes without saying that I was thrilled to stumble upon Brown Girls Do Ballet years later. I immediately reached out to applaud their efforts and offer up my support. My career had taught me the power of representation. I understood the impact of one singular image and within these pages you will see and feel that power come to life. As you turn each page, know that each image is a testament to our resilience, beauty, and our ongoing fight to be seen in the art form we all love.

Thanks to their tireless work, Brown Girls Do Ballet has blossomed into a community of artists that inspire and lift each other up through mentoring and outreach as well as the beautiful photography whose images have inspired current and future ballerinas. As we all know, seeing is believing.

By holding this book, you are not only helping to grow this village, but helping to spread the message that brown girls do indeed do ballet.

—Aesha Ash, founder of The Swan Dreams Project and
Associate Chair of Faculty at the School of American Ballet

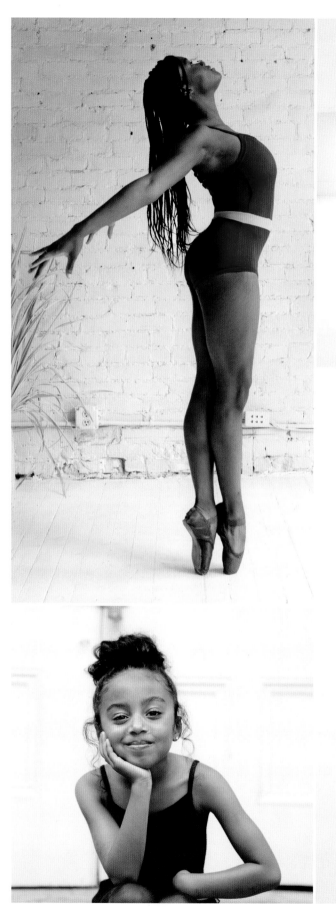

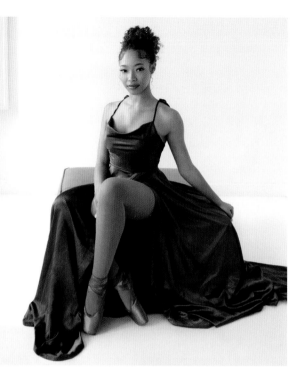

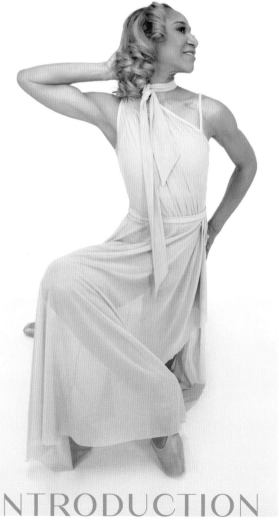

INTRODUCTION

> Never be limited by other people's limited imaginations.
>
> —DR. MAE JEMISON

In 2012, I set out on a personal journey that would flip not only my life upside down but also the lives of so many others around the country. At the time, I was a mom, teacher, and newbie freelance photographer trying to hold my life together with what felt like duct tape. I had pages of daily checklists and wall calendars that constantly attracted dust. My days were filled with juggling motherhood, masquerading as a mediocre wife, aspiring to be a decent elementary school teacher, and establishing myself as a weekend photographer warrior to my growing client list of young families.

My daughter was three, and I remember her watching television one day and coming to me to say she wanted to take ballet classes like the cartoon character Angelina Ballerina. Now, it's important to note that I wasn't THAT mom. The universe played a crazy game by giving me a girl first because I was opposed to everything traditionally girly. I had a deep desire to purchase only gender-neutral clothing, and Lord knows I hated those gigantic hair bows. But here I was with a little girl, and my daughter was turning out to be a walking-early, talking-early, gender stereotype—with a love for all things pink, glittery, light-up Skechers, and now, possibly, tutus.

To understand how a simple request for ballet classes prompted what happened next, it's necessary for me to go back to my own childhood. Many adults have these defining moments in childhood that eventually contribute to who they will ultimately become in adulthood. I remember being eight years old, having this amazing superhero of a dad suddenly become ill and unable to work. Overnight my working-class two-parent, two-income household dwindled to a single-income home with a mom who struggled to keep my brother's and my world spinning while she worked multiple jobs and

took care of a sick spouse. I remember seeing my mom hovering over bills, trying to figure out how to keep things together through my dad's frequent hospital stays, surgeries, and therapies. From a very young age, I remember having a deep desire to not want to add any more stress on her than she was already dealing with, taking care of two young children and my father.

Later, when my brother began elementary school, the school would send home flyers for every after-school activity under the sun—football, cheerleading, basketball, etc. I remember my brother wanting to play football and my mother's face, which revealed she was thinking about the time it would take for such a commitment outside of the house when she was already stretched thin and how much all of this would cost. I remember going to the store with her and trying to find all the things that he would need for football and thinking at that moment, as cool as the opportunity was going to be for him to do something outside of the house and outside of school, I never wanted to stress my parents out that much trying to figure out how they would do something for me. I knew that they would try their best, but it would absolutely stretch them thin. I never asked about extracurricular activities. I never asked about school trips. I never asked to go to school parties. As time passed, I remember watching my little brother, as he got older, continue to participate in activities, and the joy it gave him. When the time came, I decided that if I were ever blessed with children, I would do my absolute best to make sure that they had every opportunity under the sun to do anything that they asked to do; I would try to make sure I'd get it done. I never wanted them to feel like there were financial barriers in our house to achieve it. So, when this three-year-old, beautiful, big bushy–haired, chubby-cheeked little girl that I gave birth to came up to me and said that she wanted to take ballet, I did what I knew I'd always do, and I started looking for ballet classes.

The initial search floored me. Yes, I found ballet classes, but it was what I didn't see that led me here. On every dance studio website in our area, none of the kiddos in their glossy images looked like my kid. There was no diversity at all. As a photographer and a mom to a brown girl, it jumped out at me—the lack of color. I remember growing more curious and googling "Black Ballerina," and at that time, what popped up were the shoes, black ballet flats. This was before Misty Copeland was promoted to principal dancer at American Ballet Theatre and before many dancers of color were searchable online. Now, thanks to social media

I need to see my own beauty and to continue to be reminded that I am enough, that I am worthy of love without effort, that I am beautiful, that the texture of my hair and that the shape of my curves, the size of my lips, the color of my skin, and the feelings that I have are all worthy and okay.

—TRACEE ELLIS ROSS

> The need for change bulldozed a road down the center of my mind.
>
> —MAYA ANGELOU

sites like Instagram and archives like the Museum of Blacks in Ballet, we are learning the rich history of ballet dancers of color that often went unseen in the media outside of the historically diverse companies like the phenomenal Dance Theatre of Harlem.

A few days after I began my search, I was in a group chat with several amazing women that I like to call my Tog Sisters. We were all moms and photographers from all over the country who would find ourselves chatting daily about everything from motherhood to genealogy, but always trying to keep each other motivated behind the camera and in business. I told them about my search to find a ballet studio and what I noticed and didn't notice, and they immediately encouraged me to explore things further. A few days later, I created a casting notice using an image that I shot of my daughter and another friend's daughter in a bathroom in my building. It read that I was shooting a project that I was now calling Brown Girls Do Ballet and looking for dancers ages three to eighteen in three cities: Dallas, Austin, and Houston, Texas. I threw the casting notice up on Facebook and went to bed. By the time I woke up the following day, the casting had gone viral. Up until that point, I had heard the phrase "going viral" plenty of times, but living it was completely different. I learned very quickly that viral means you don't sleep.

At the time, I thought taking pictures of young ballerinas ages three to eighteen would be easy. I didn't understand ballet technique or posing.

To say that early images were abysmal would be stating it lightly, but this story goes so much further than those initial images. After meeting the parents during that first weekend of shoots in Dallas, I understood that it wasn't just me who noticed the lack of color in dance in mainstream media. For many of the girls, it was their reality in dance since their first lesson. For many of the parents, it was the reality of years of navigating a space where their little ones loved what they were doing, but the space didn't often treat them as if it loved them doing it. By the time I finished shooting in Austin the following weekend, I knew I had to do more, but I didn't know how or what.

Fast-forward several years and multiple iterations, what began as just a photo project is now a full-fledged nonprofit organization that provides resources, mentorship, inspiration, and encouragement to young dancers of color worldwide. It turns out, more people than just my little girl needed to SEE themselves in that space, and by creating a platform built on the visual representation of dance diversity, we created a movement.

When I set out to put this book project together, it was important to me to have all phases of a dancer's journey represented—from a young girl's first introduction to ballet going to their first classes, to their retirement—and also their continued enjoyment in the art form and desire to show that the love of ballet was still forever in their heart and feet. I think I initially believed that I would have

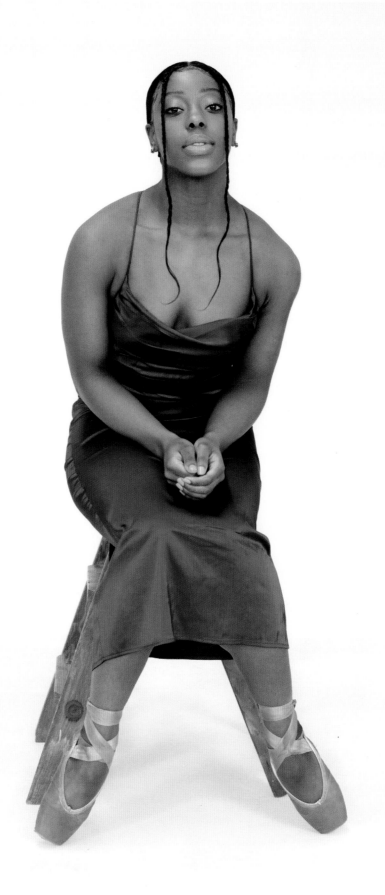

DYMON SAMARA

> If they don't give you a seat at
> the table, bring a folding chair.
>
> —**SHIRLEY CHISHOLM**

several professional dancers reach out and want to be a part of this project, or that many of the ones I reached out to be photographed would immediately jump at the opportunity, but this did not happen. It caused a lot of stress trying to figure out how to make such a project happen, especially during a pandemic when many dancers (and myself) were still afraid to leave their homes. It wasn't until after I started going through the first set of images, and responding to the new casting requests that started rolling in as recent as 2022, that I realized that this book was not just for the dance experts breaking apart the dance photography or the technique and lines of each dancer photographed. Because, after all, it would've been easier to shoot pros for these reasons. This book is for all girls, all hues, shapes, sizes, and different ability levels in ballet. I want every girl to be able to find themselves somewhere in this book. To find someone who looks like them, where they hope to be in their training, where they are, or where they've been, and I hope that it inspires them to keep going. So, it may not be perfect, for sure, but this particular book is for every little brown girl who may not have ever seen themselves at the barre to know there is a whole village of brown girls out there rooting and waiting for them to take that first twirl.

The power of brown ballerinas steeped in their grace and beauty can now belong to us for our personal musing, casual perusal, and a deep sense of wonder. I am so honored and excited for everyone to get this book, display it, gift it, and most importantly, lean into the many incredible discussions the photography, quotes, and short notes in *The Color of Dance* are sure to provoke. Prepare to be wowed and eager to share.

> —**AMBER N. CABRAL, FOUNDER, CABRAL CO.; CHAIR,
> BROWN GIRLS DO BALLET**

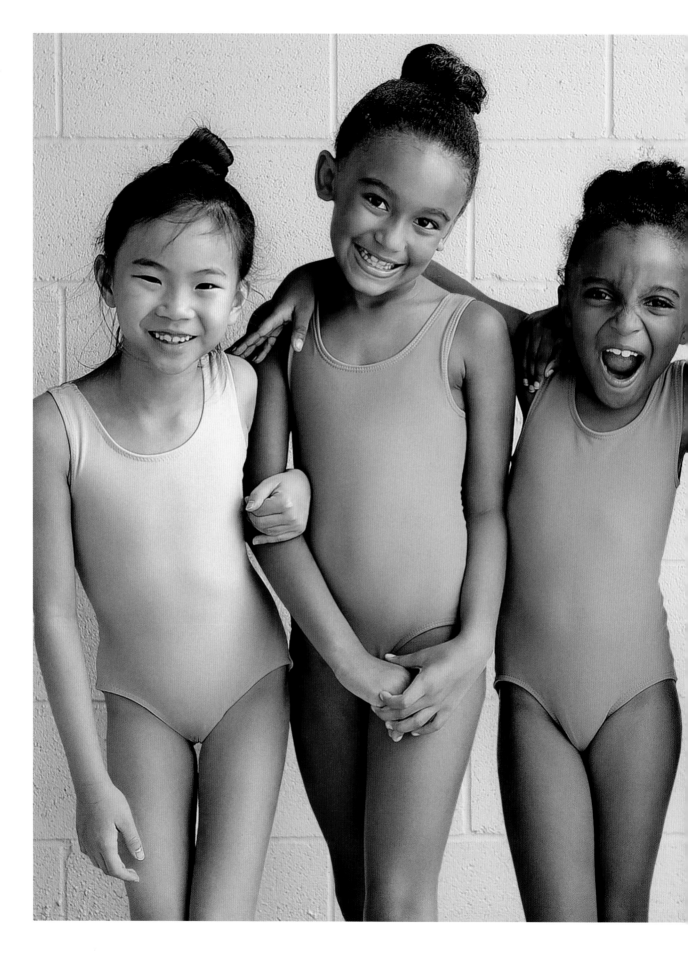

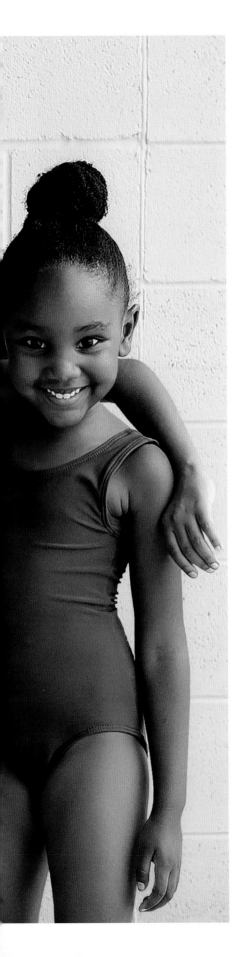

Dance has the power to move and change people. I dance because dance is a creative outlet that allows me to explore how I feel about the world around me.

—CHARLIE REESE

L TO R: ABBIE NGUYEN-THIEM, OLIVIA LOTT, CHARLIE REESE, DALLAS KNOWLES

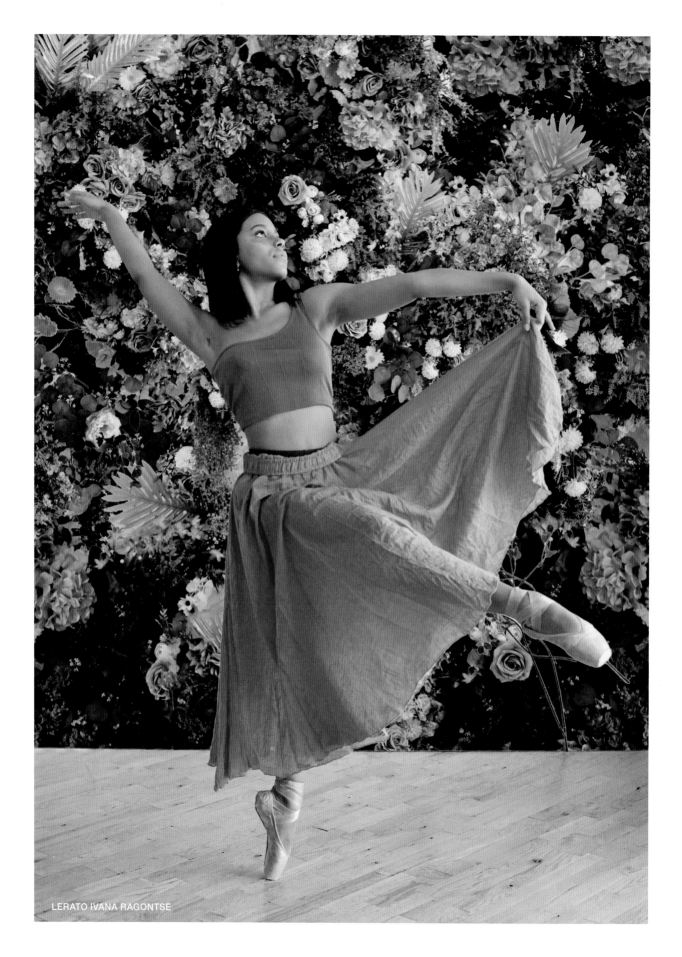

LERATO IVANA RAGONTSE

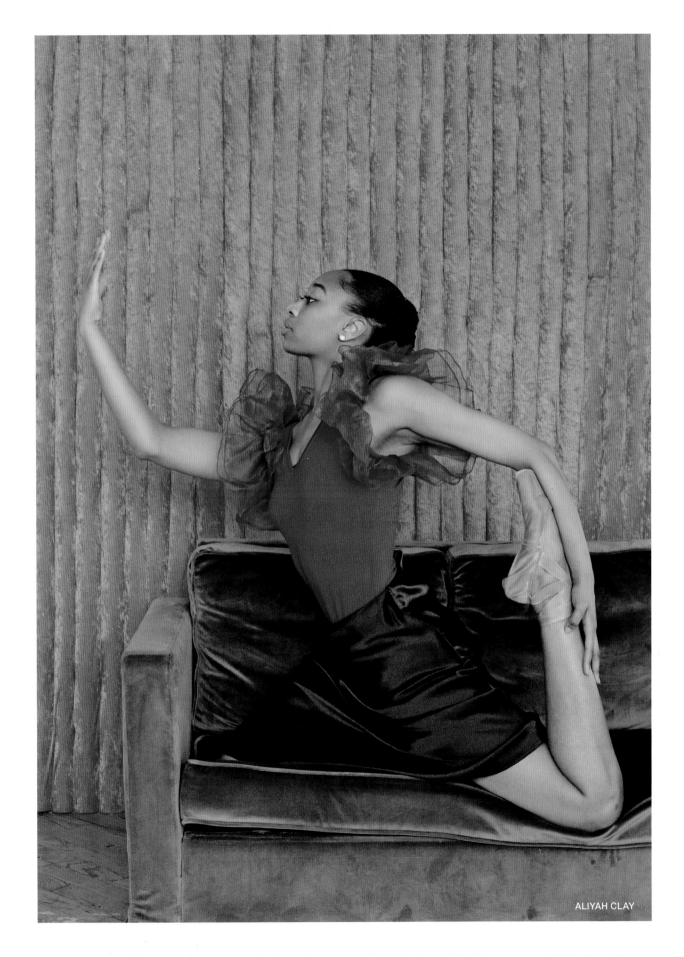

ALIYAH CLAY

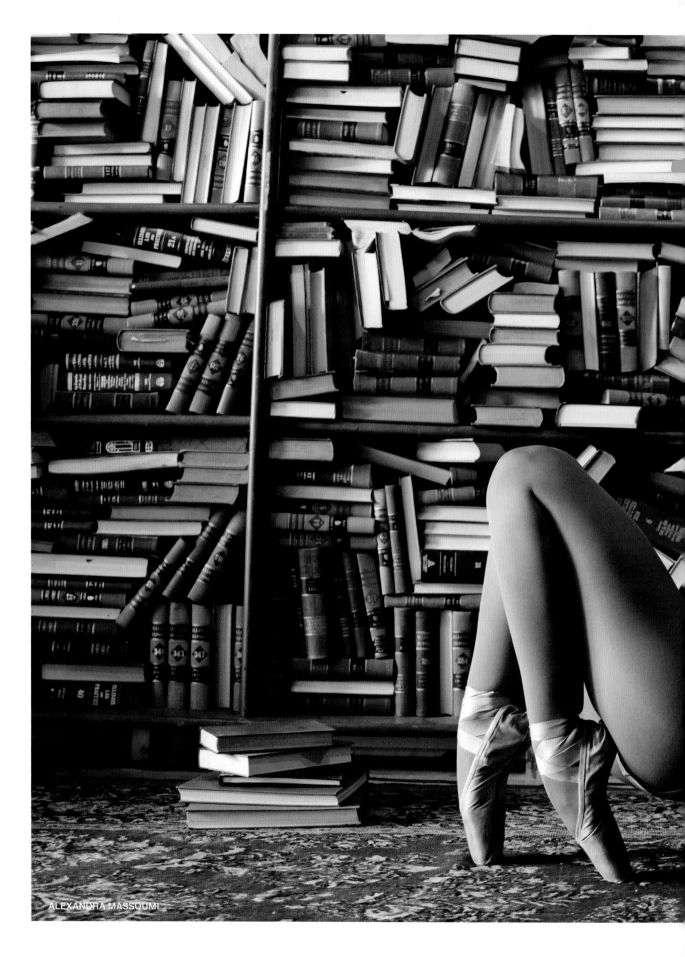

ALEXANDRA MASSOUMI

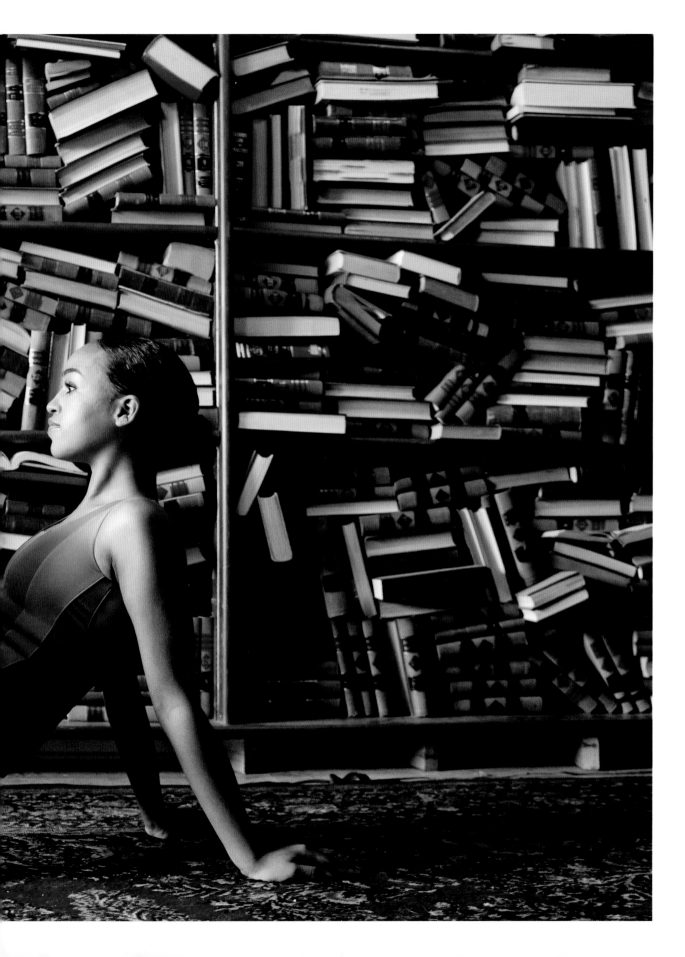

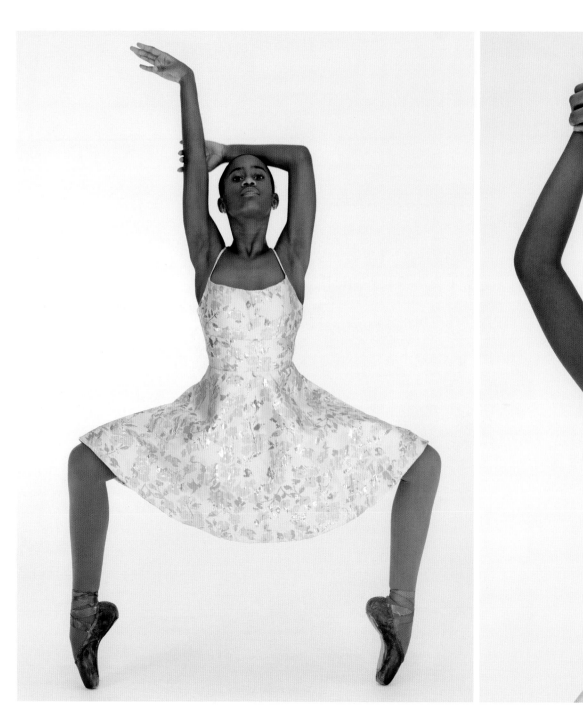

ALEXANDRA FRANCOIS

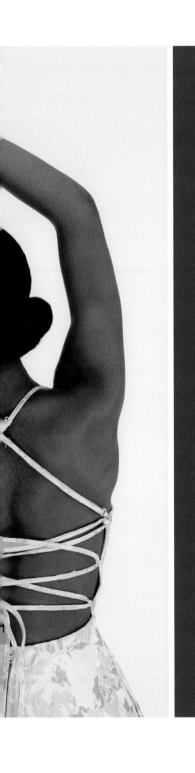

Your hair represents who you are.
We shouldn't have to change it to fit
in or to have a certain look. We should
embrace our natural curls and coils.

—ALEXANDRA FRANCOIS

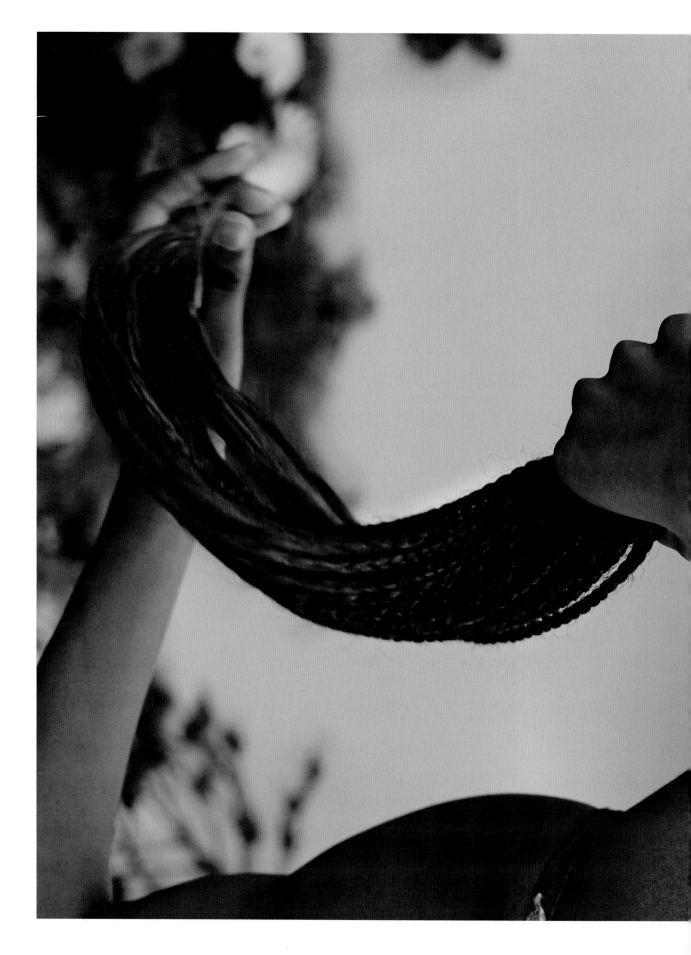

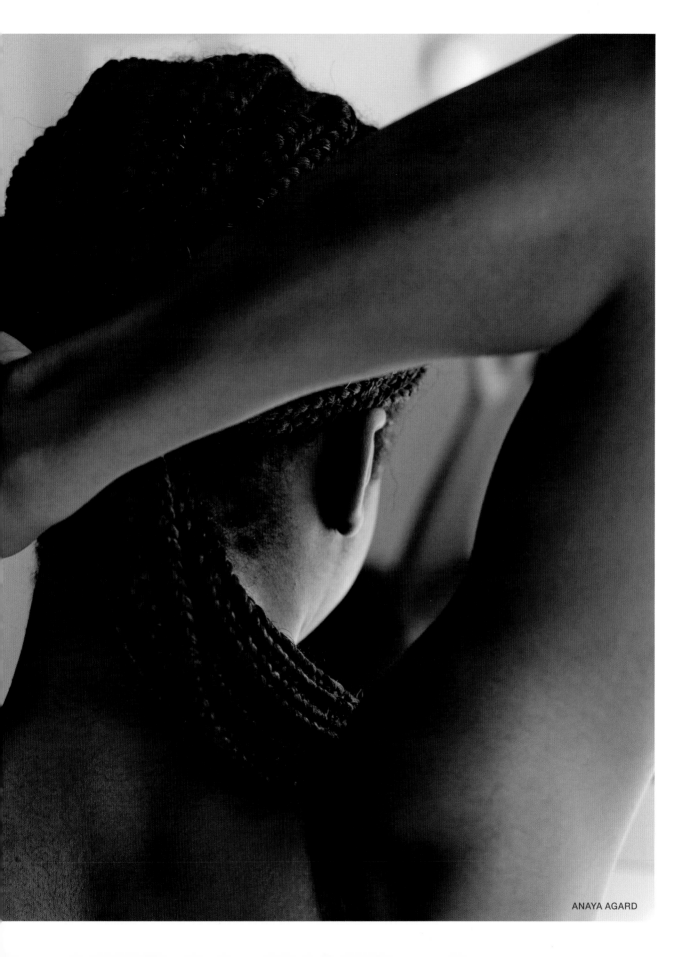

ANAYA AGARD

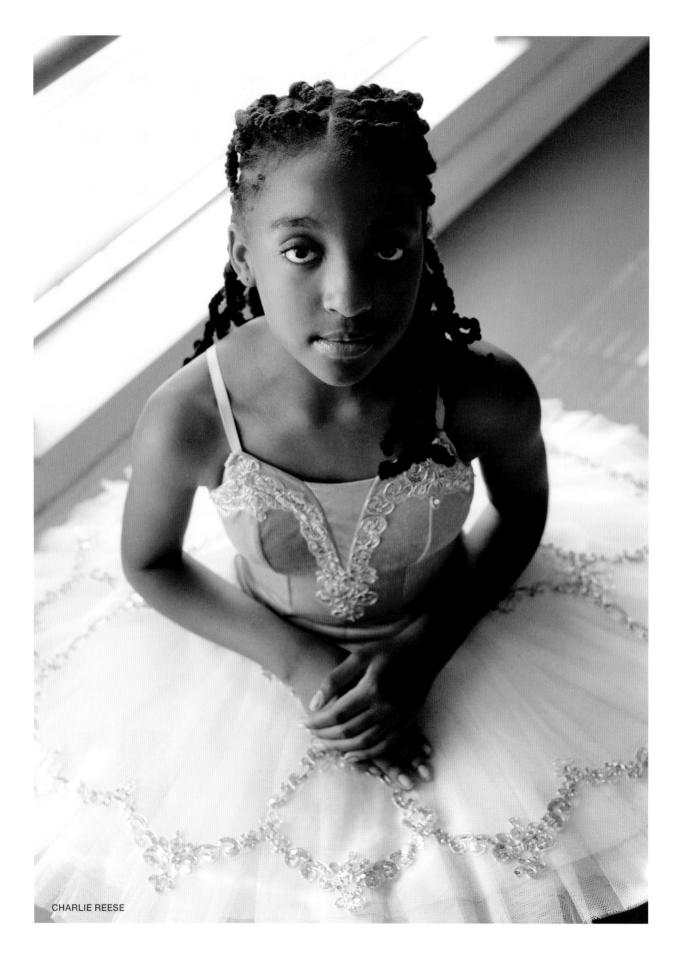

CHARLIE REESE

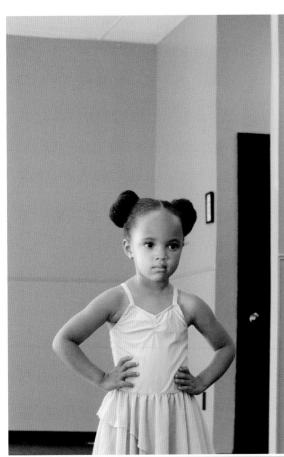
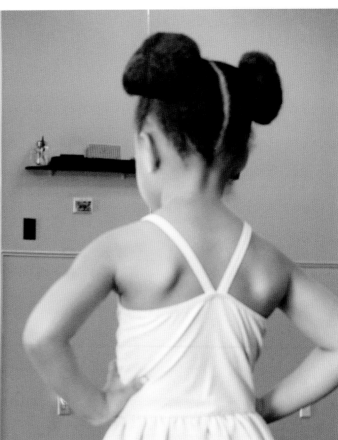
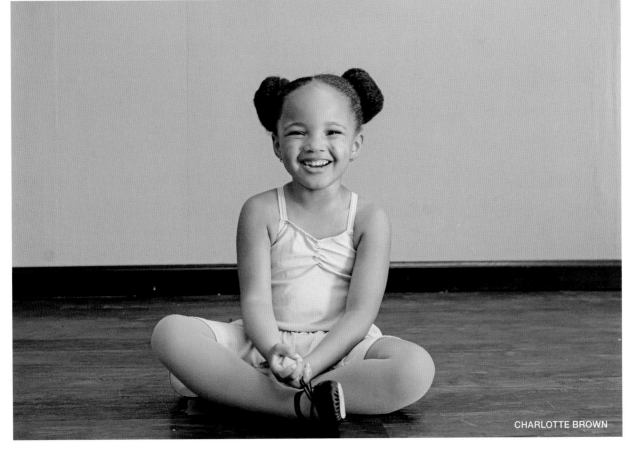

CHARLOTTE BROWN

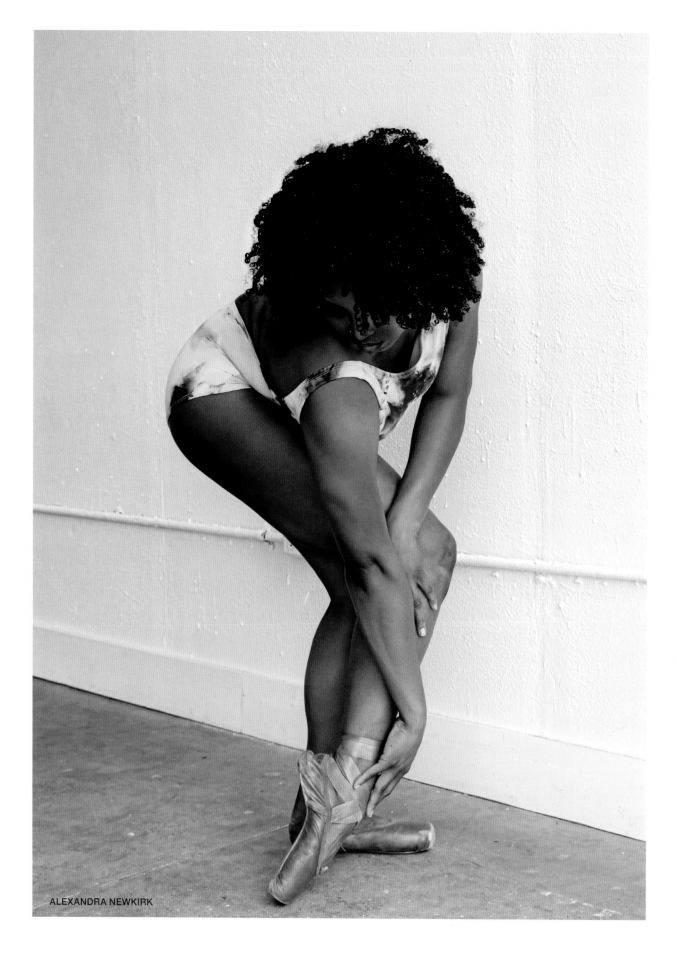

ALEXANDRA NEWKIRK

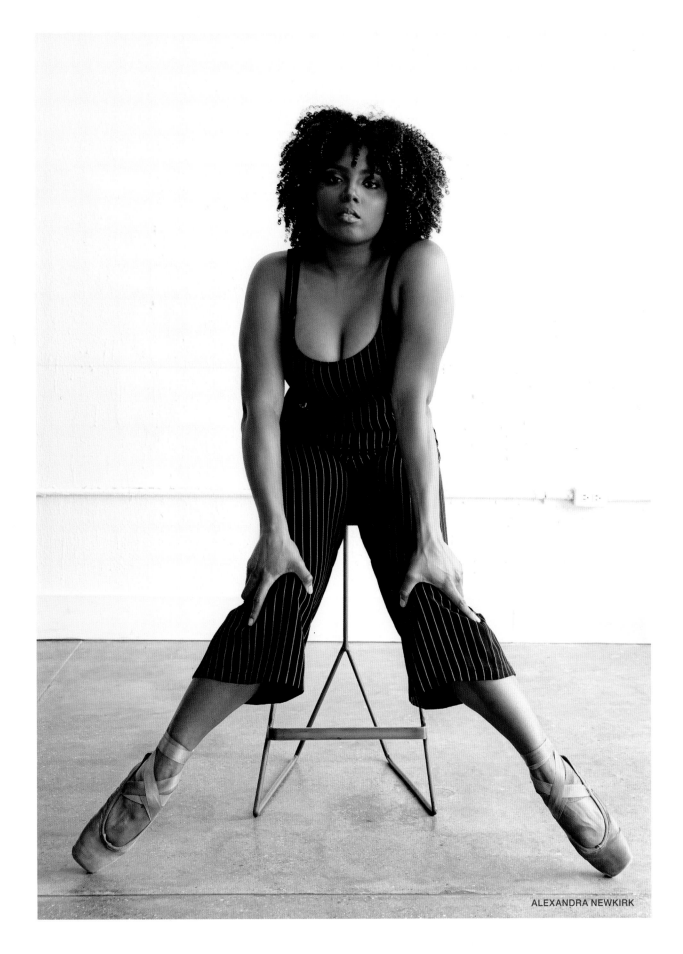

ALEXANDRA NEWKIRK

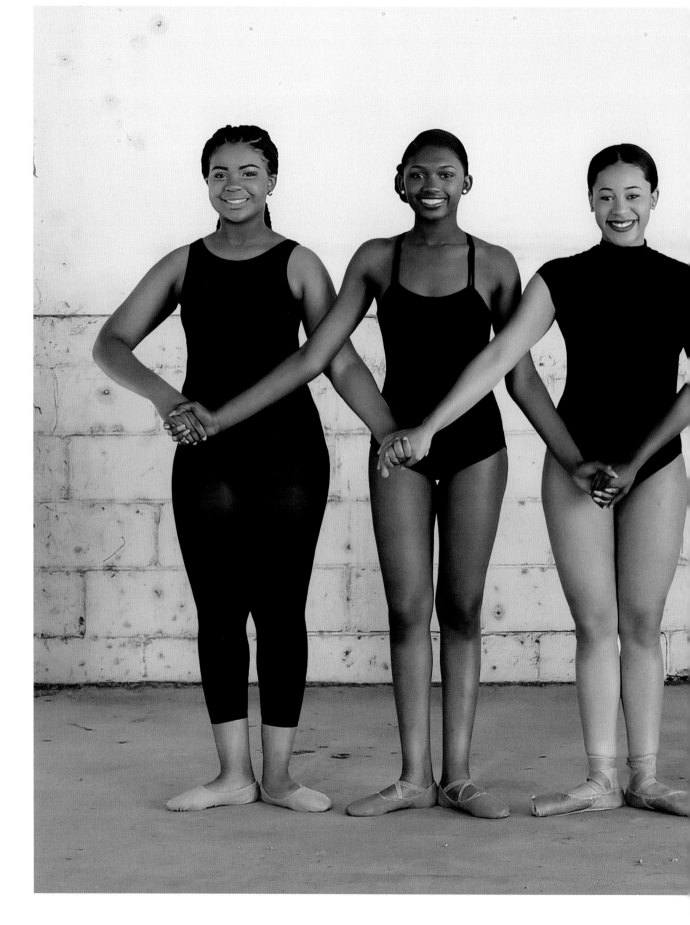

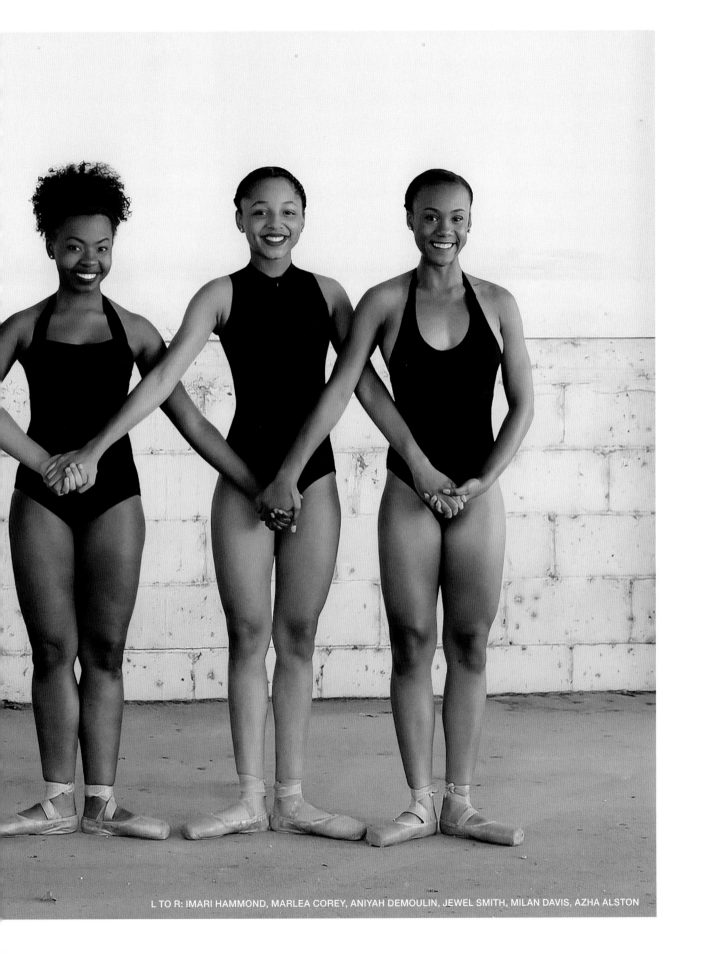

L TO R: IMARI HAMMOND, MARLEA COREY, ANIYAH DEMOULIN, JEWEL SMITH, MILAN DAVIS, AZHA ALSTON

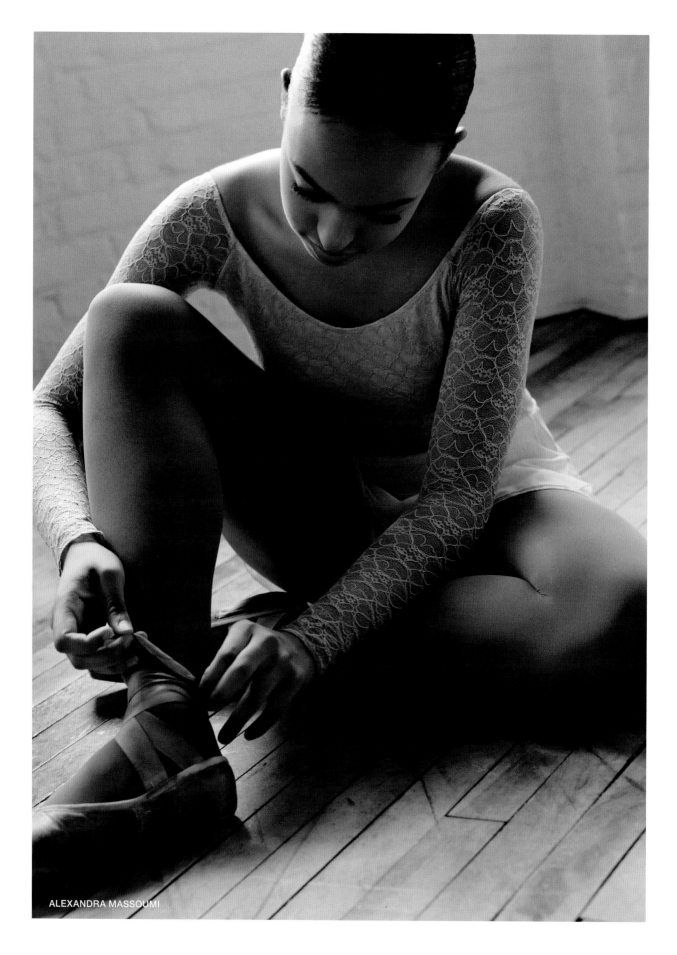

ALEXANDRA MASSOUMI

To be able to dance at the level I currently do is a gift from God. It is a true blessing and honor to be able to express myself through dance. I started dance at four years old. It has been amazing to see my body strengthen and grow. There have been many changes since I have started dance, including more diversity. However, many times I am still the only person of color in the dance. This makes me stand out for better or worse. It is my pledge to myself to stand out solely for doing my best, pushing myself, and challenging myself to do better each and every time I am in the studio.

—ALEXANDRA MASSOUMI

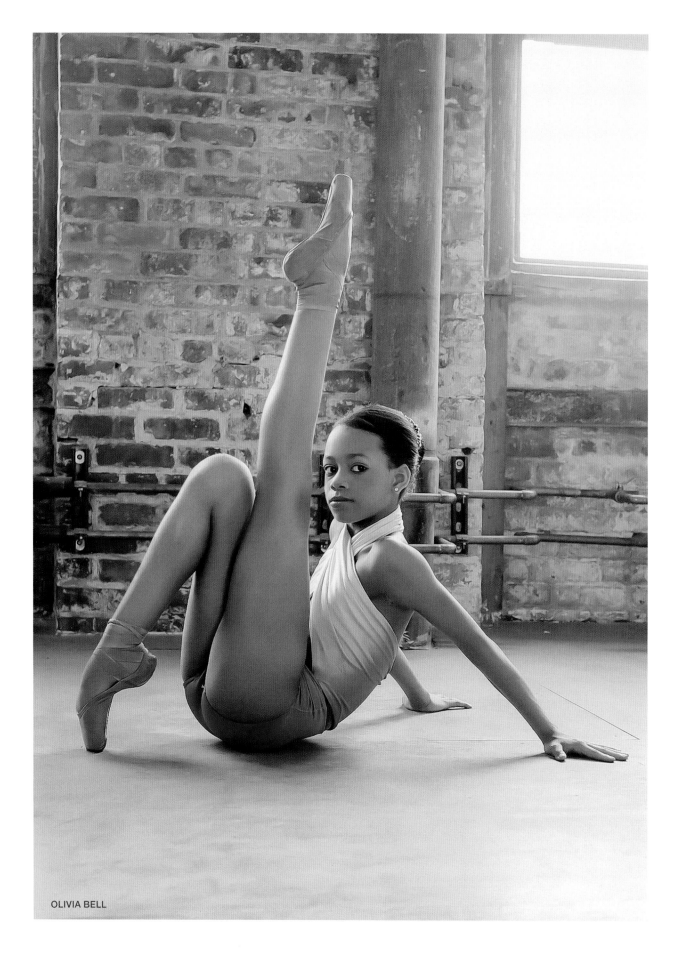

OLIVIA BELL

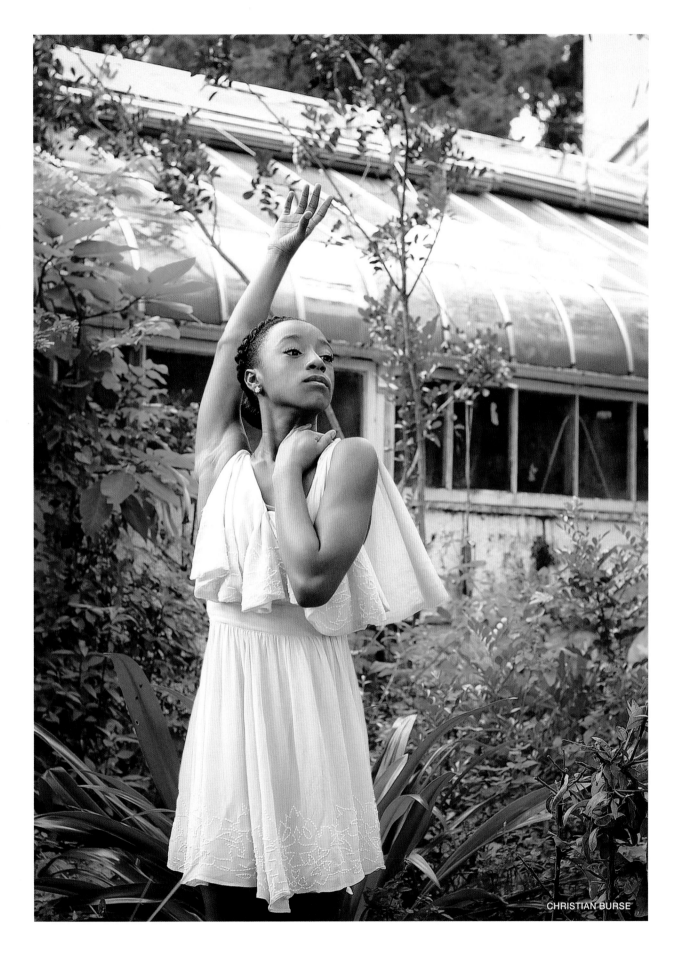

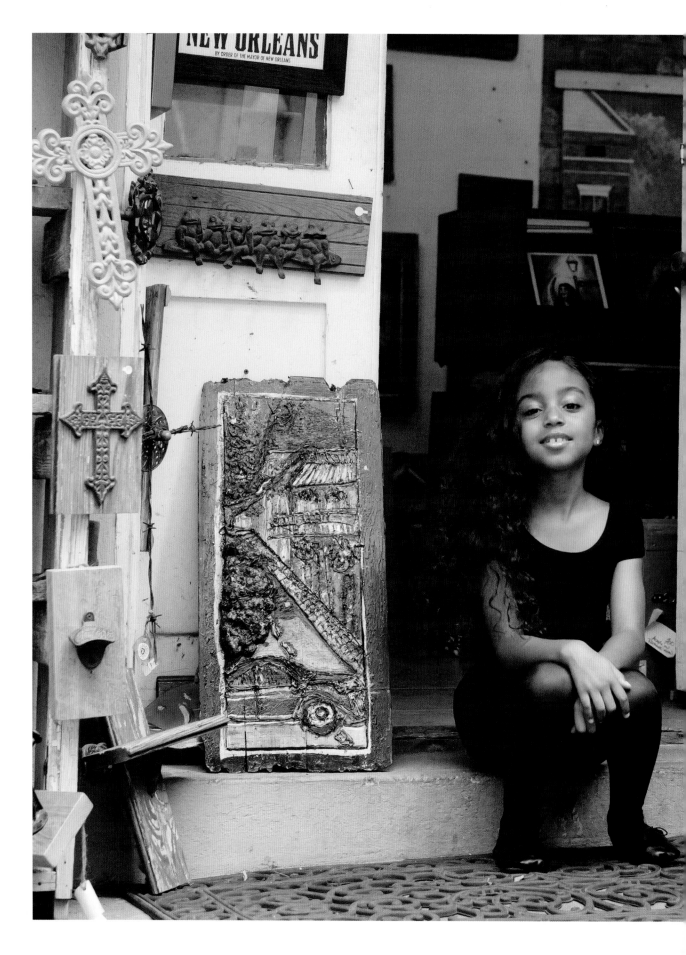

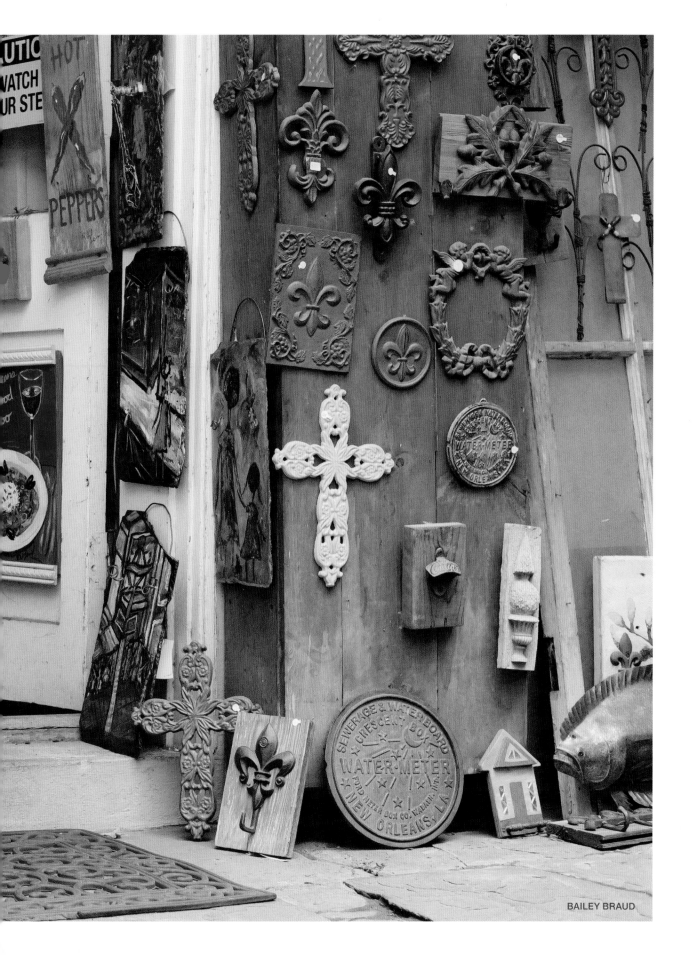

BAILEY BRAUD

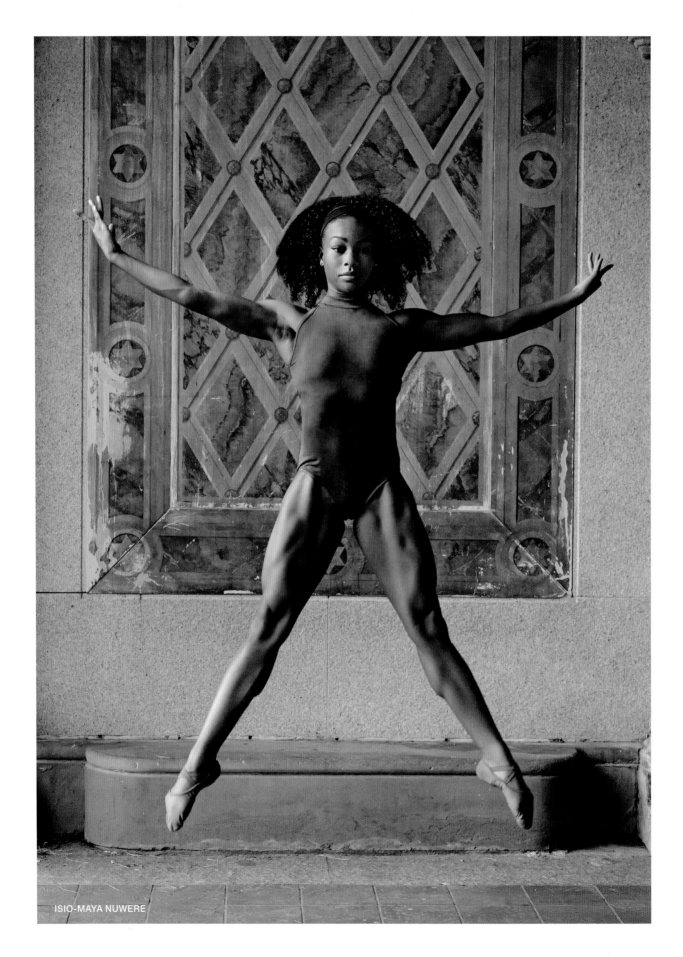

ISIO-MAYA NUWERE

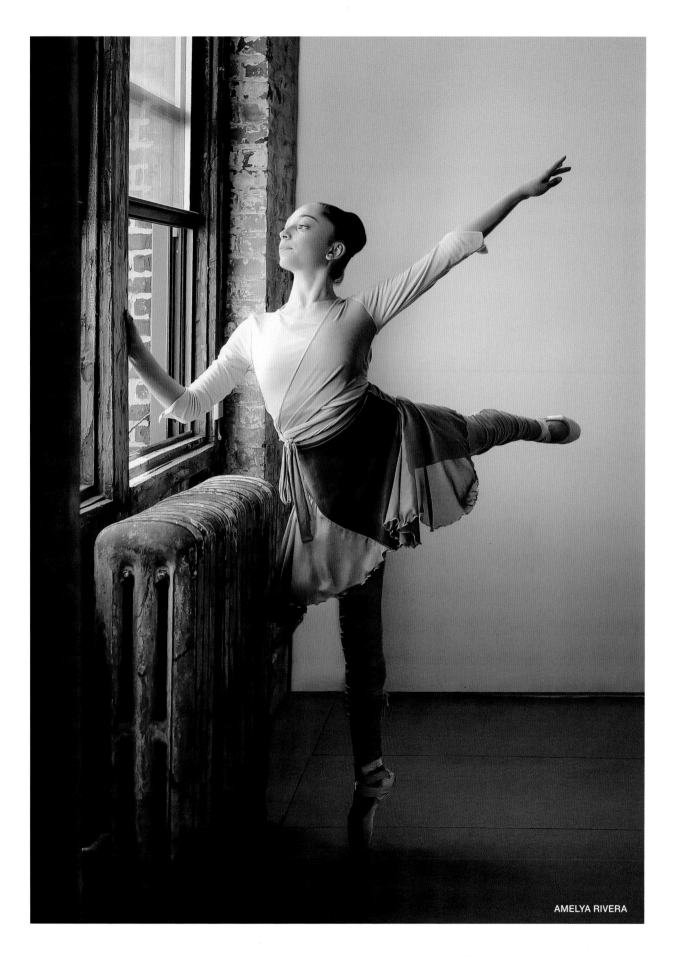

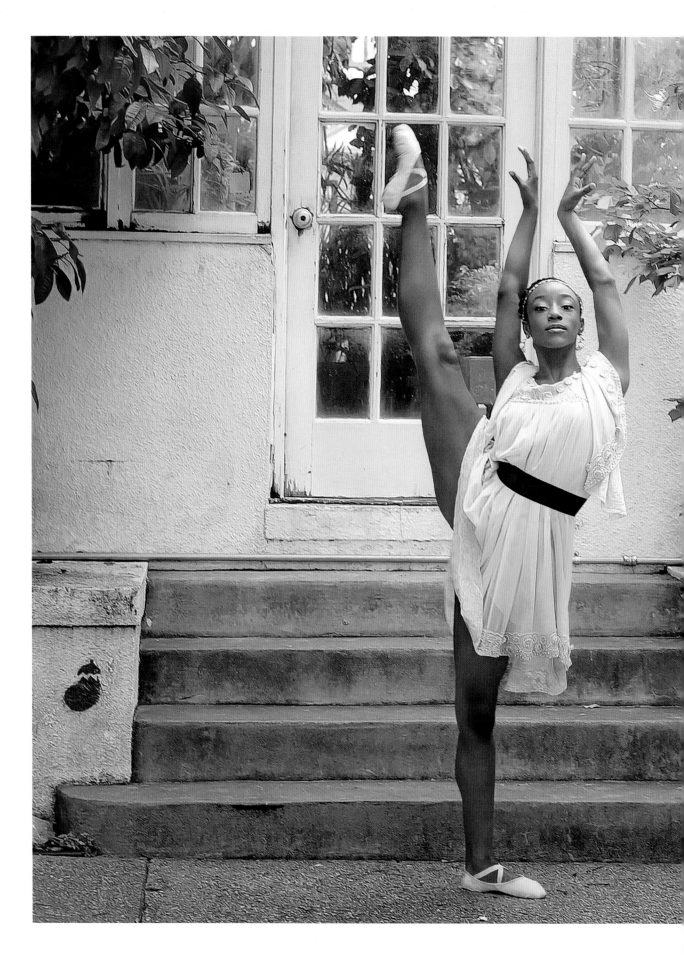

CHRISTIAN BURSE

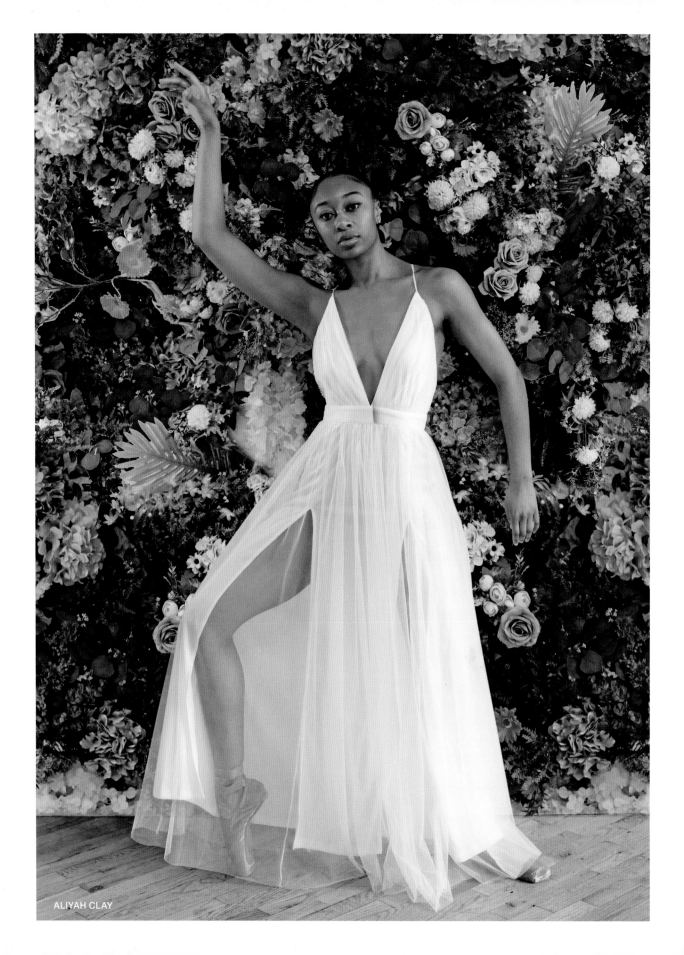

ALIYAH CLAY

I am a vessel. Being a dancer means giving myself permission to trust, let go, be vulnerable, find pleasure, enjoy the process, take up space, reimagine, listen, and move with full body expression—unapologetically surrendering.

—ALIYAH CLAY

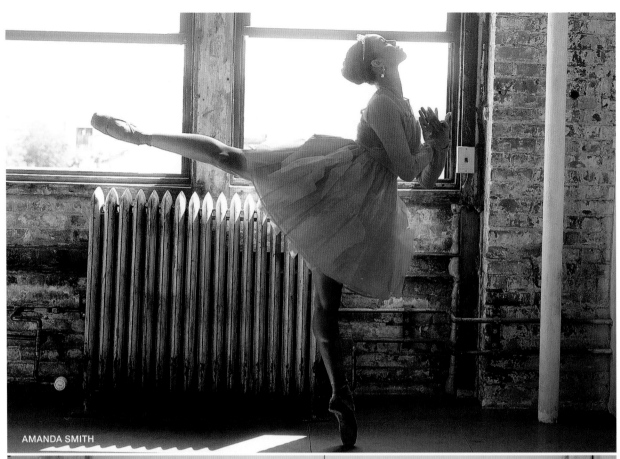

AMANDA SMITH

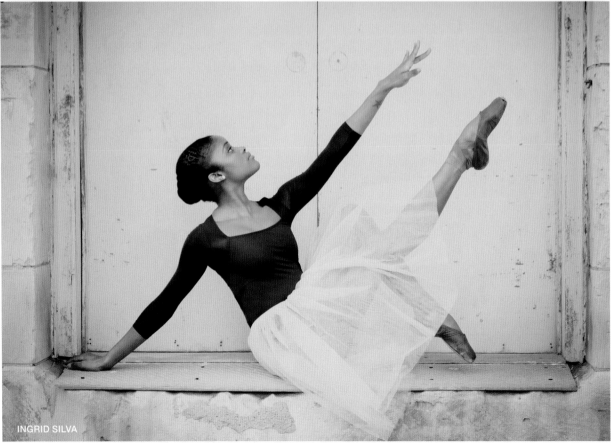

INGRID SILVA

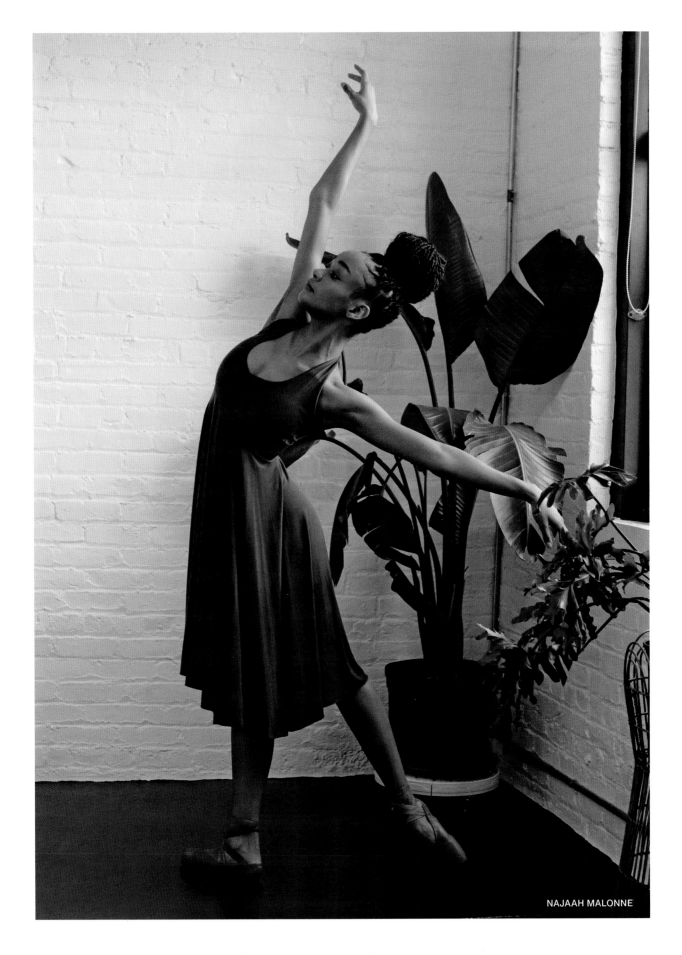

NAJAAH MALONNE

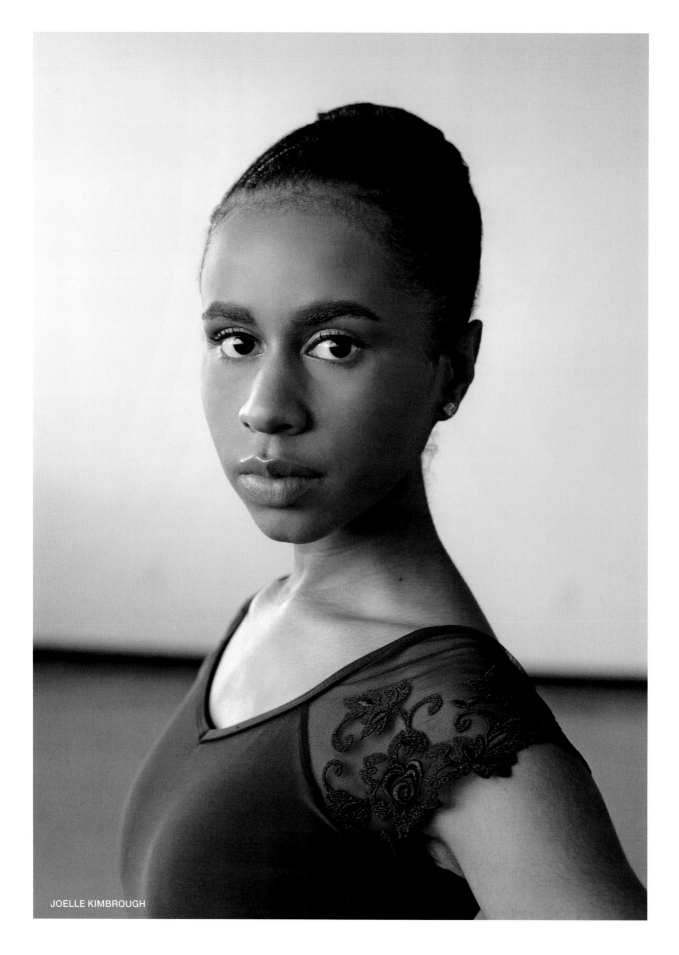

JOELLE KIMBROUGH

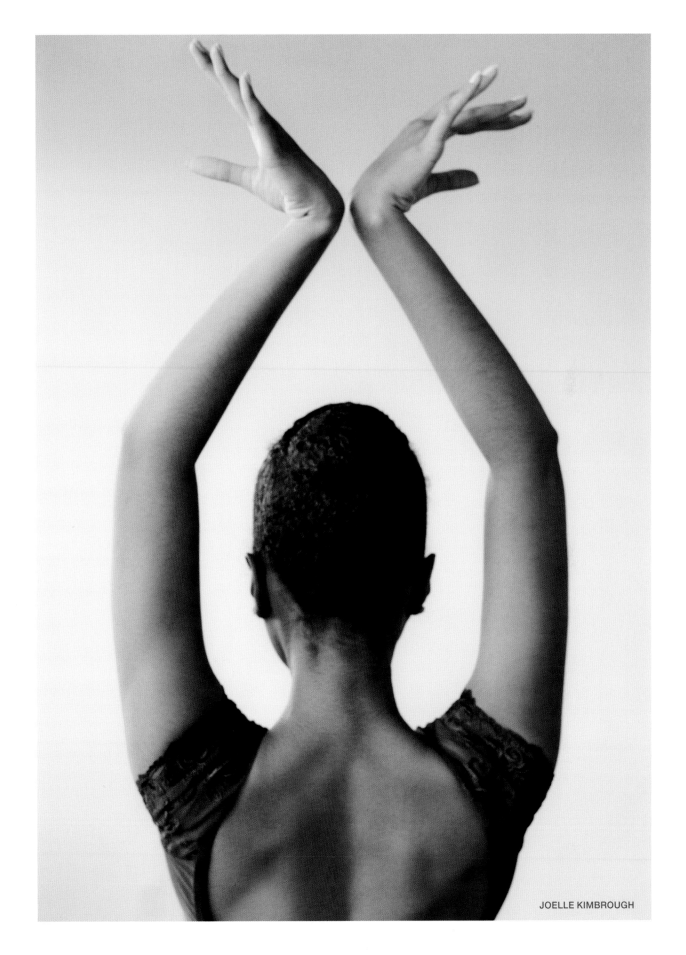

JOELLE KIMBROUGH

ISIO-MAYA NUWERE

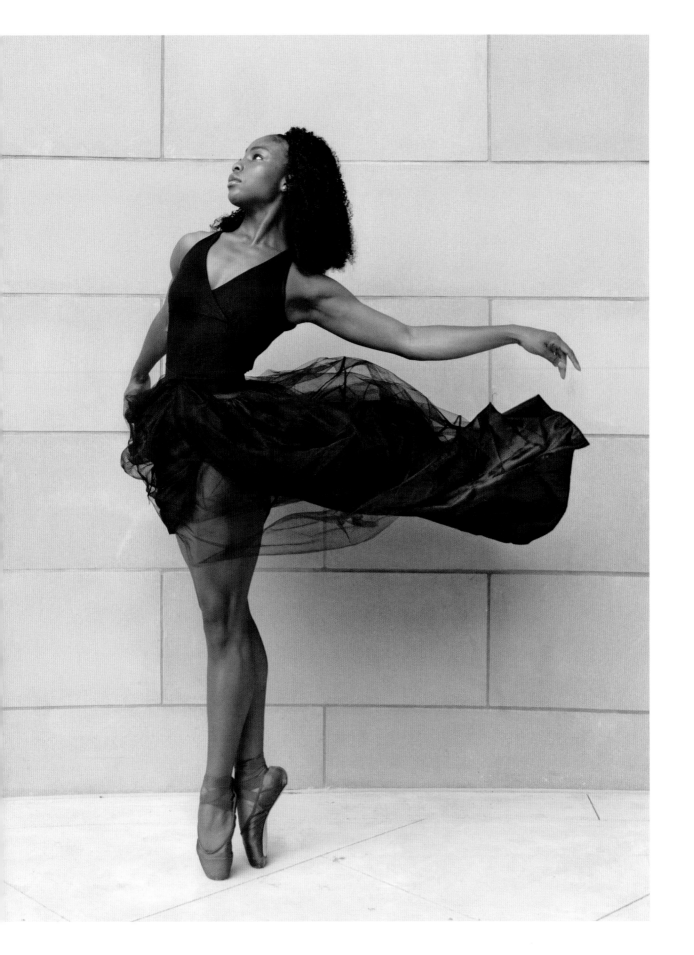

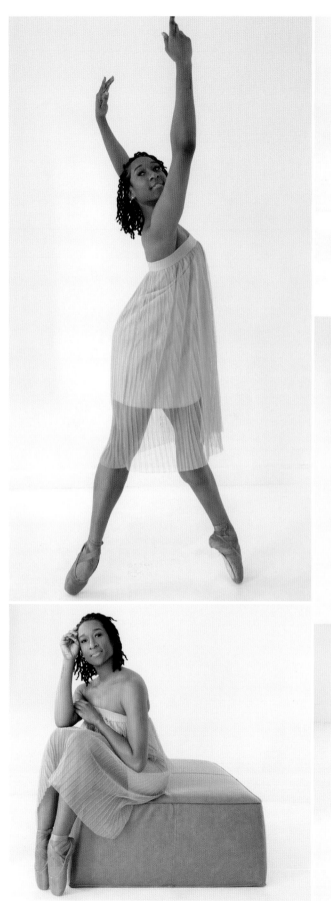
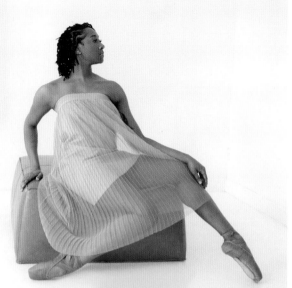
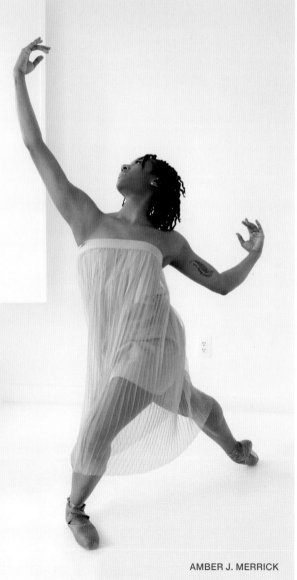

AMBER J. MERRICK

I realized early on that my journey is bigger than me. Show a girl she can, watch a woman live a dream. I dance for little brown girls with big dreams.

—AMBER J. MERRICK

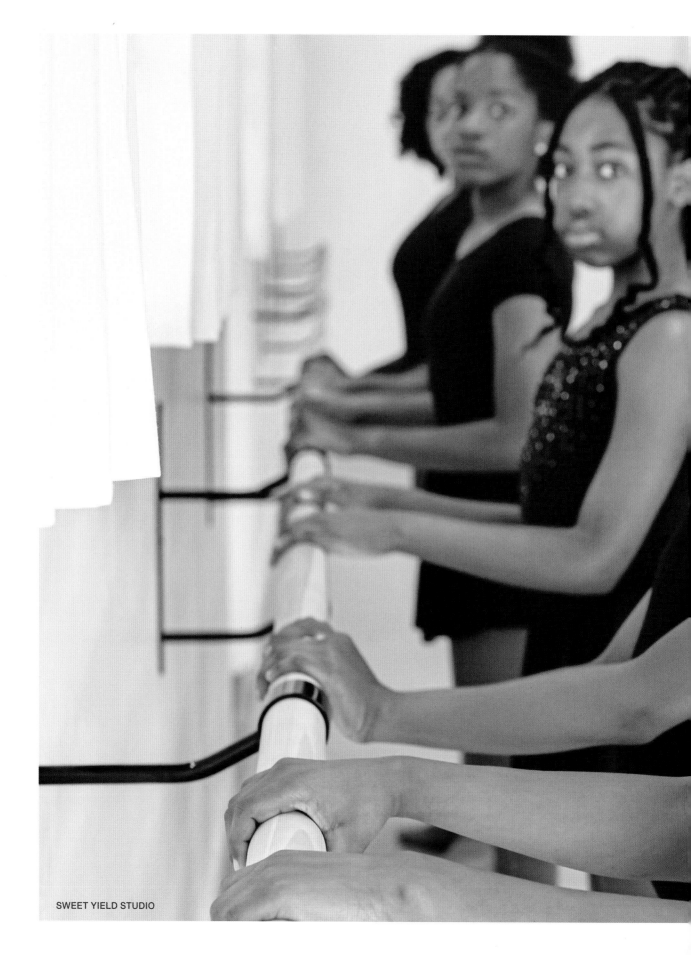

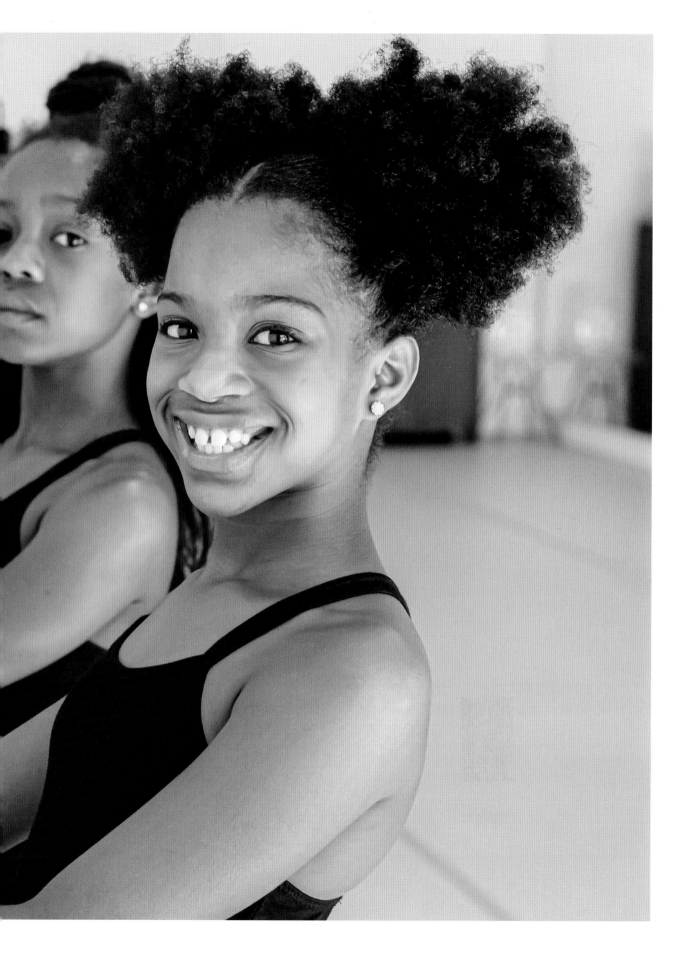

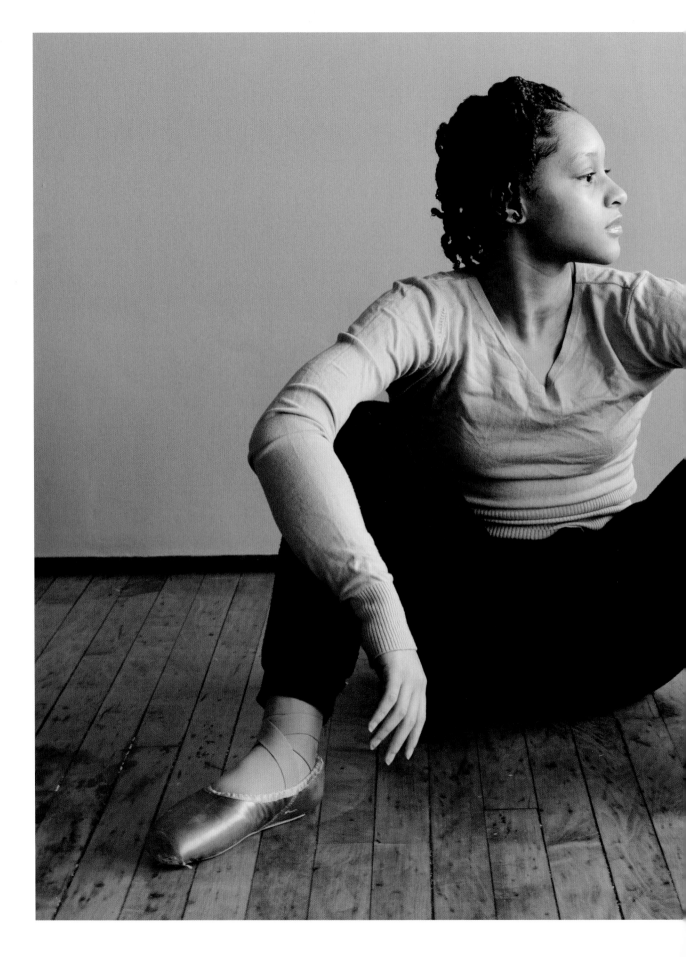

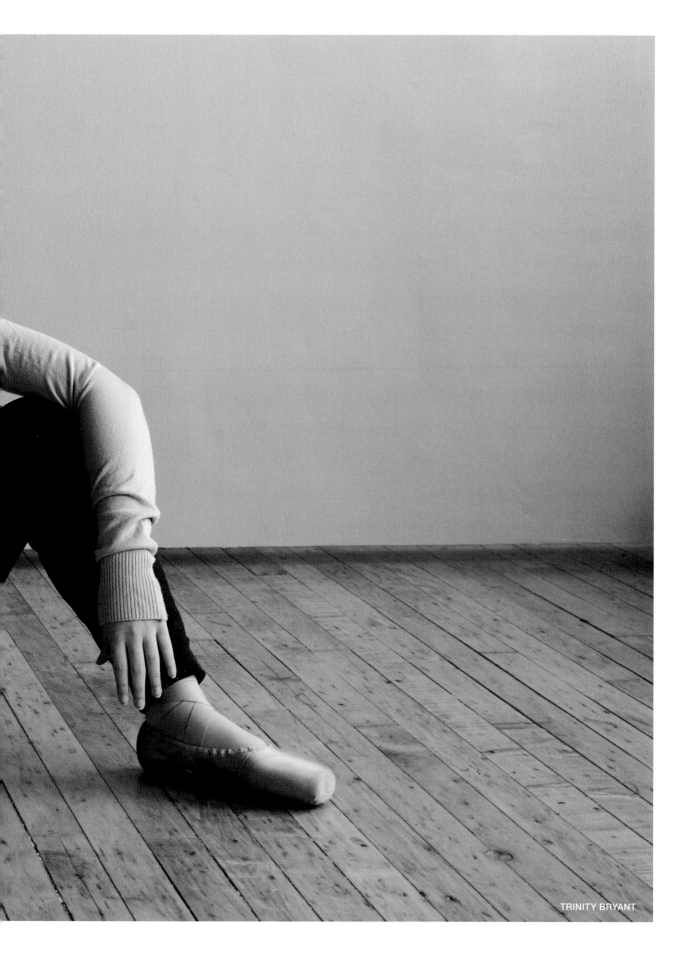

TRINITY BRYANT

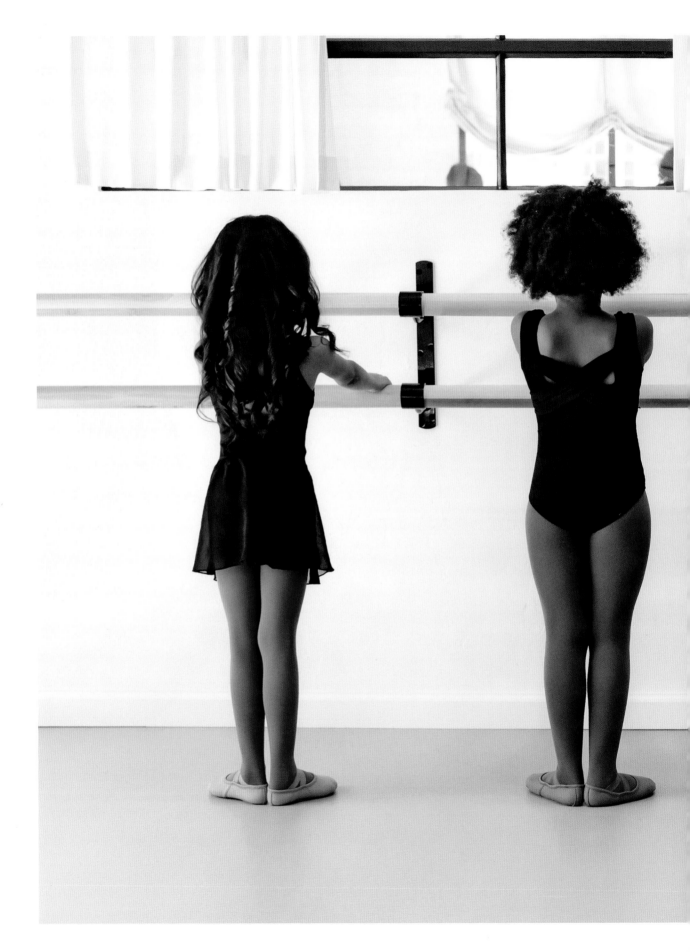

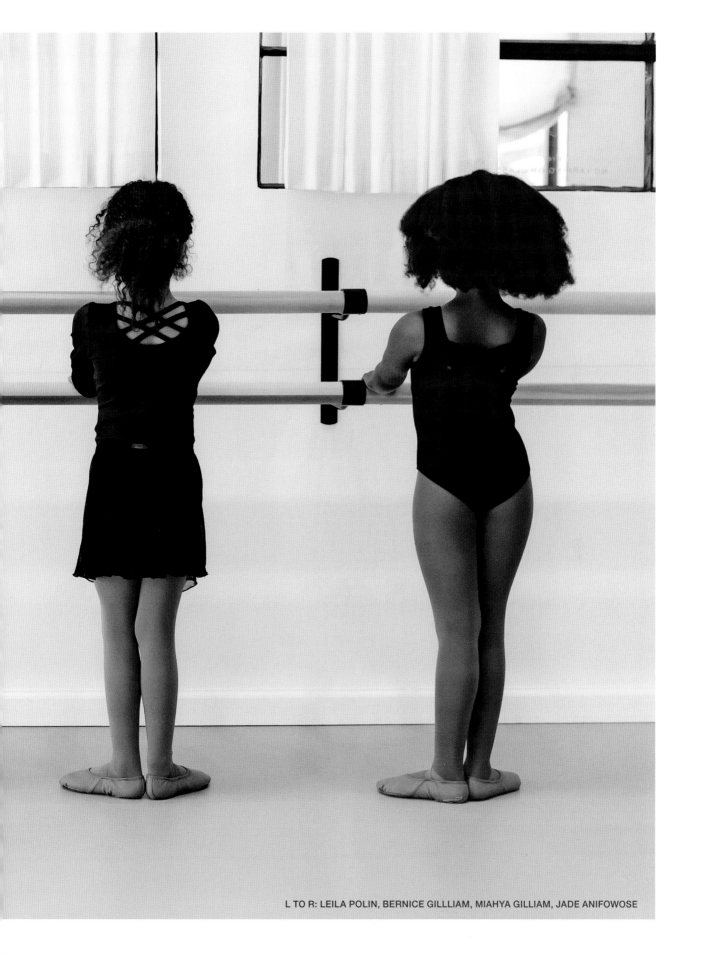

L TO R: LEILA POLIN, BERNICE GILLLIAM, MIAHYA GILLIAM, JADE ANIFOWOSE

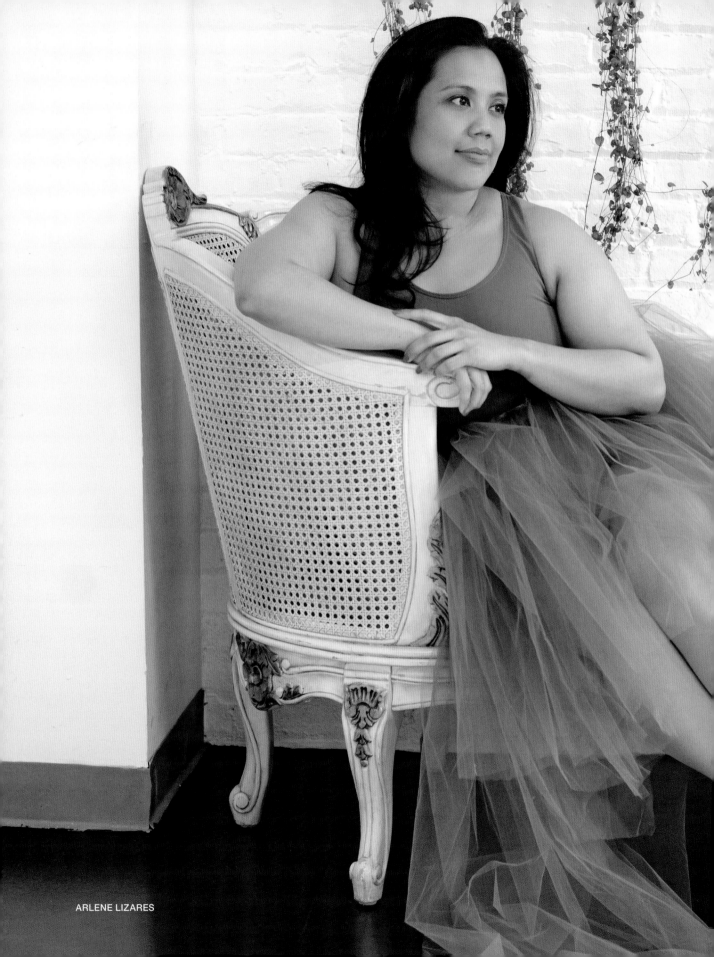

ARLENE LIZARES

Ballet is the foundation for all of my athletic abilities.
I am strong and agile because of it. It will always be
my home for mind-body connection through graceful
movement.

—ARLENE LIZARES

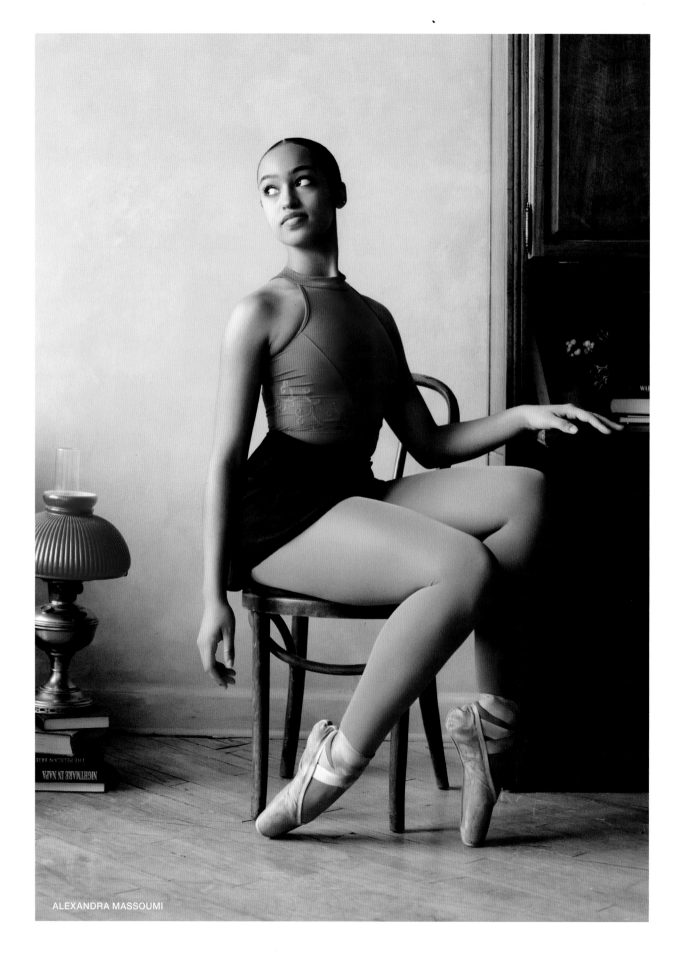

ALEXANDRA MASSOUMI

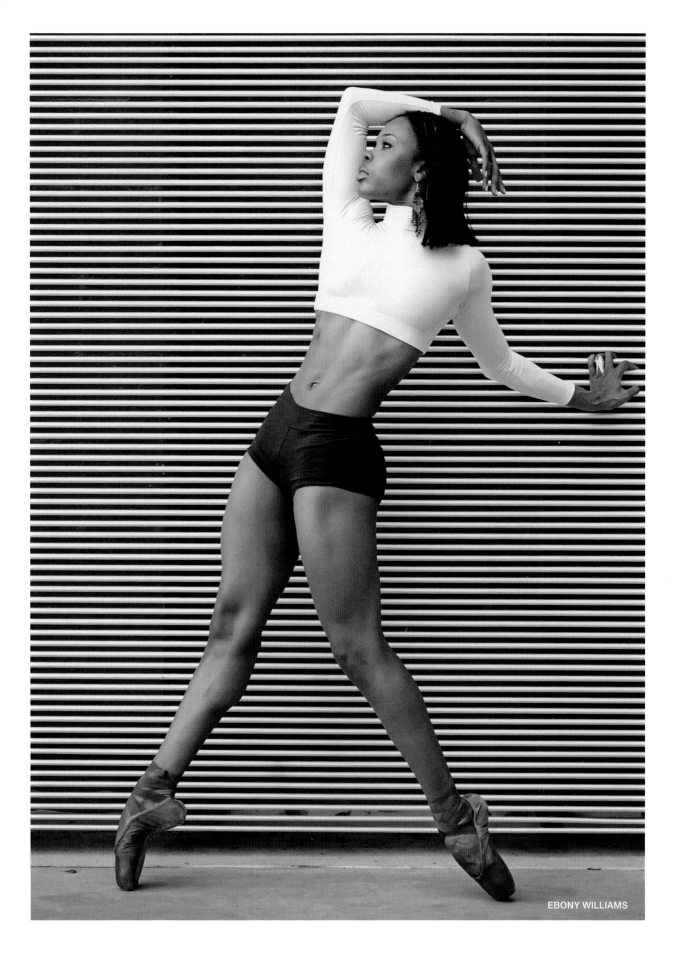

EBONY WILLIAMS

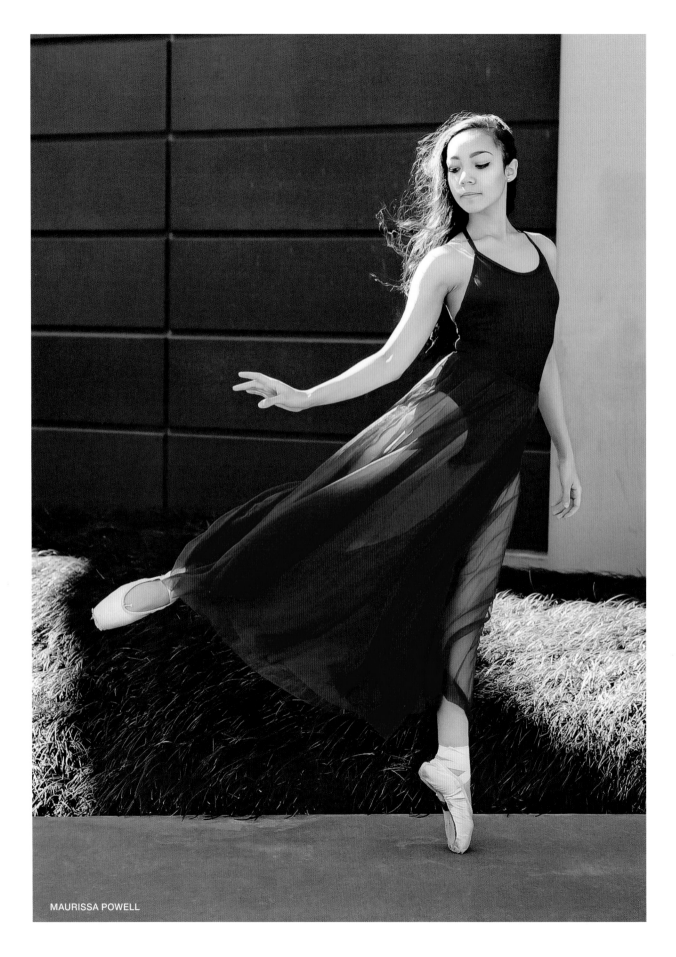

MAURISSA POWELL

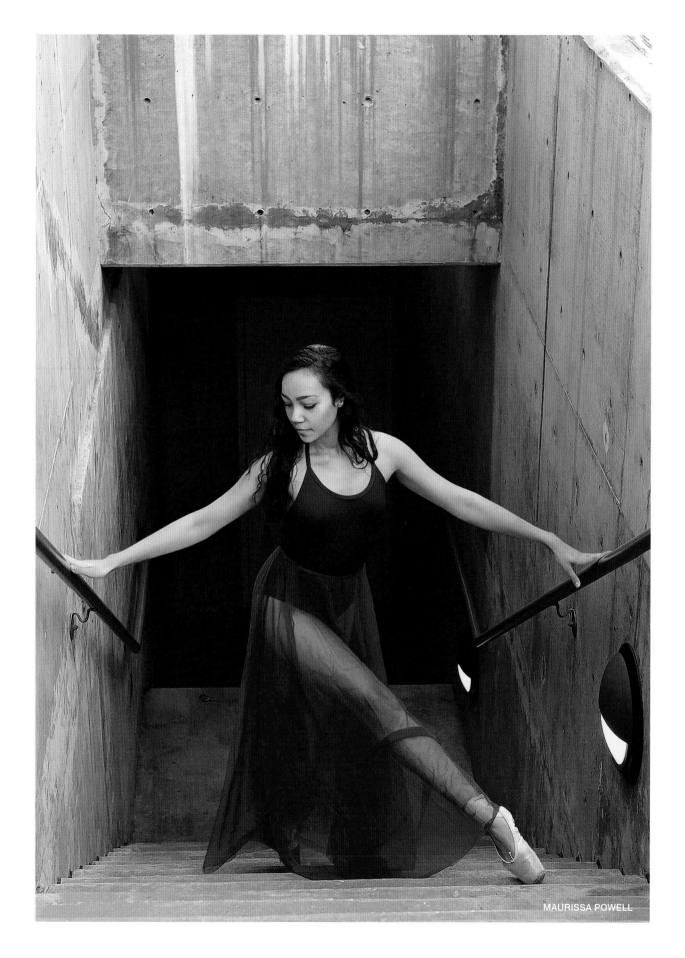

MAURISSA POWELL

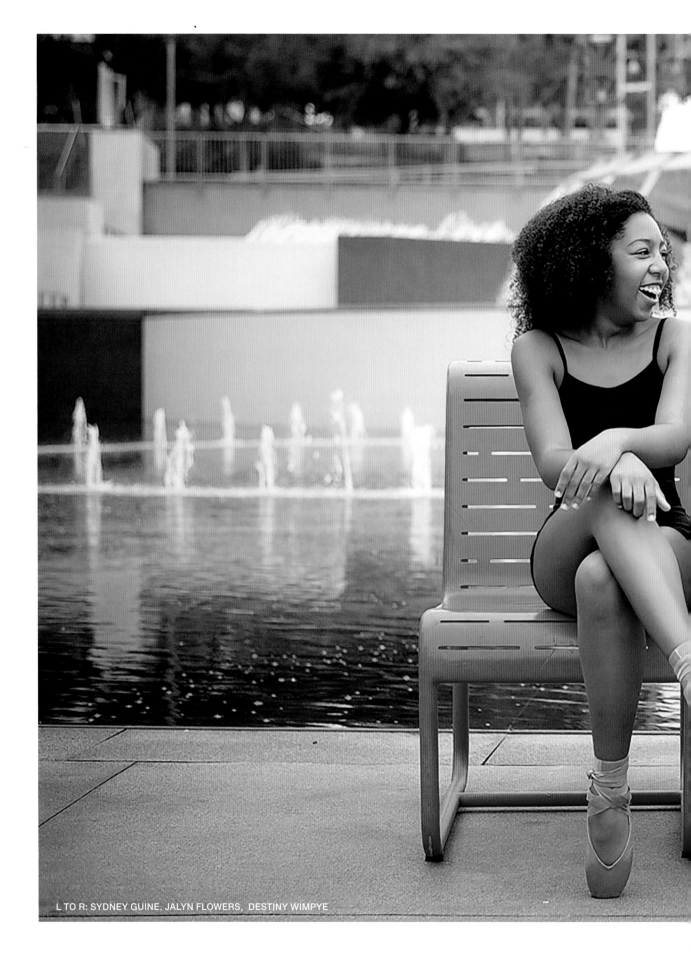

L TO R: SYDNEY GUINE, JALYN FLOWERS, DESTINY WIMPYE

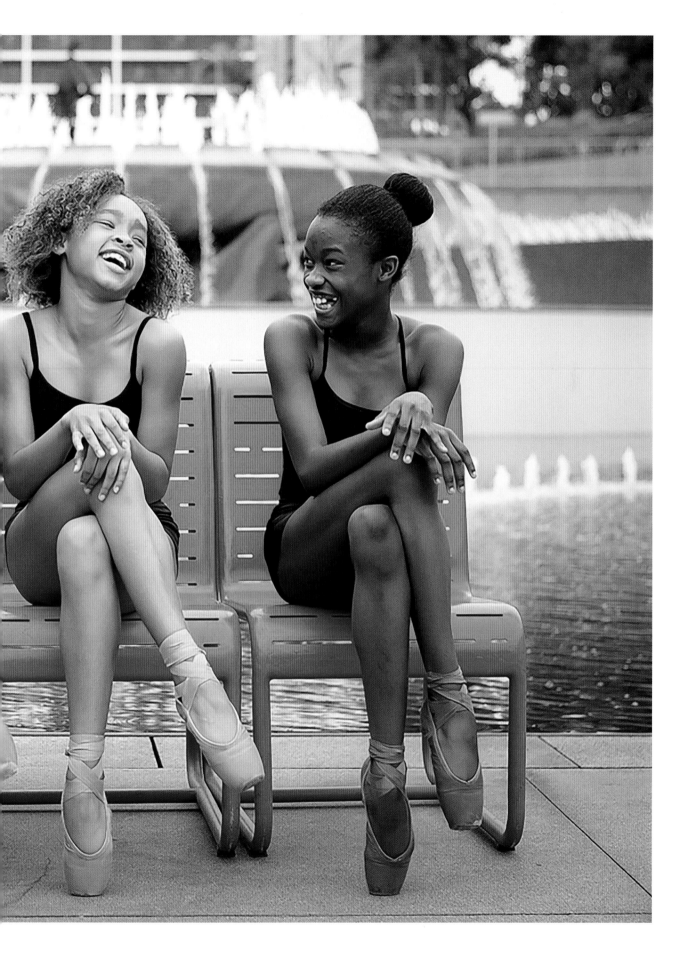

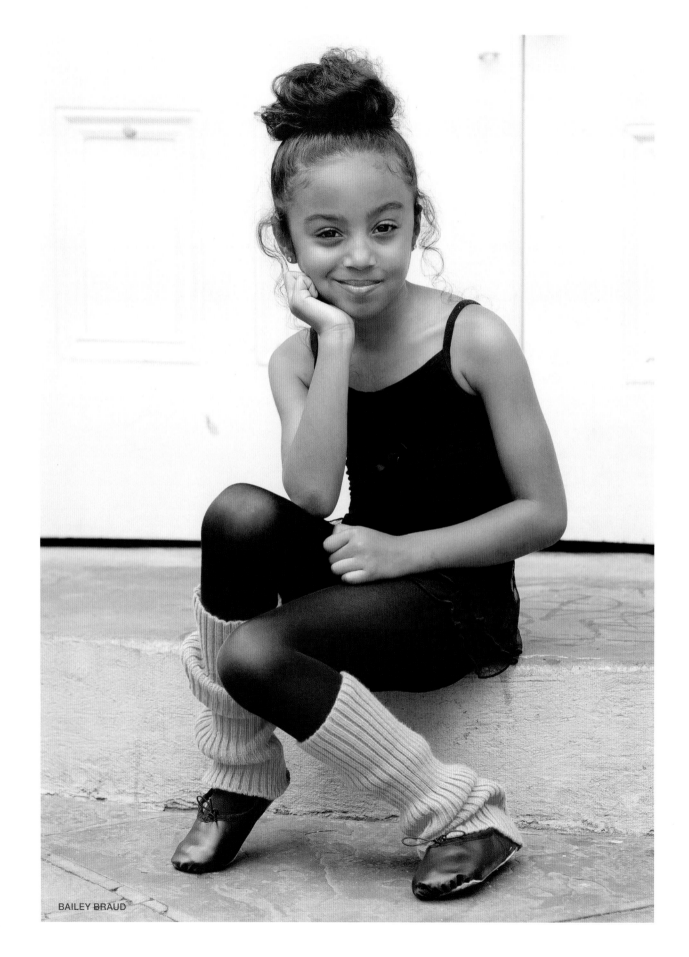

BAILEY BRAUD

Dancing gives me an outlet to demonstrate my creativity, gracefulness, strength, and independence.

—BAILEY BRAUD

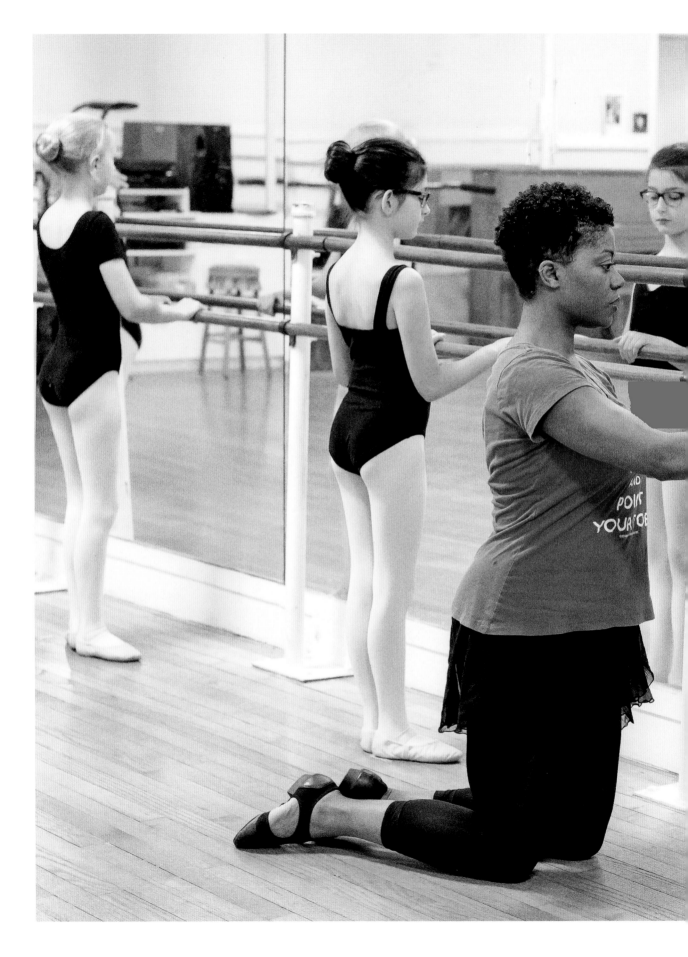

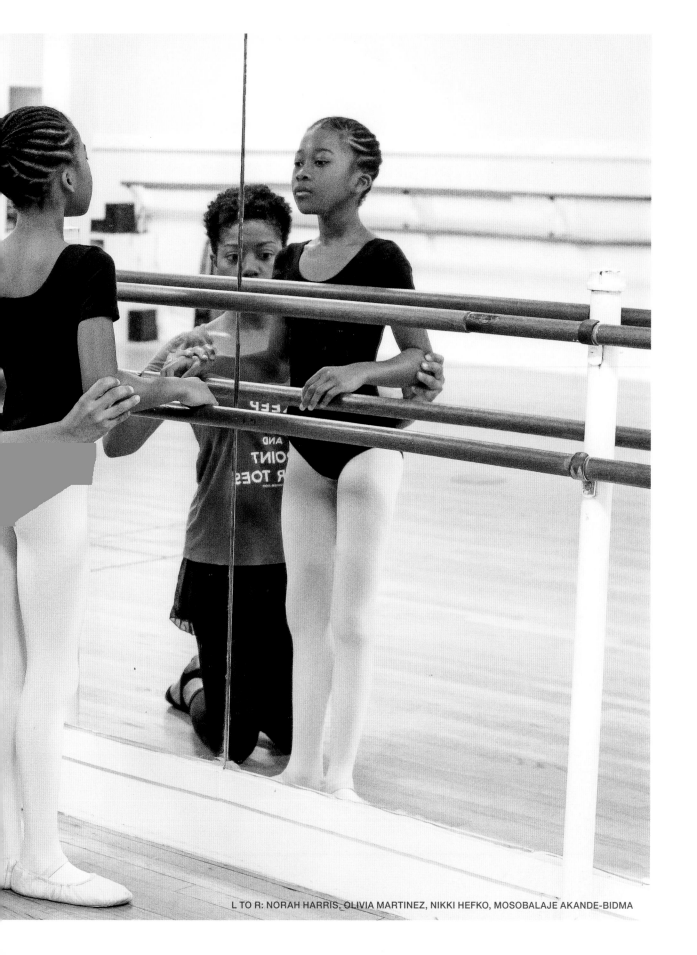

L TO R: NORAH HARRIS, OLIVIA MARTINEZ, NIKKI HEFKO, MOSOBALAJE AKANDE-BIDMA

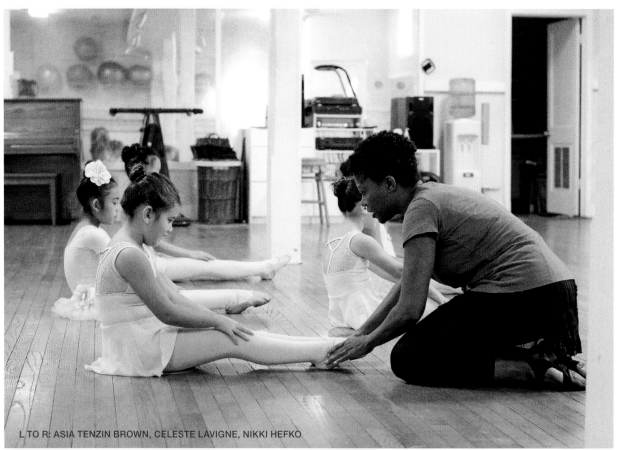

L TO R: ASIA TENZIN BROWN, CELESTE LAVIGNE, NIKKI HEFKO

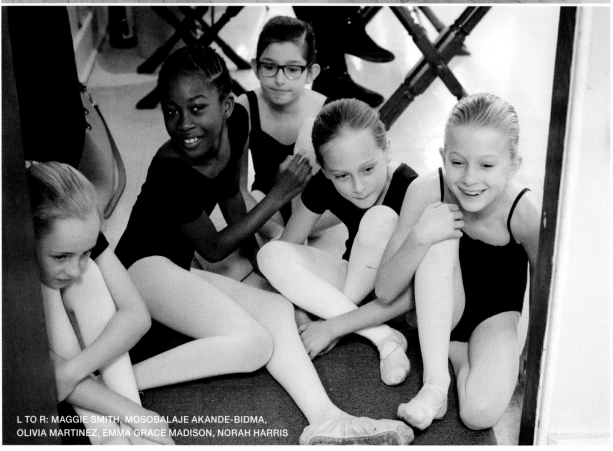

L TO R: MAGGIE SMITH, MOSOBALAJE AKANDE-BIDMA,
OLIVIA MARTINEZ, EMMA GRACE MADISON, NORAH HARRIS

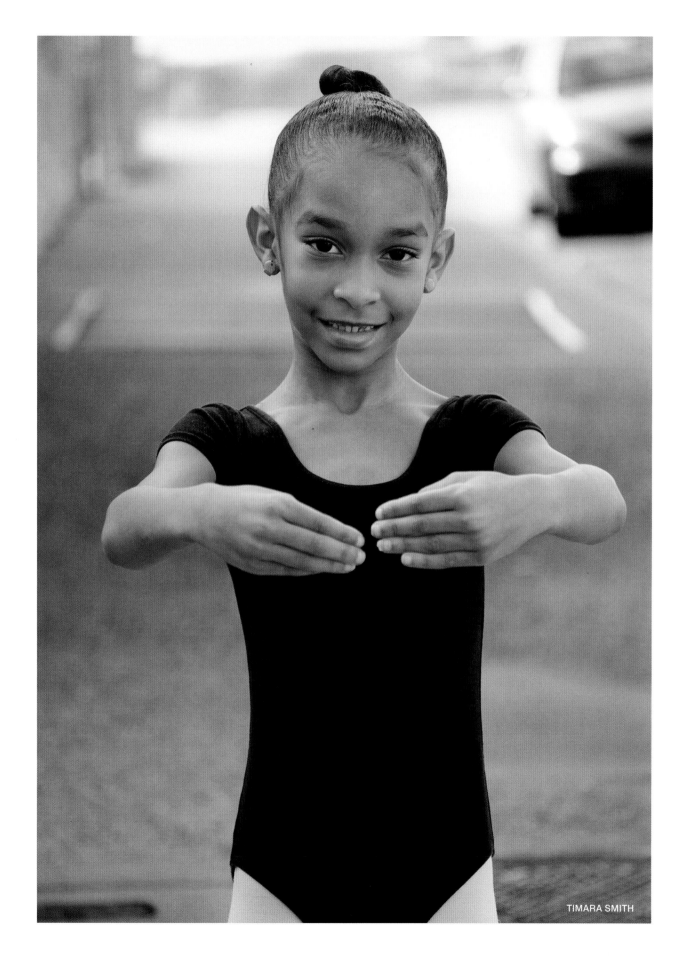

TIMARA SMITH

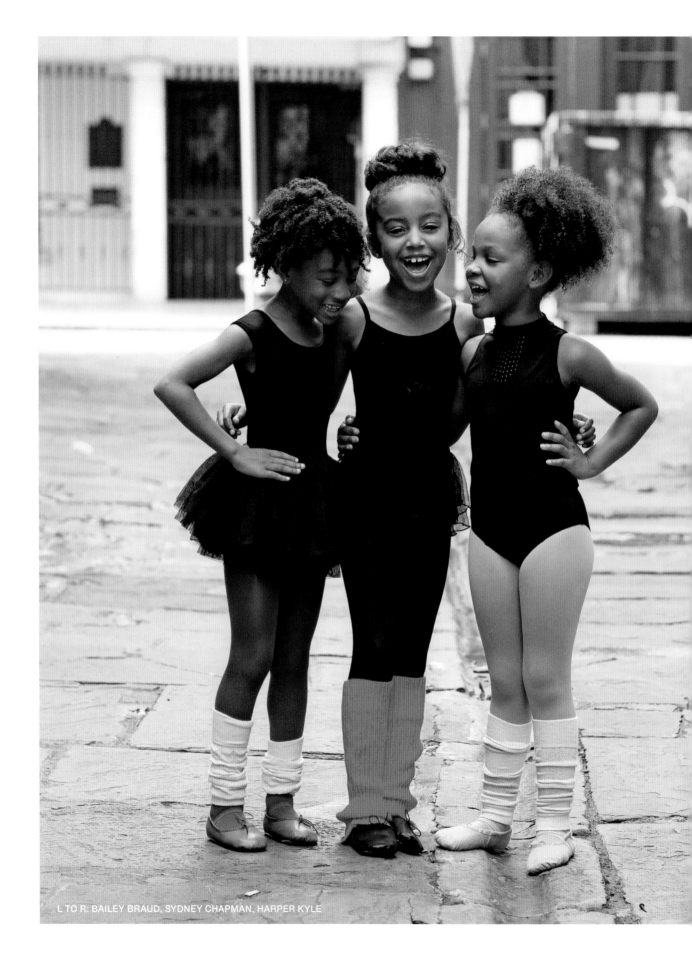

L TO R: BAILEY BRAUD, SYDNEY CHAPMAN, HARPER KYLE

What it means to me to be a dancer is that you always try your hardest, stand tall, shine bright, and always believe in yourself.

—HARPER KYLE

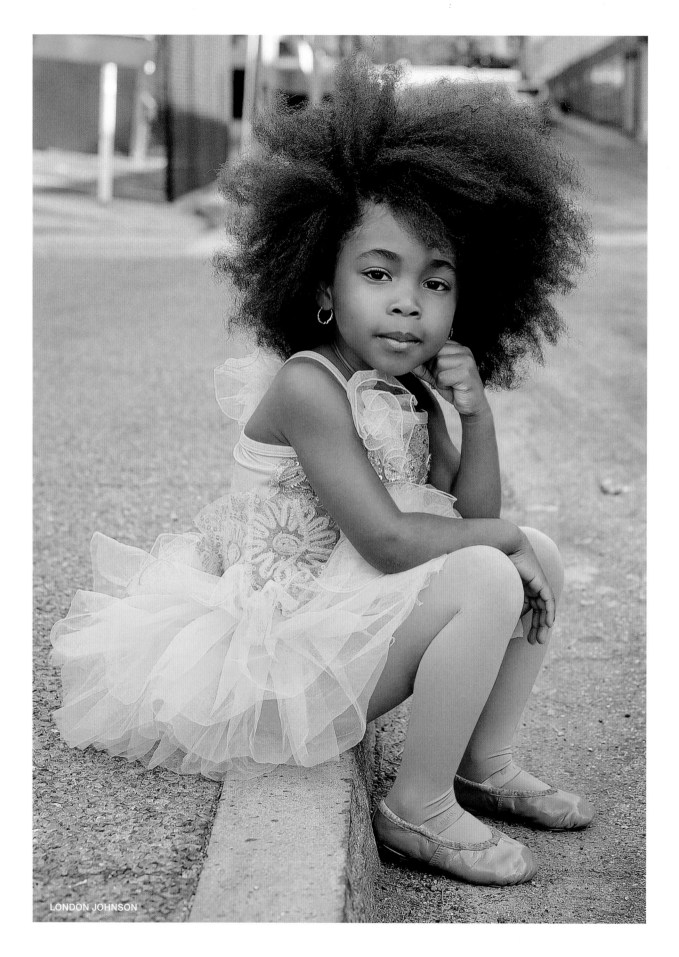

LONDON JOHNSON

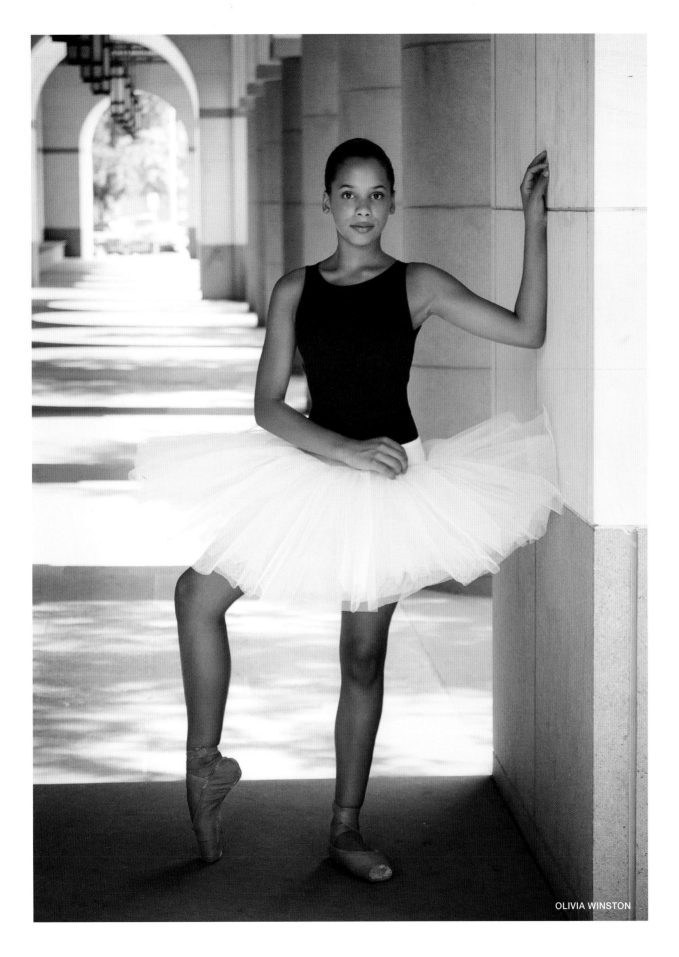

OLIVIA WINSTON

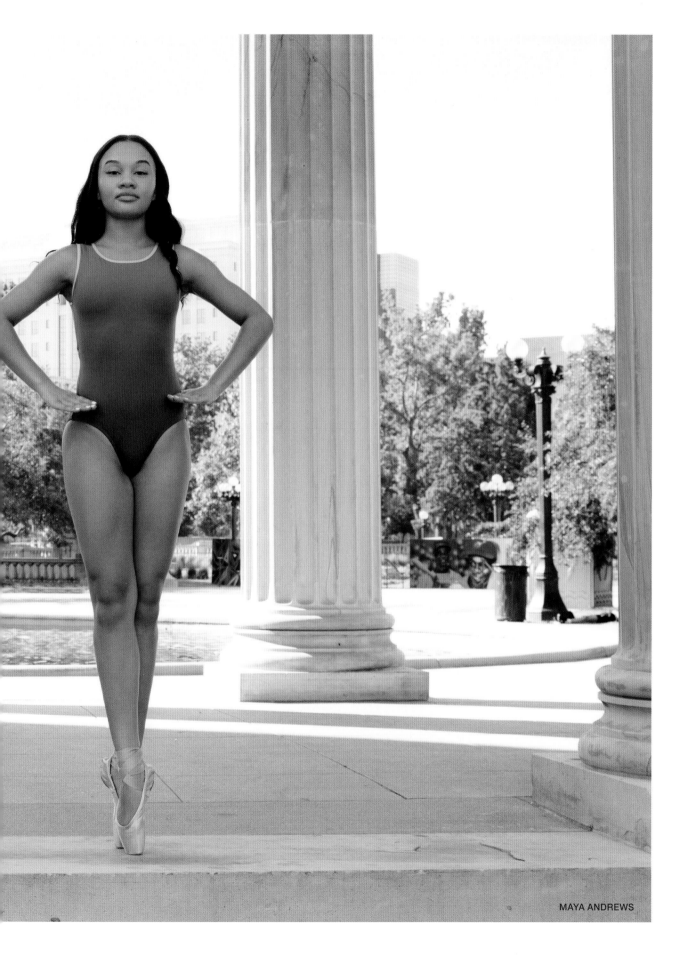

MAYA ANDREWS

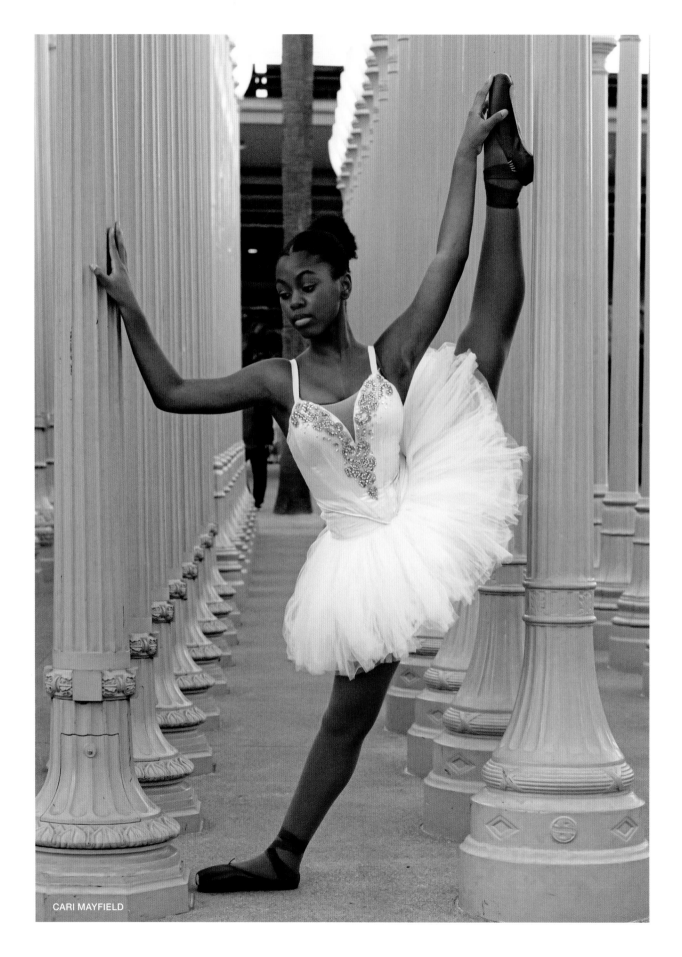

CARI MAYFIELD

The only way people will understand how you feel when you're dancing is by dancing your heart out.

—CARI MAYFIELD

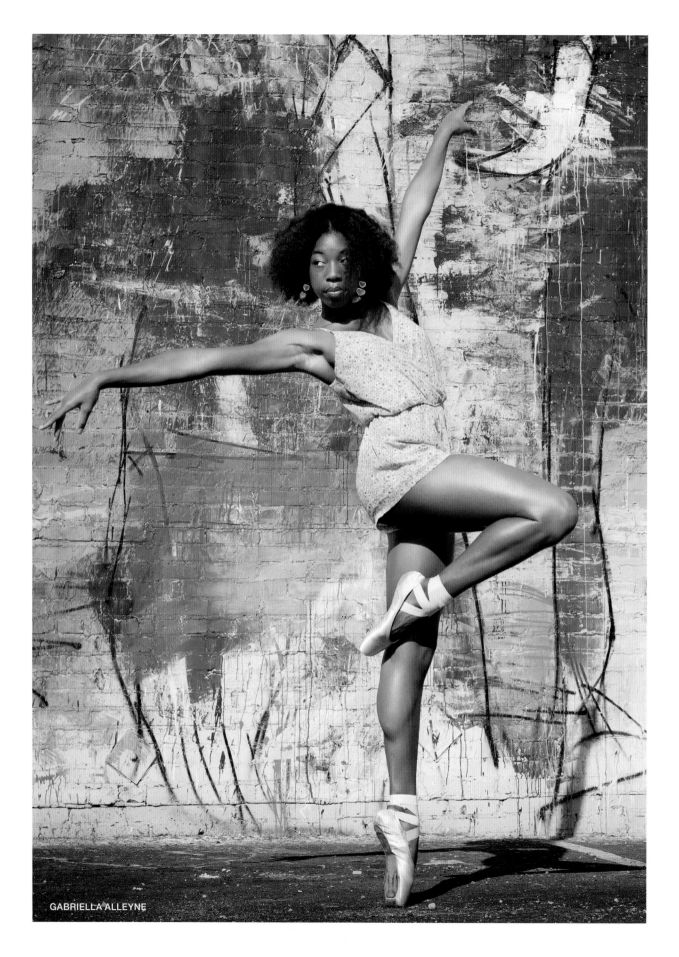
GABRIELLA ALLEYNE

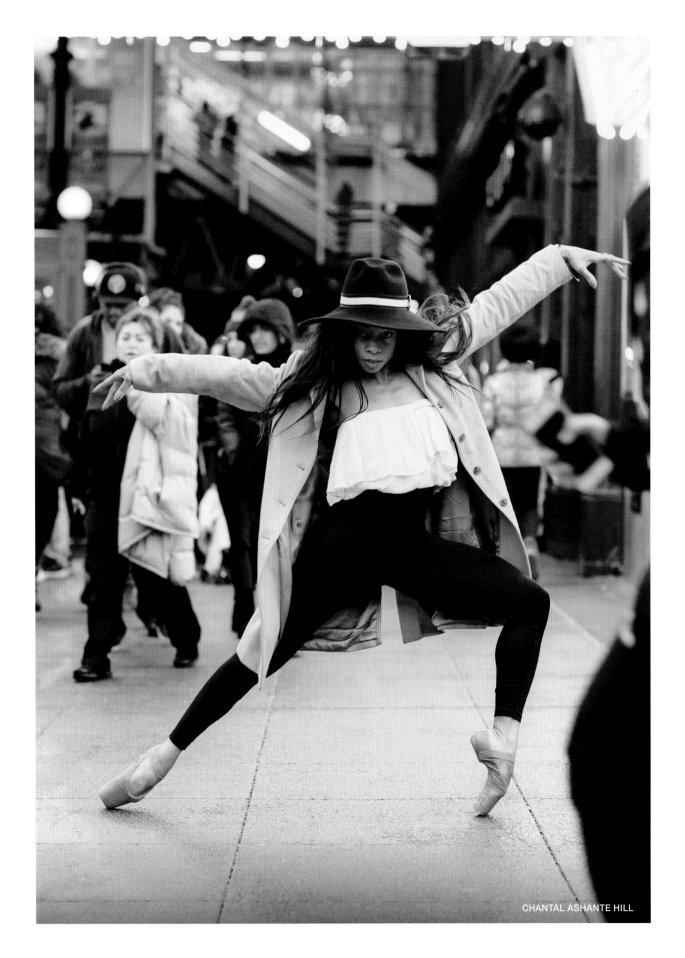

CHANTAL ASHANTE HILL

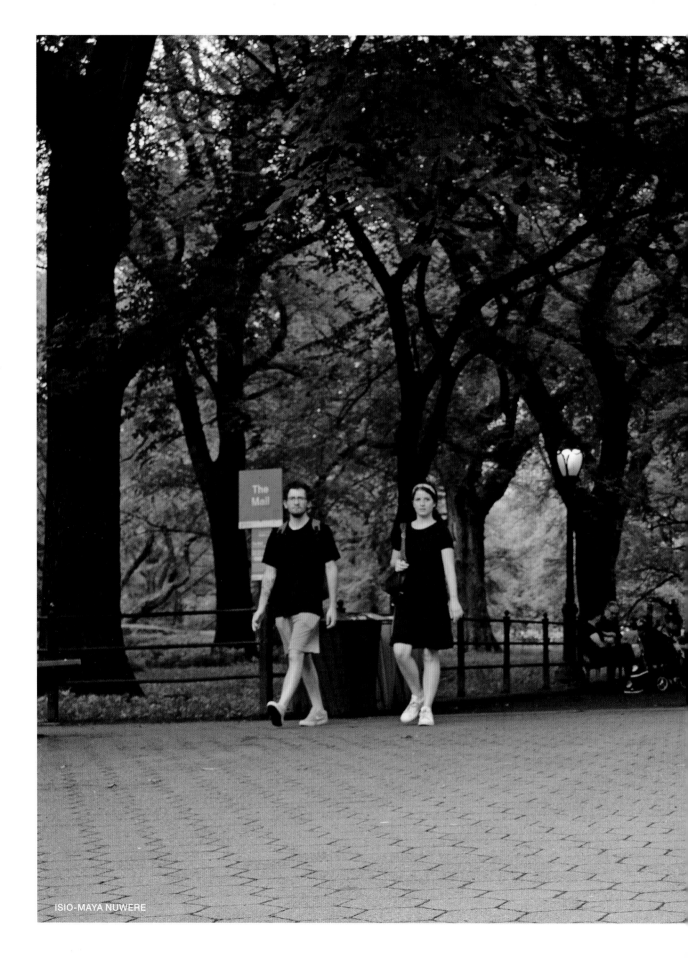

ISIO-MAYA NUWERE

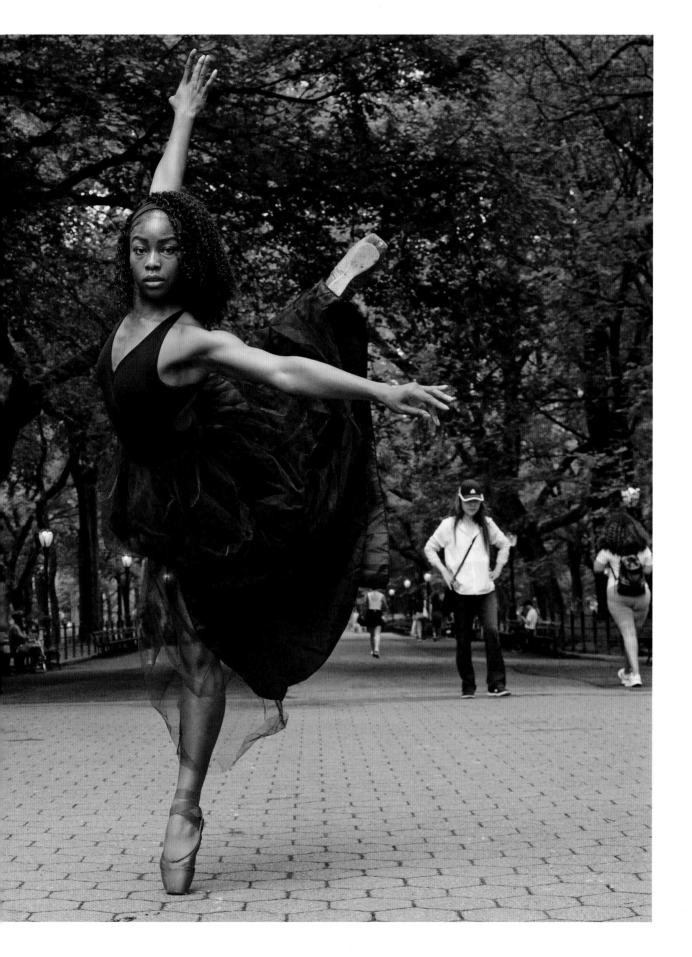

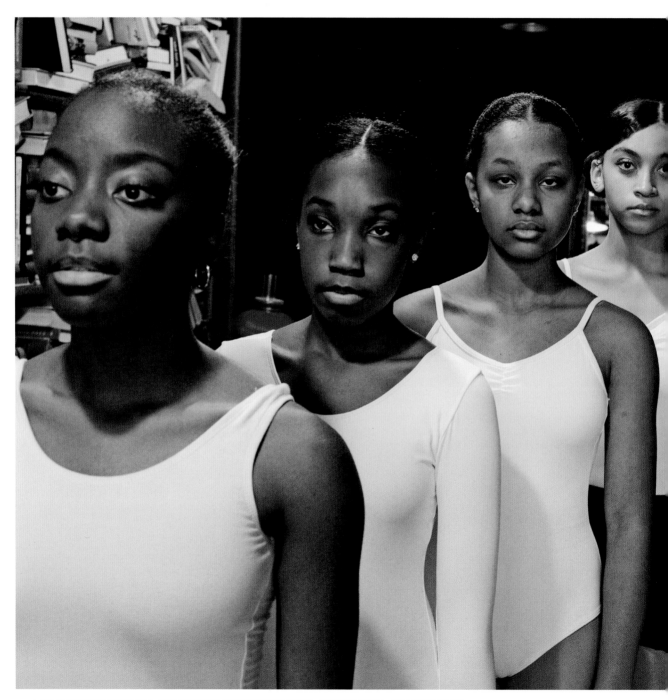

L TO R: MORIAH MITCHELL, MIA MCCRAY, DREW BETTS-VOSS, ALYSSIA DUDA, GRACE BUTLER

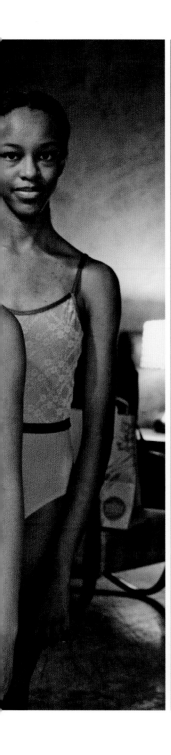

No matter who you are or where you come from, when you dream, always dream big. The possibilities are endless.

—ALYSSIA DUDA

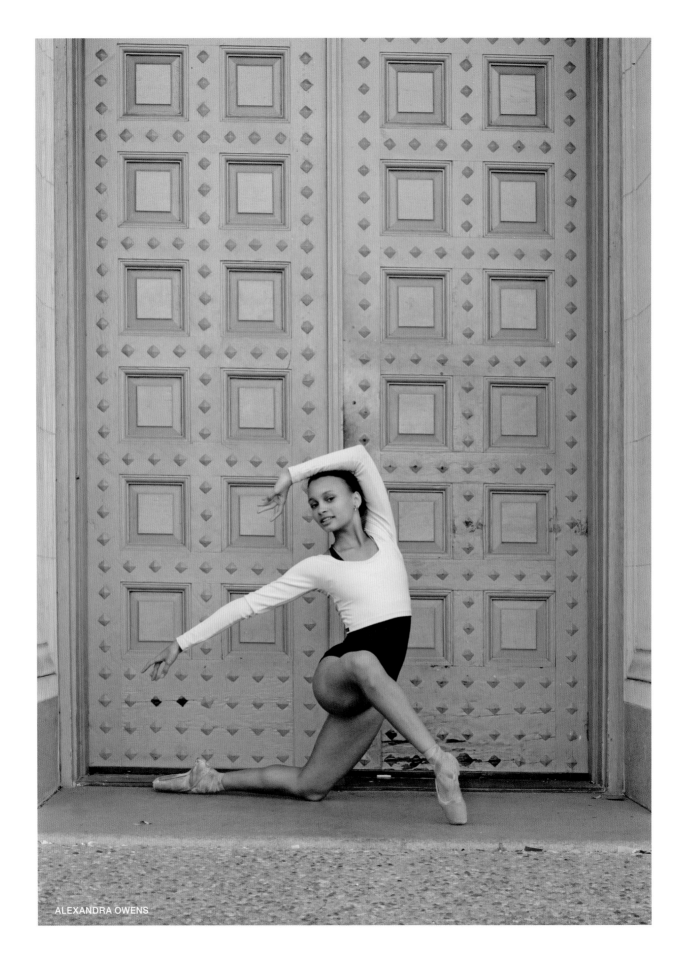

ALEXANDRA OWENS

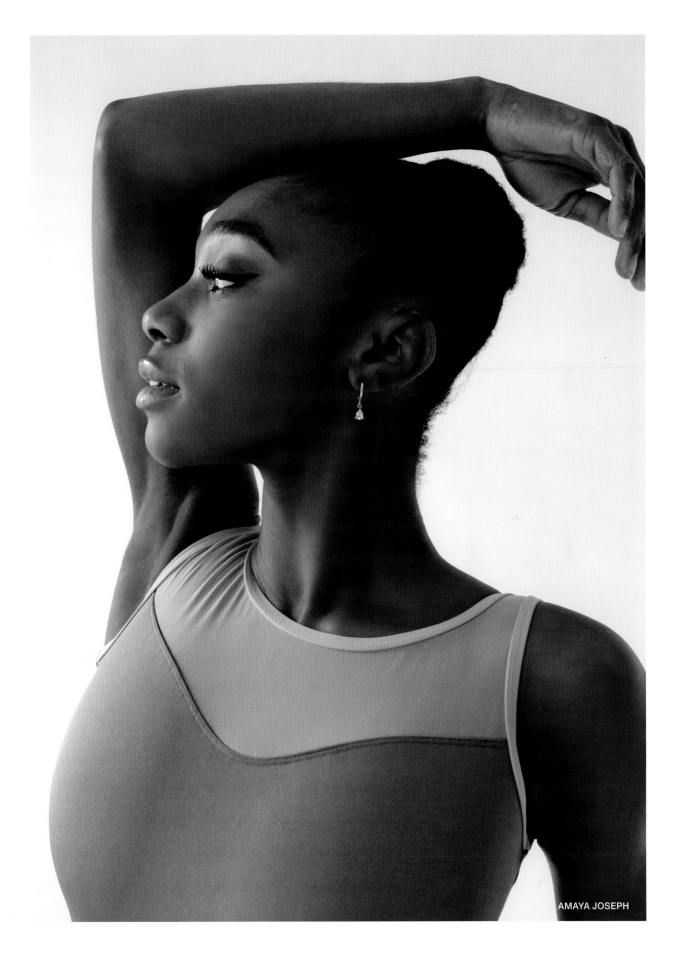

AMAYA JOSEPH

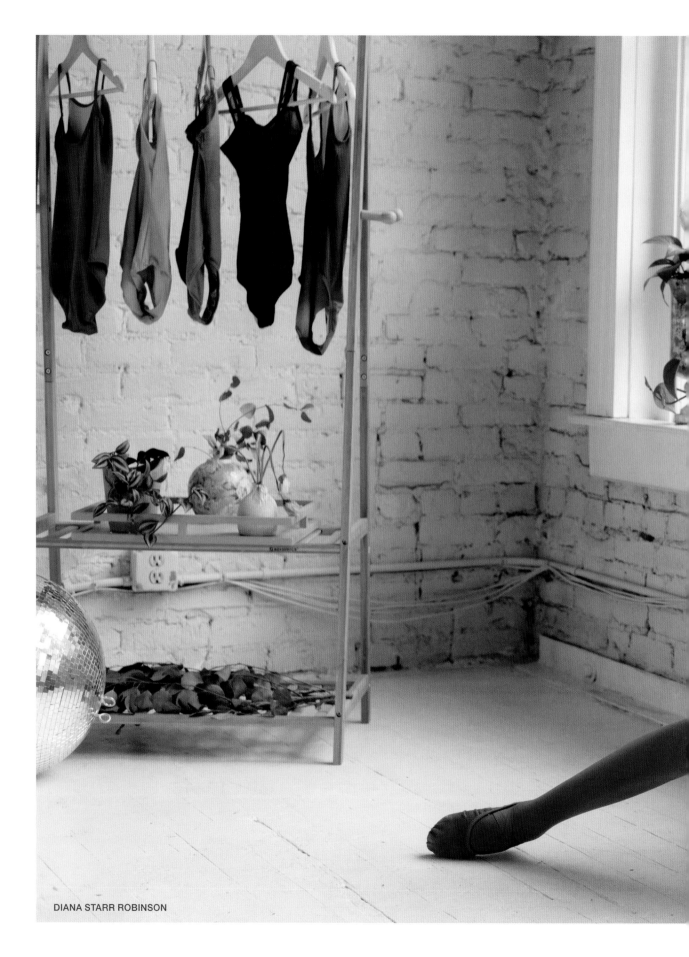

DIANA STARR ROBINSON

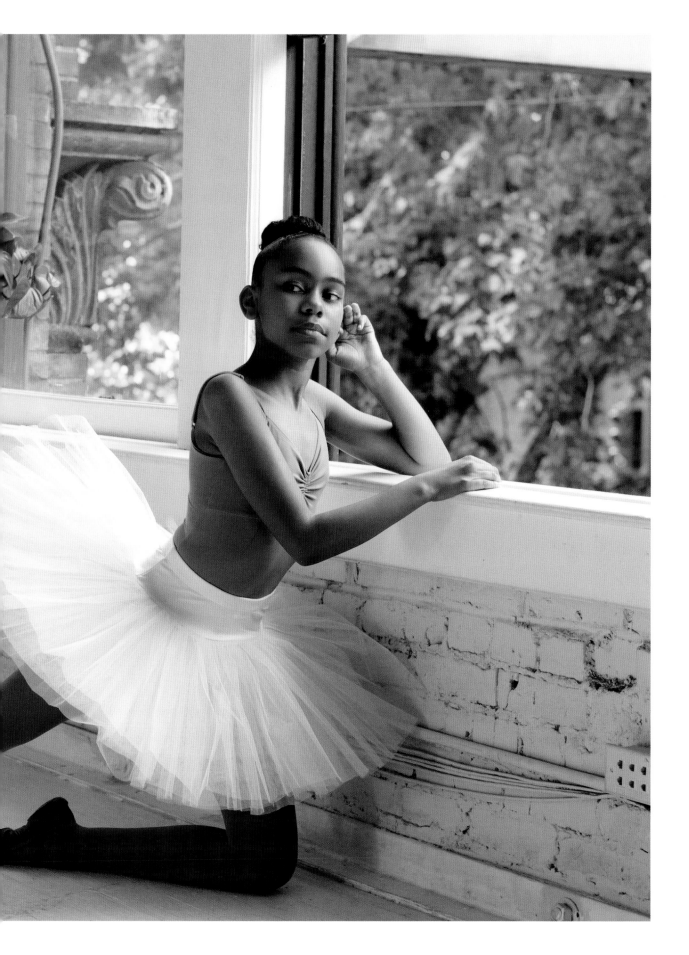

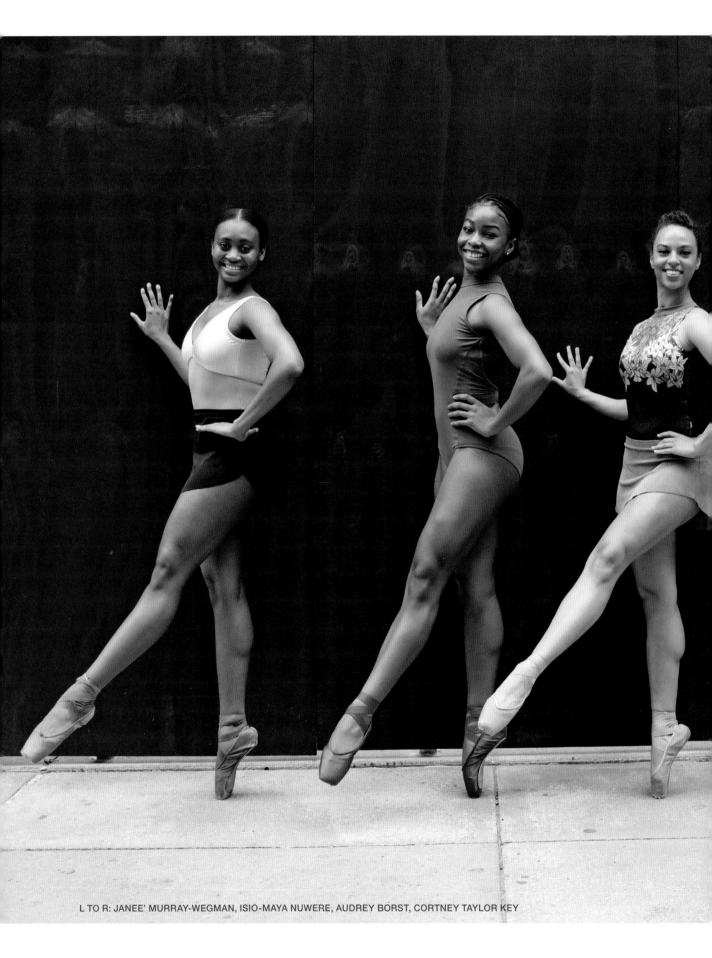

L TO R: JANEE' MURRAY-WEGMAN, ISIO-MAYA NUWERE, AUDREY BORST, CORTNEY TAYLOR KEY

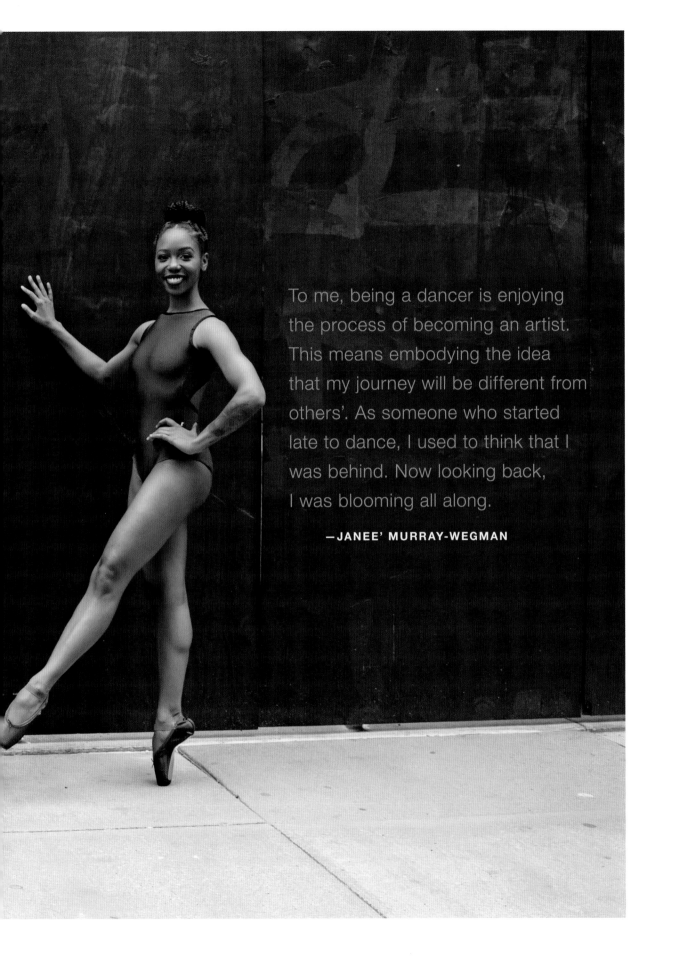

To me, being a dancer is enjoying the process of becoming an artist. This means embodying the idea that my journey will be different from others'. As someone who started late to dance, I used to think that I was behind. Now looking back, I was blooming all along.

—JANEE' MURRAY-WEGMAN

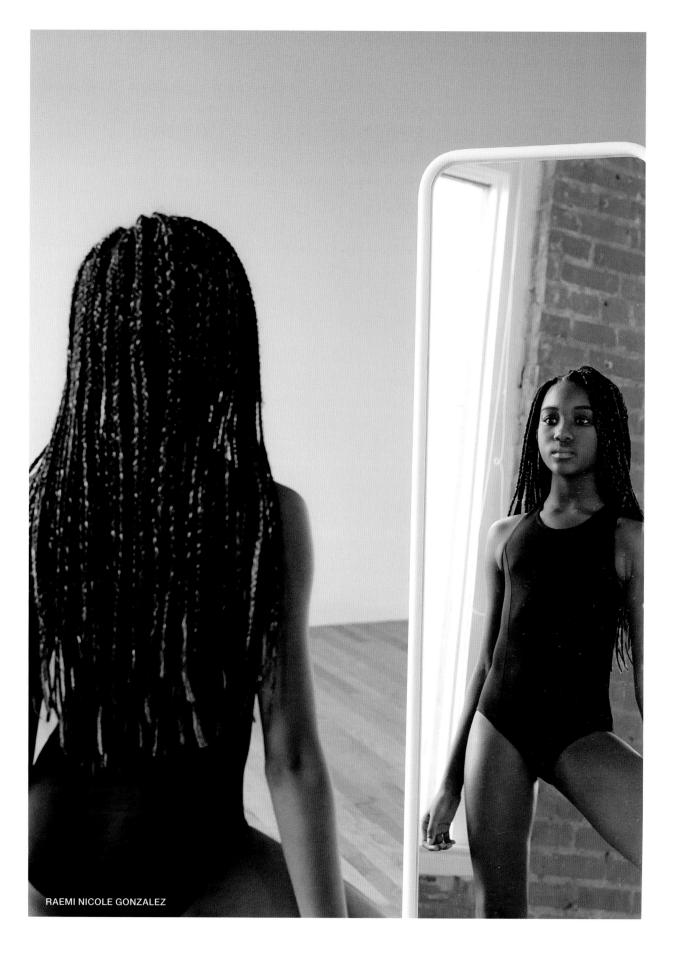

RAEMI NICOLE GONZALEZ

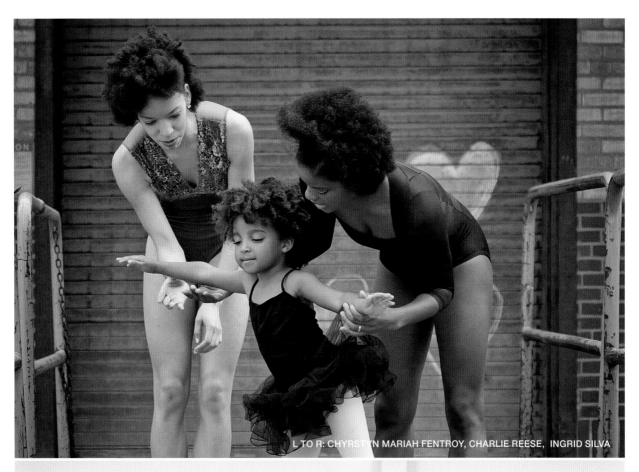

L TO R: CHYRSTYN MARIAH FENTROY, CHARLIE REESE, INGRID SILVA

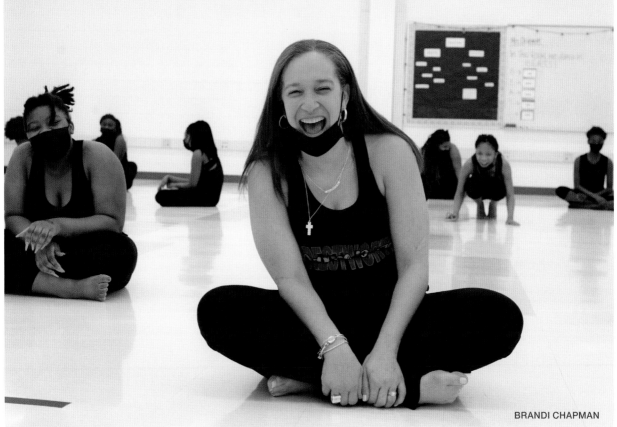

BRANDI CHAPMAN

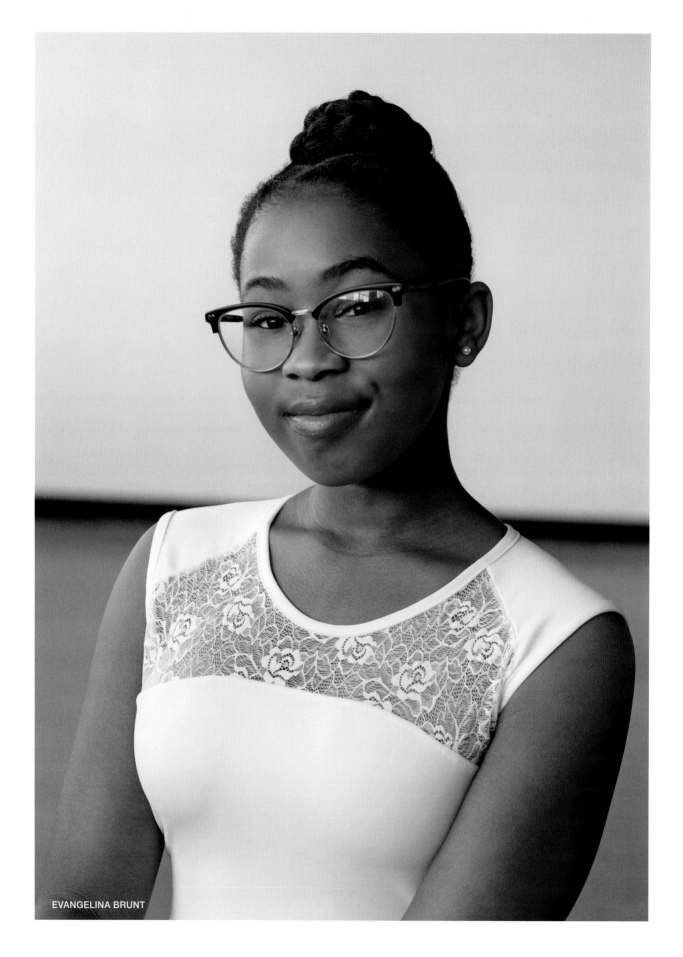
EVANGELINA BRUNT

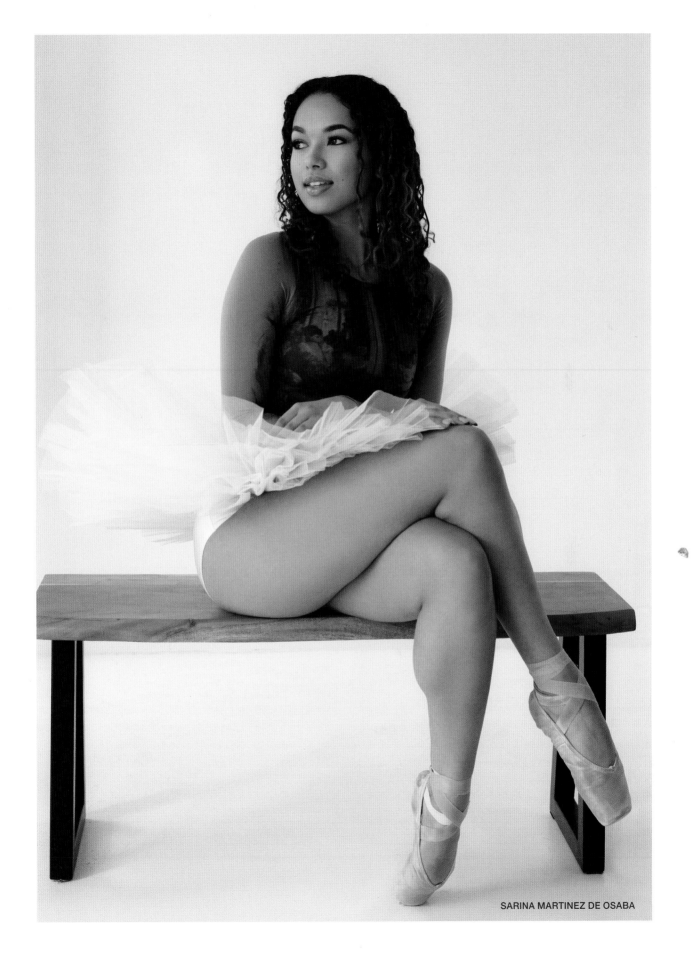

SARINA MARTINEZ DE OSABA

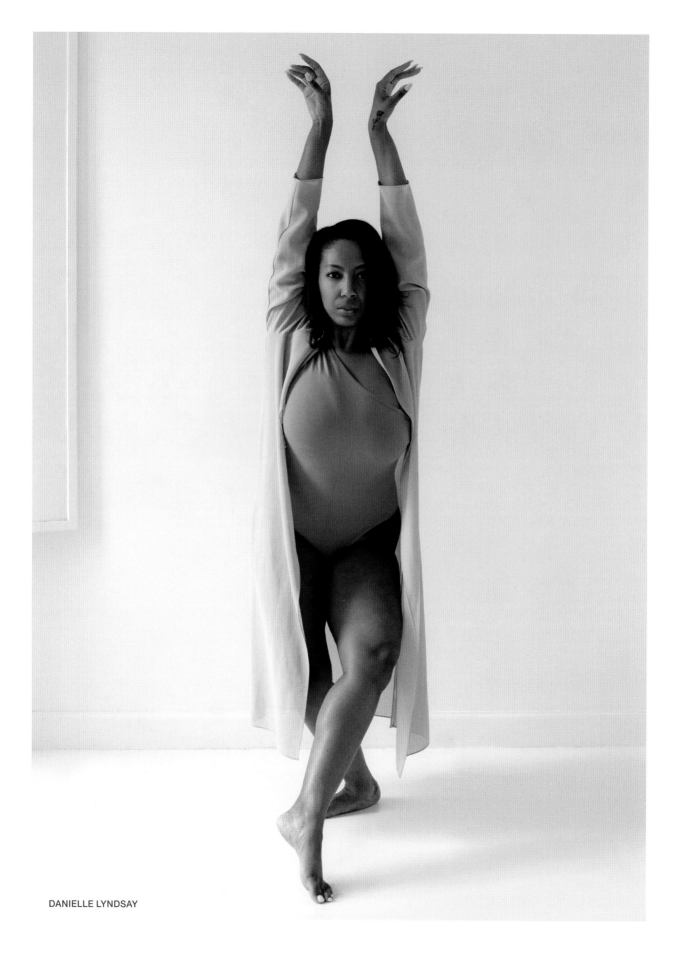

DANIELLE LYNDSAY

Being a dancer makes me feel invincible. I have honed the ability to control my body, command it to create beauty, tell a story, and invoke emotion without ever saying a word. Being a dancer is my superpower.

—DANIELLE LYNDSAY

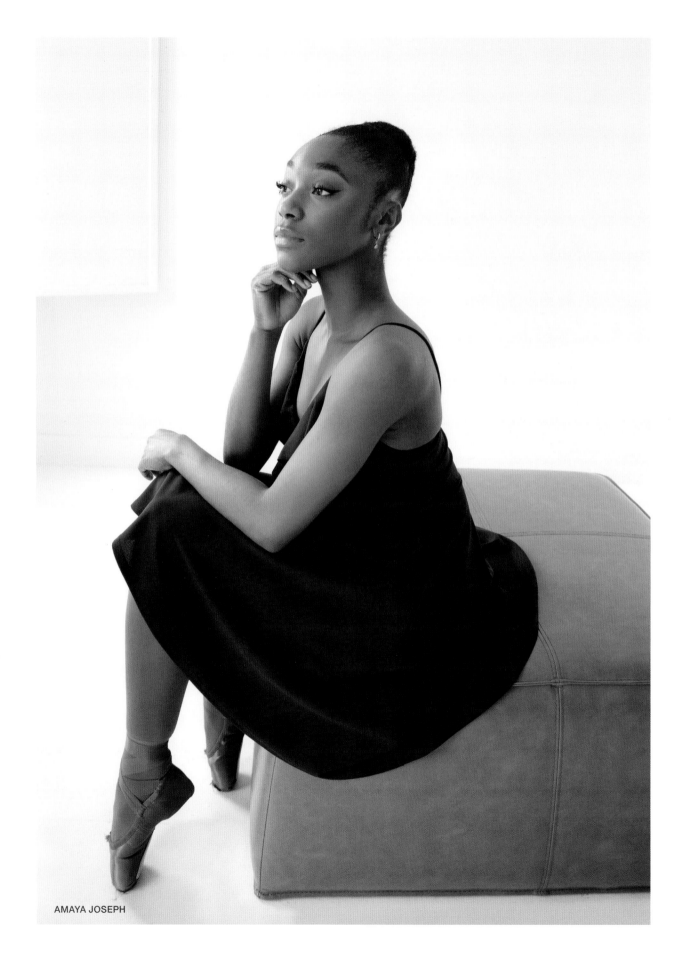

AMAYA JOSEPH

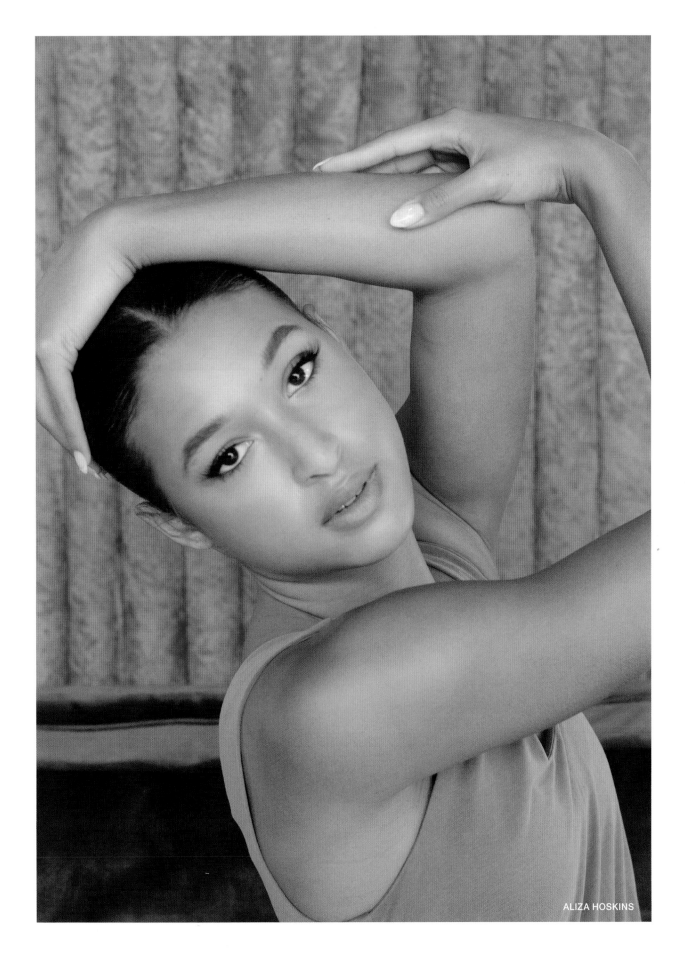

ALIZA HOSKINS

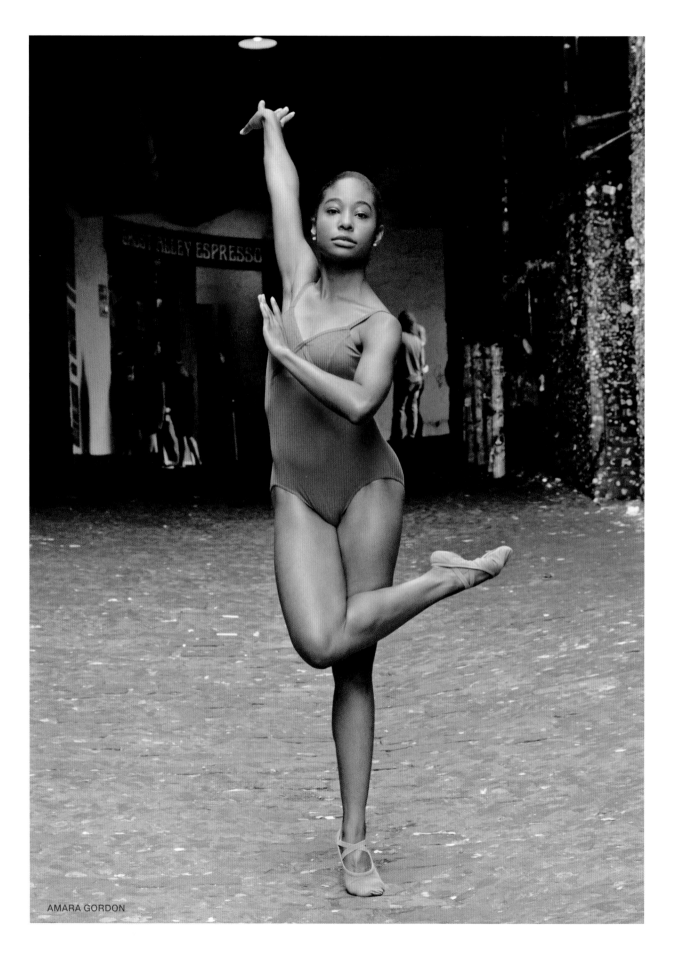

AMARA GORDON

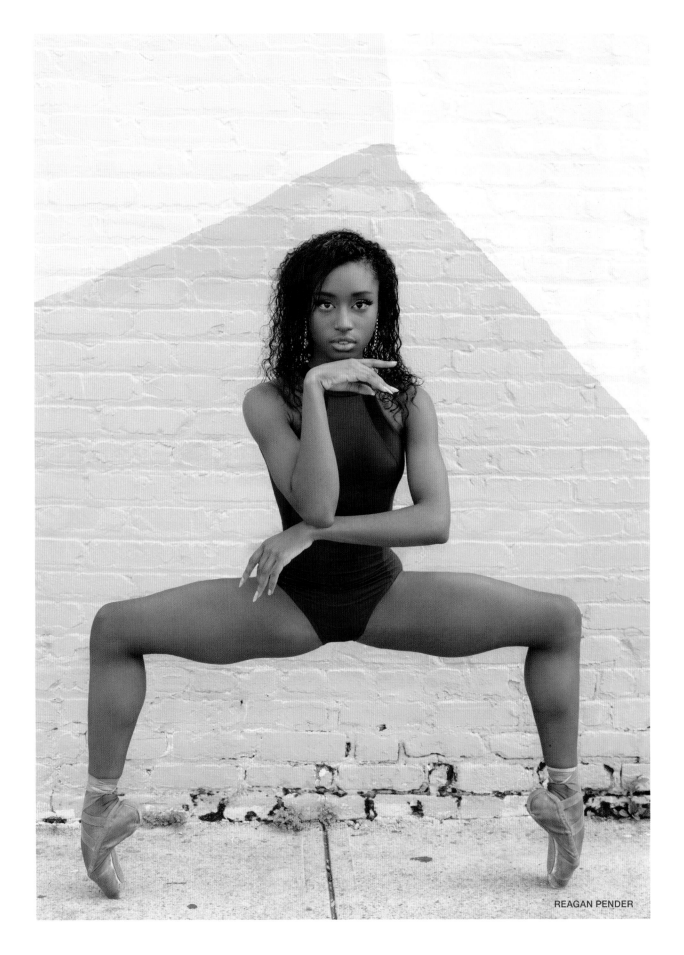

REAGAN PENDER

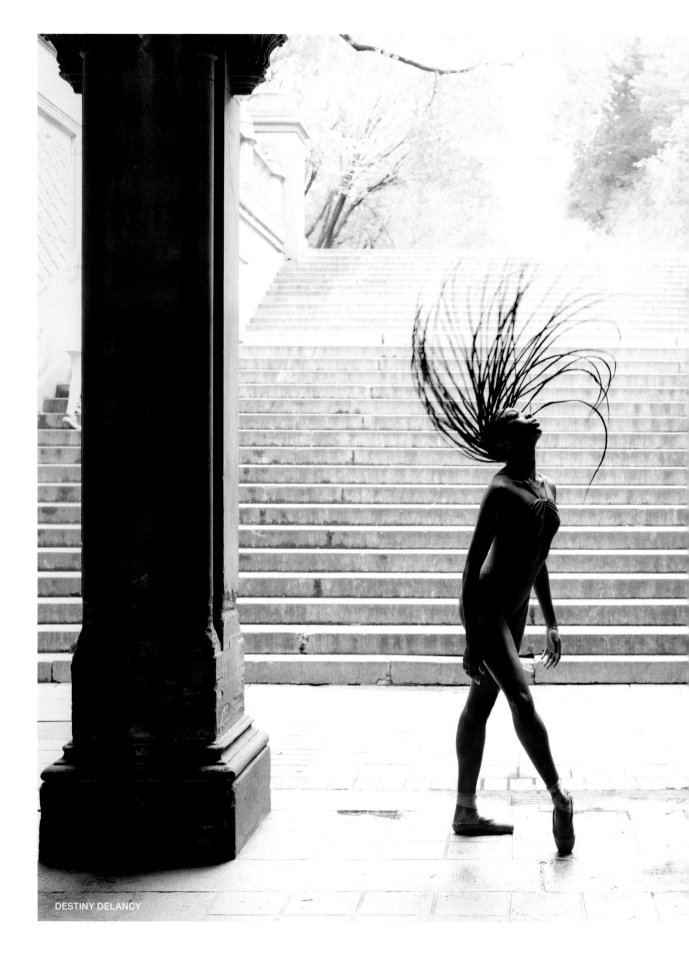

DESTINY DELANCY

My hair is my temple; it has the ability to be manipulated in so many ways. It holds the center of my confidence and adds depth to my personality.

—DESTINY DELANCY

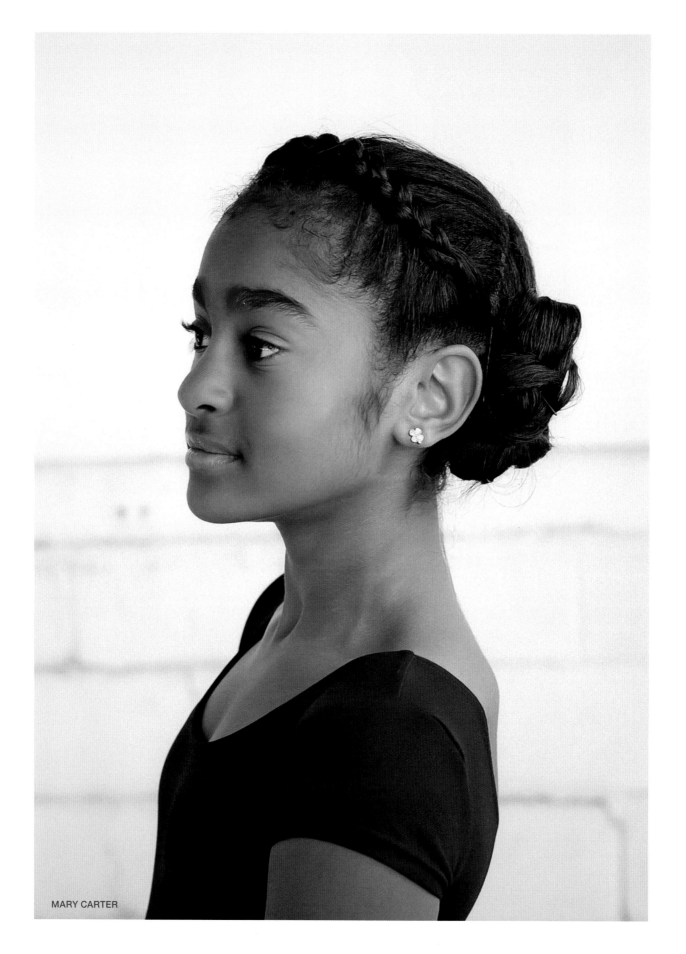

MARY CARTER

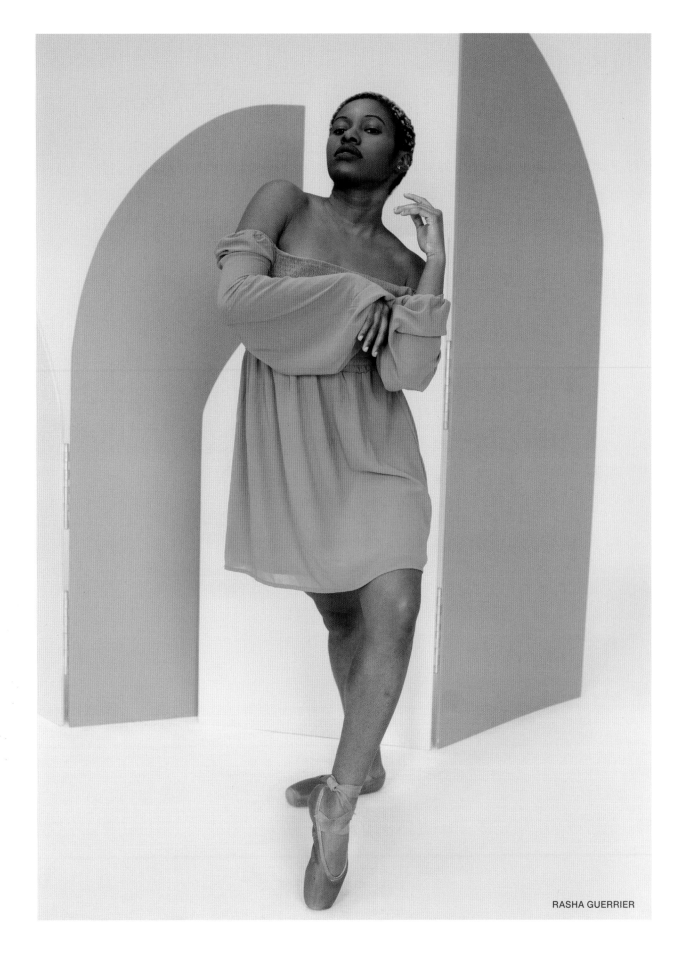

RASHA GUERRIER

ANAYA AGARD

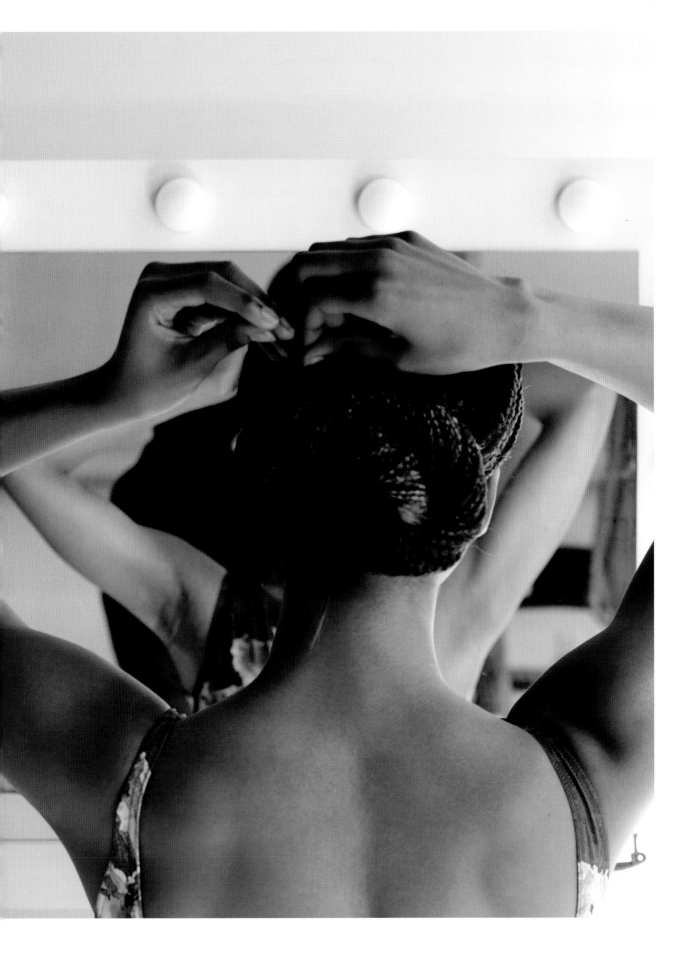

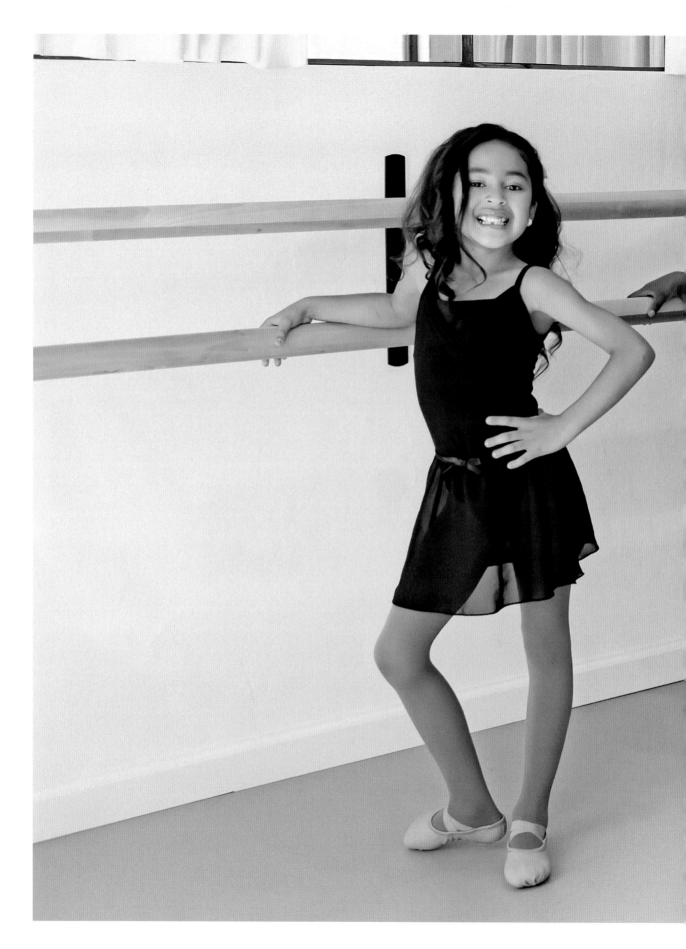

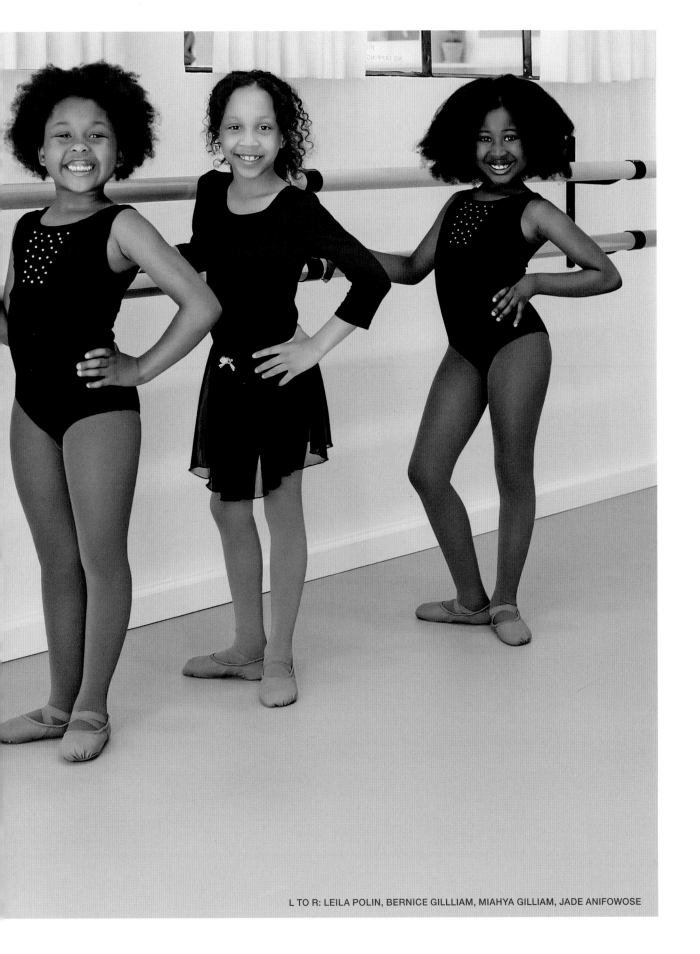

L TO R: LEILA POLIN, BERNICE GILLLIAM, MIAHYA GILLIAM, JADE ANIFOWOSE

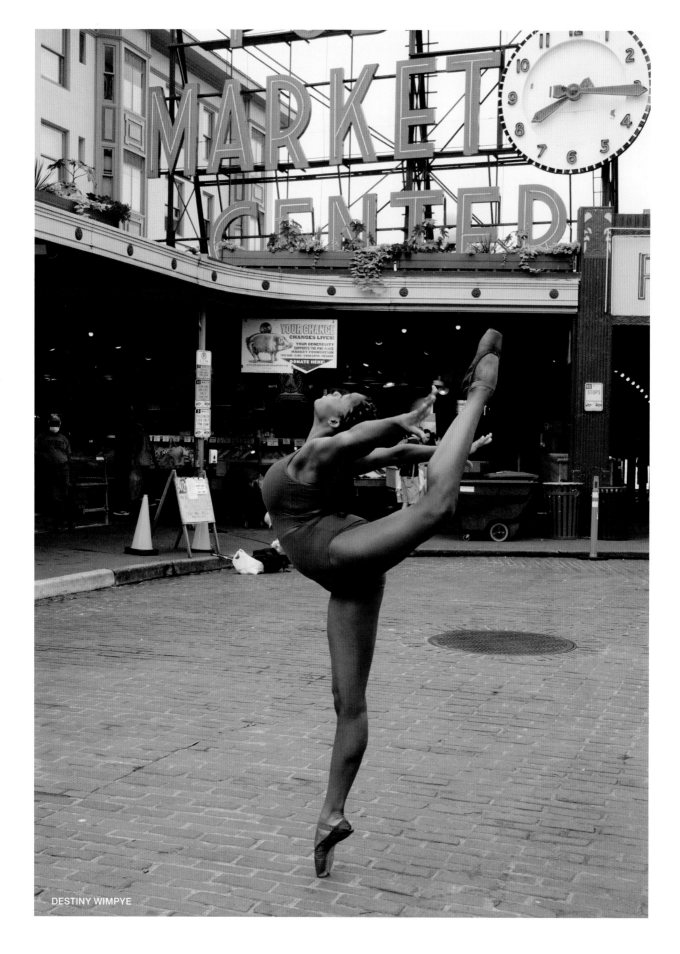

DESTINY WIMPYE

The ballet world has definitely shifted over the years. My goal is to continue to push for more diversity and inclusion. I'm lucky to be a part of a generation that is motivated to do the work that is necessary. With hard work and dedication, anything is possible.

—DESTINY WIMPYE

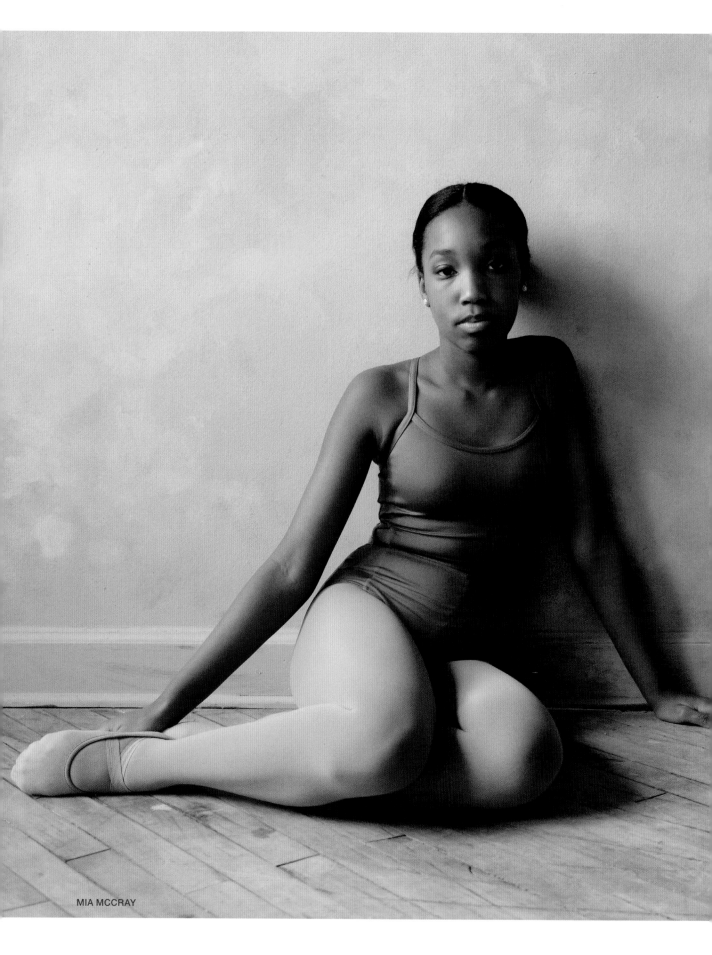

MIA MCCRAY

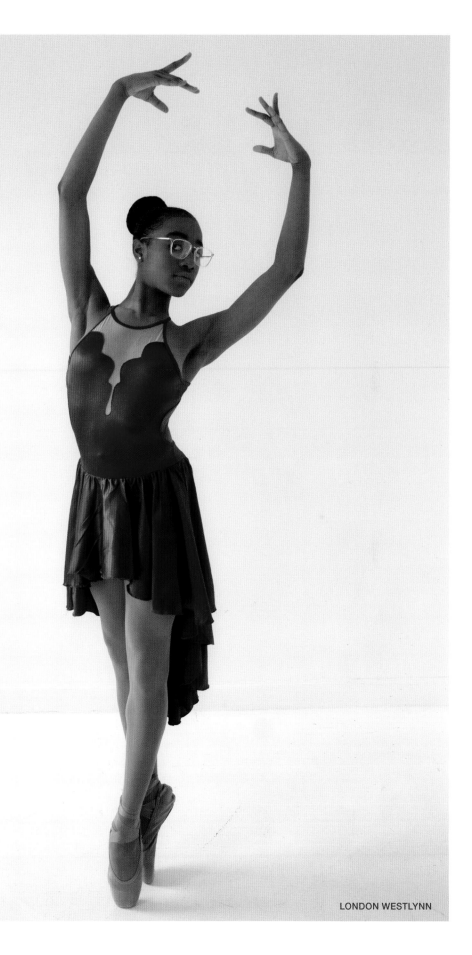

LONDON WESTLYNN

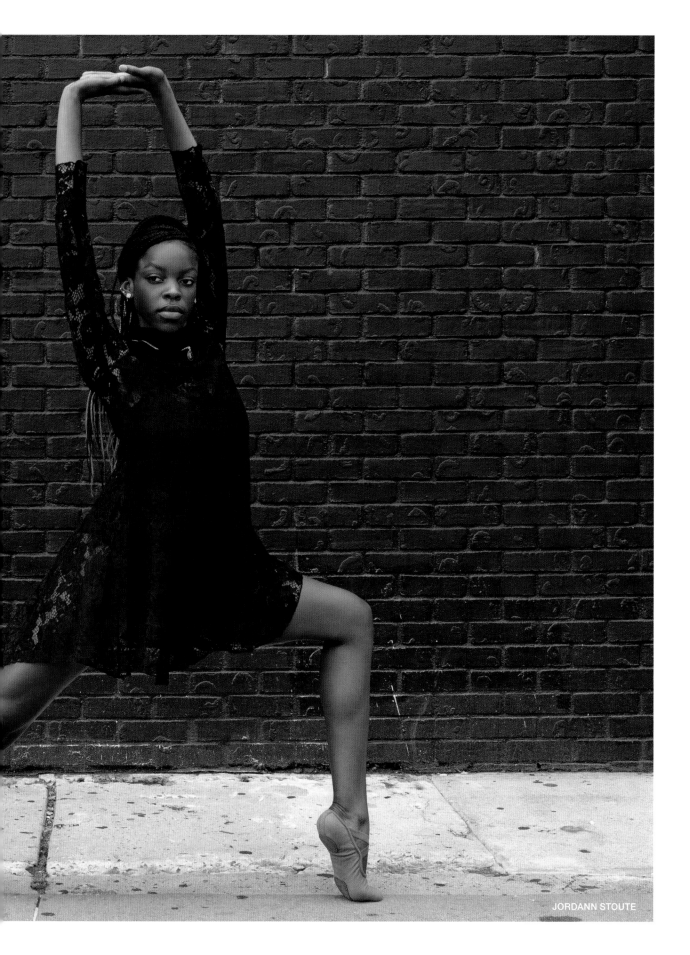

JORDANN STOUTE

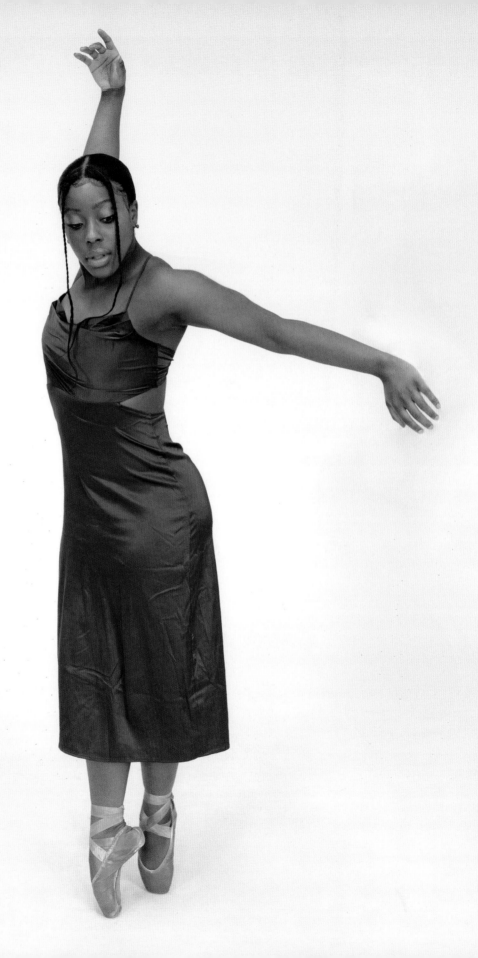

DYMON SAMARA

My body is designed
with elegance. My
body is a luminous
light that shines
effortlessly. My body
is power. My body
holds all truth. It's
the uniqueness of
my body that moves
ever so gracefully
that helps me to flow
unapologetically in
any dance space.

—DYMON SAMARA

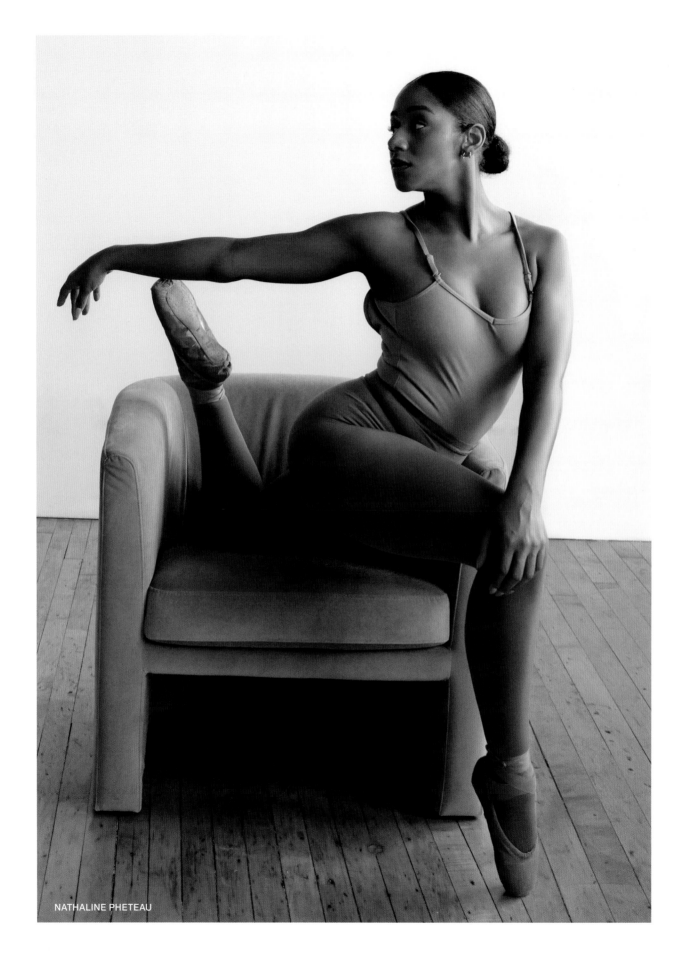

NATHALINE PHETEAU

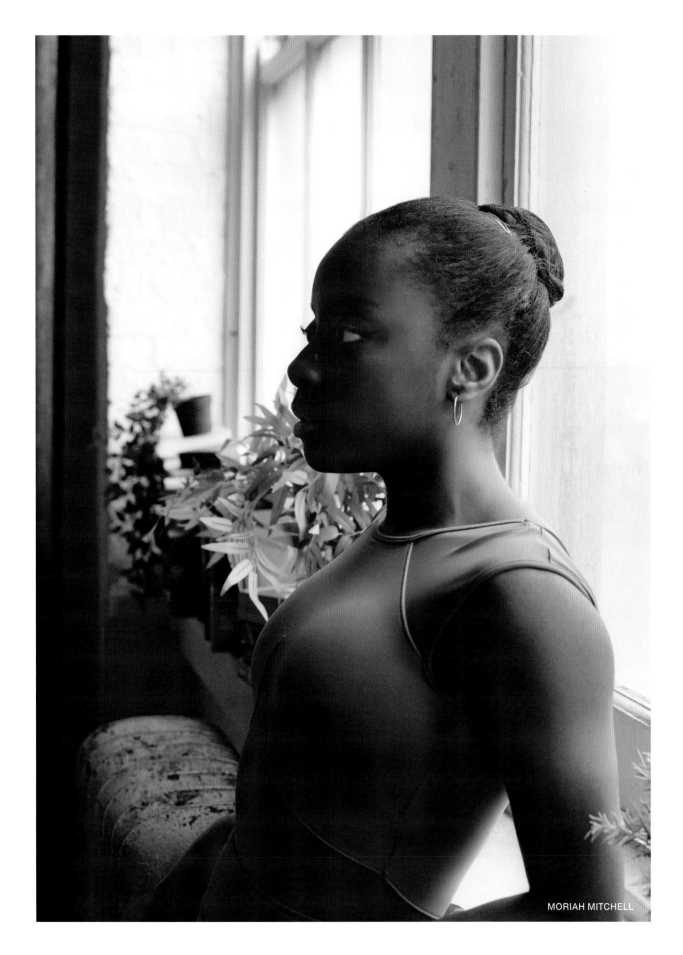

MORIAH MITCHELL

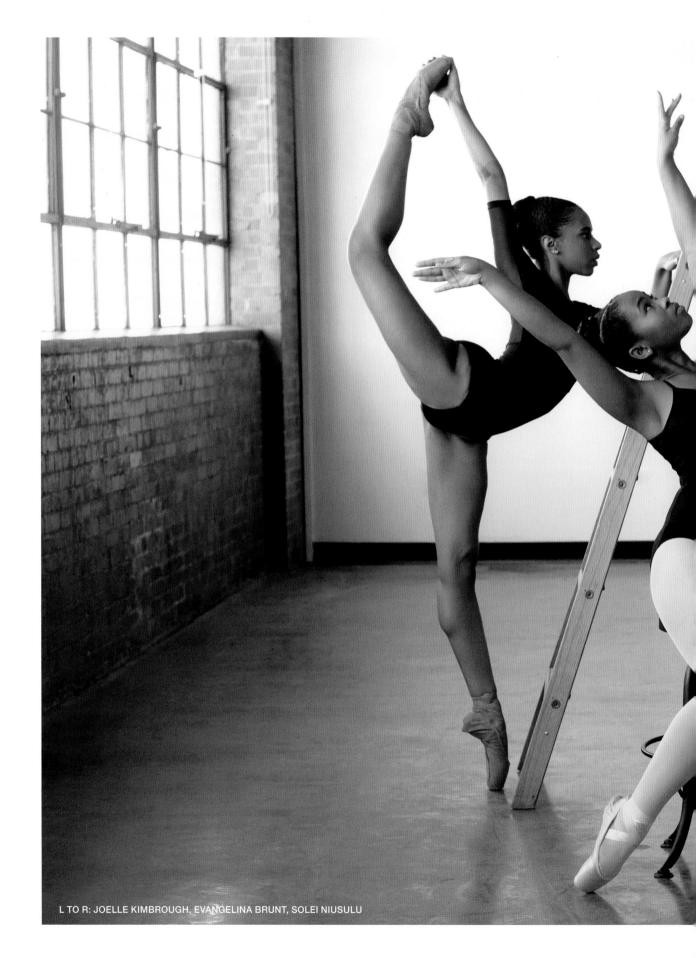

L TO R: JOELLE KIMBROUGH, EVANGELINA BRUNT, SOLEI NIUSULU

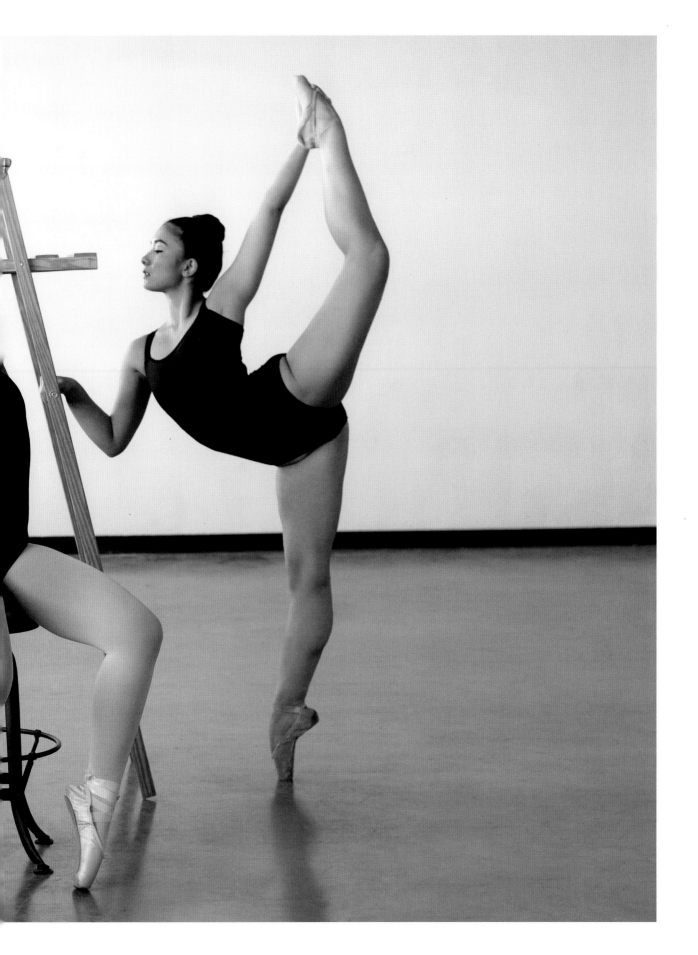

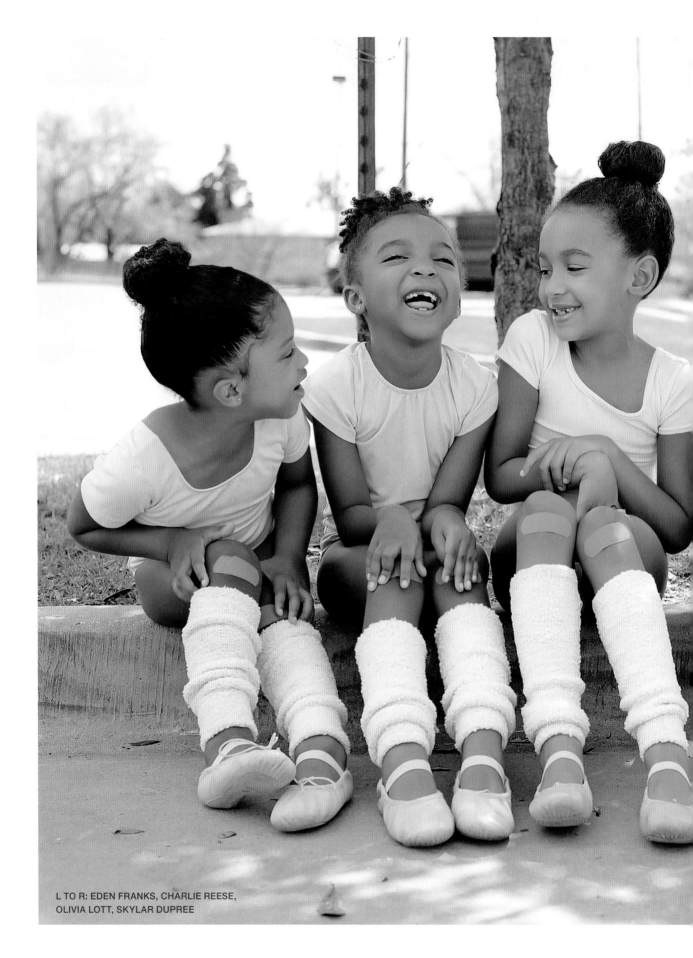

L TO R: EDEN FRANKS, CHARLIE REESE,
OLIVIA LOTT, SKYLAR DUPREE

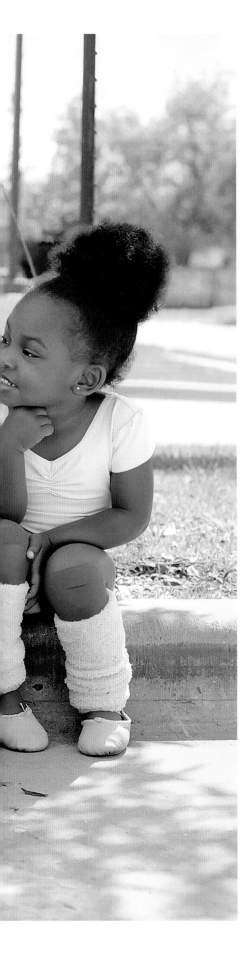

I love how
dance makes
me feel alive.
When I am happy,
I dance big!

—SKYLAR DUPREE

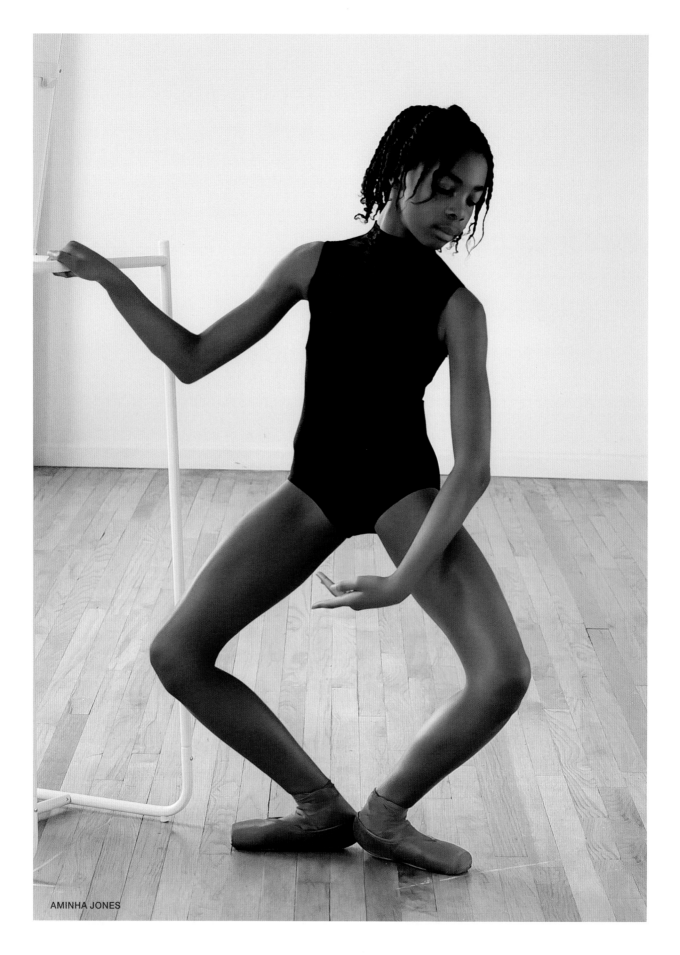

AMINHA JONES

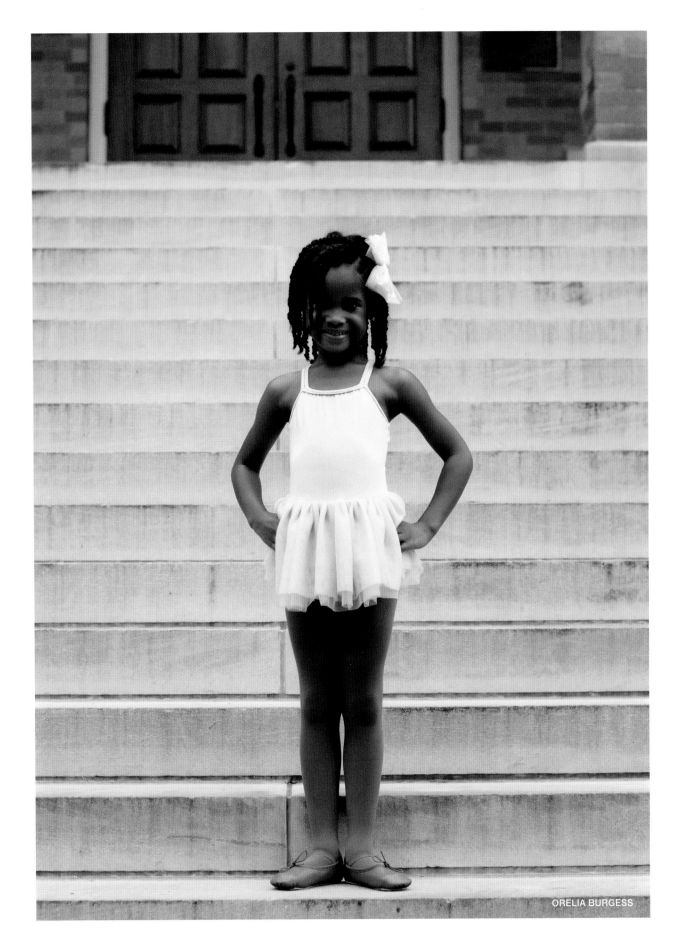

ORELIA BURGESS

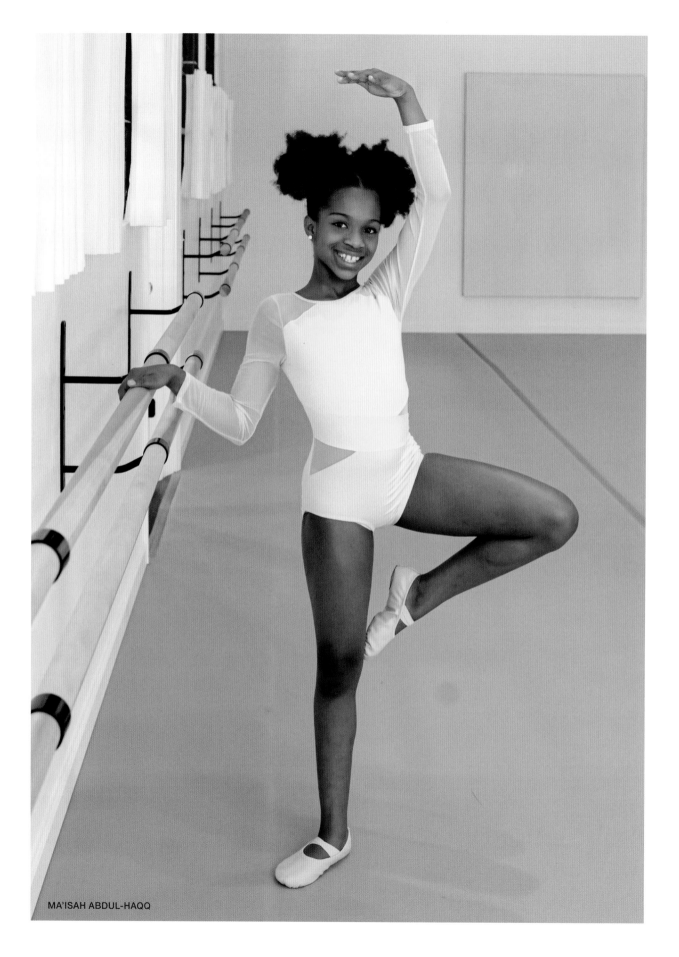

MA'ISAH ABDUL-HAQQ

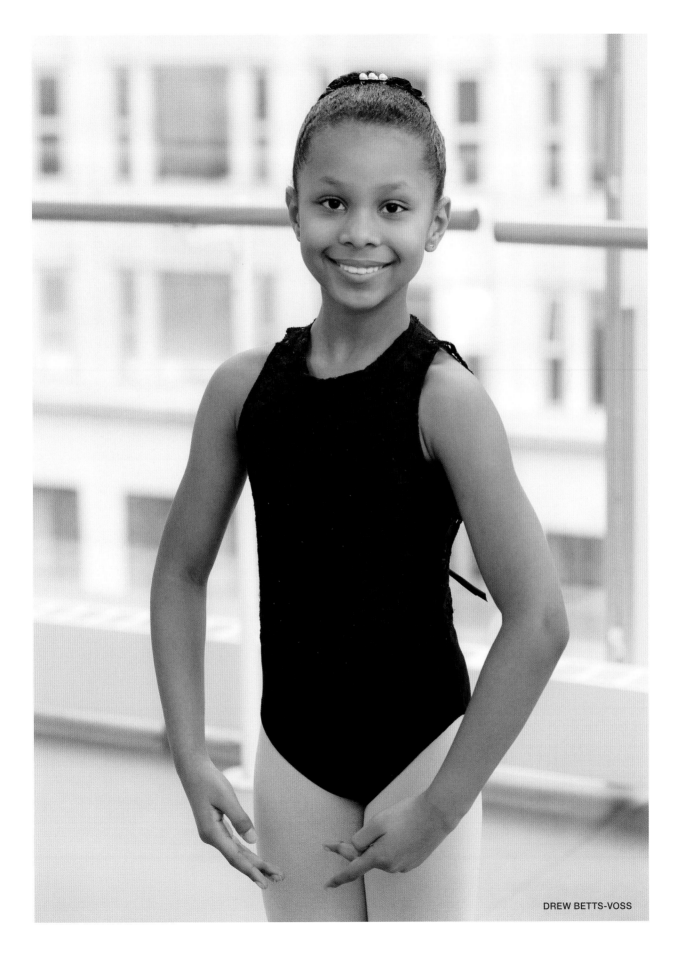

DREW BETTS-VOSS

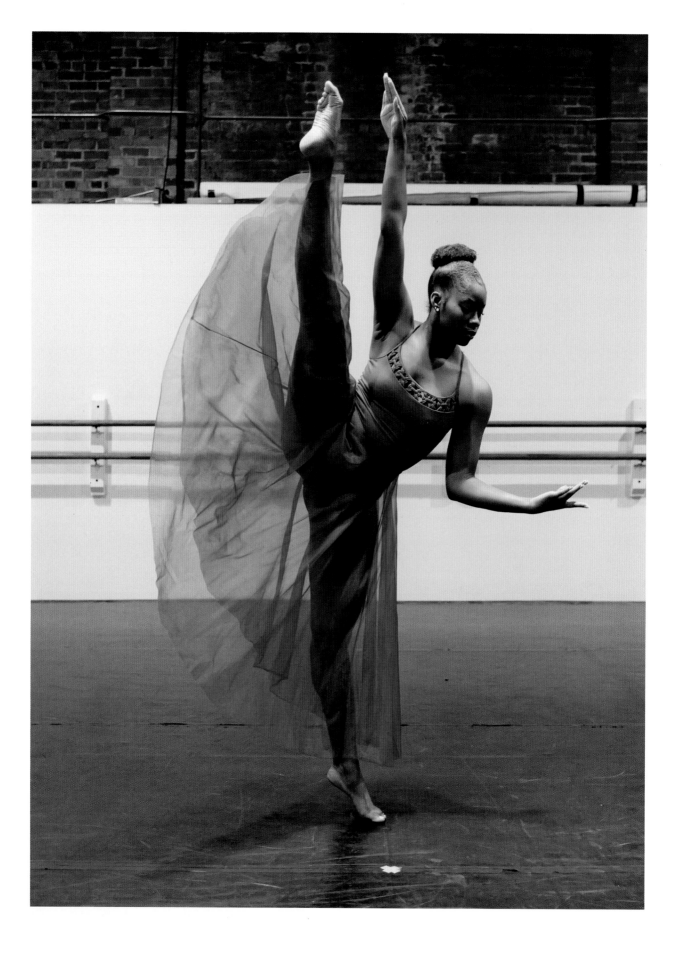

In the words of Pearl Primus, "Dance is my medicine. It's the scream which eases for a while the terrible frustration common to all human beings who, because of race, creed, or color, are 'invisible.' Dance is the fist with which I fight the sickening ignorance of prejudice."

—SIMONE MATCHETT

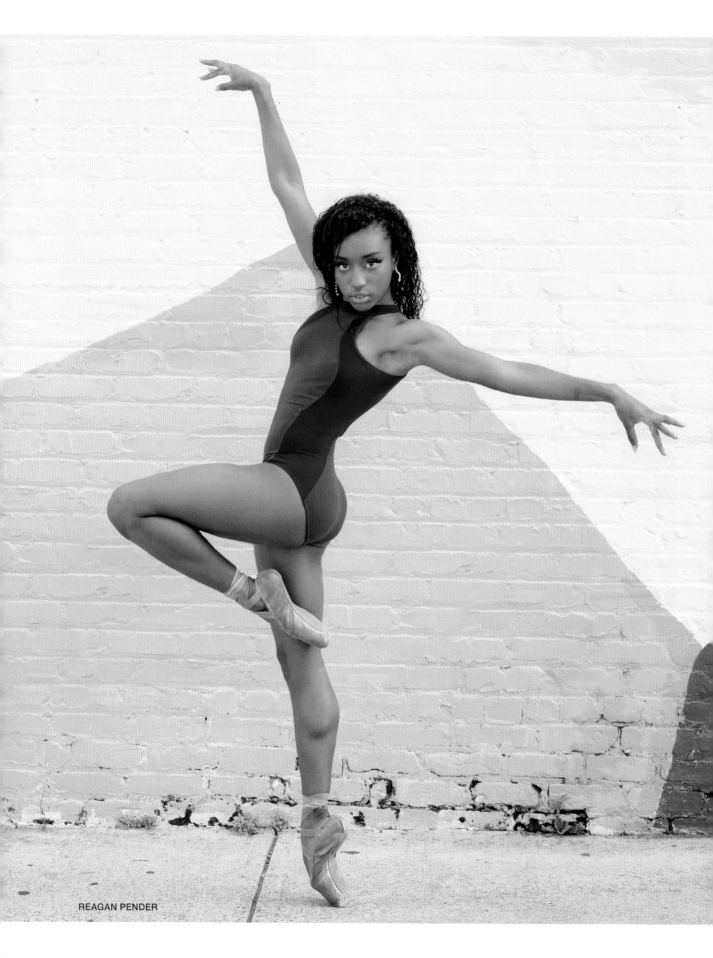

REAGAN PENDER

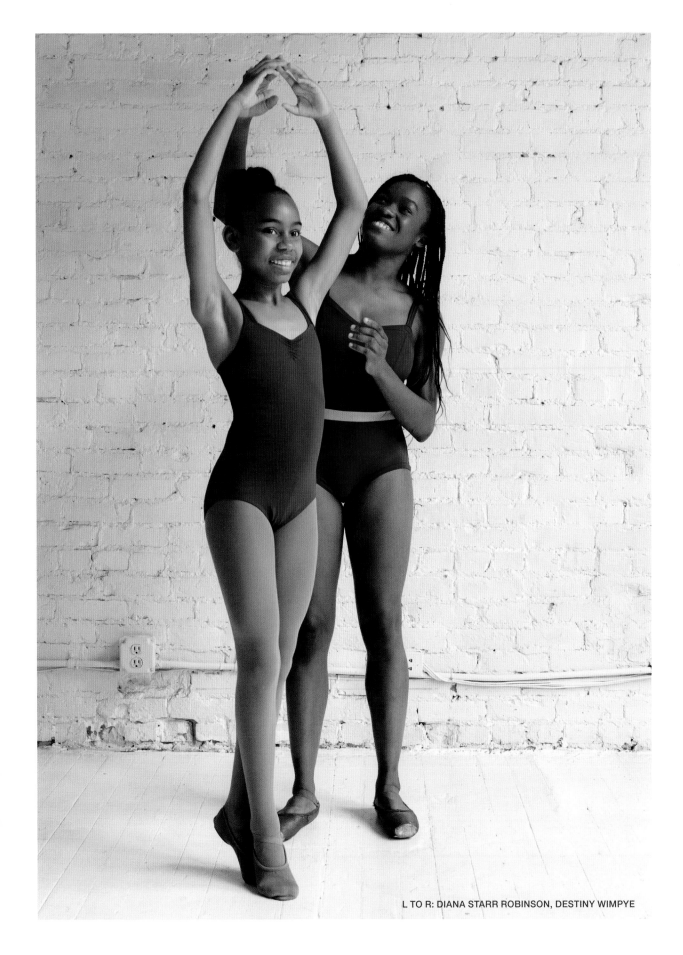

L TO R: DIANA STARR ROBINSON, DESTINY WIMPYE

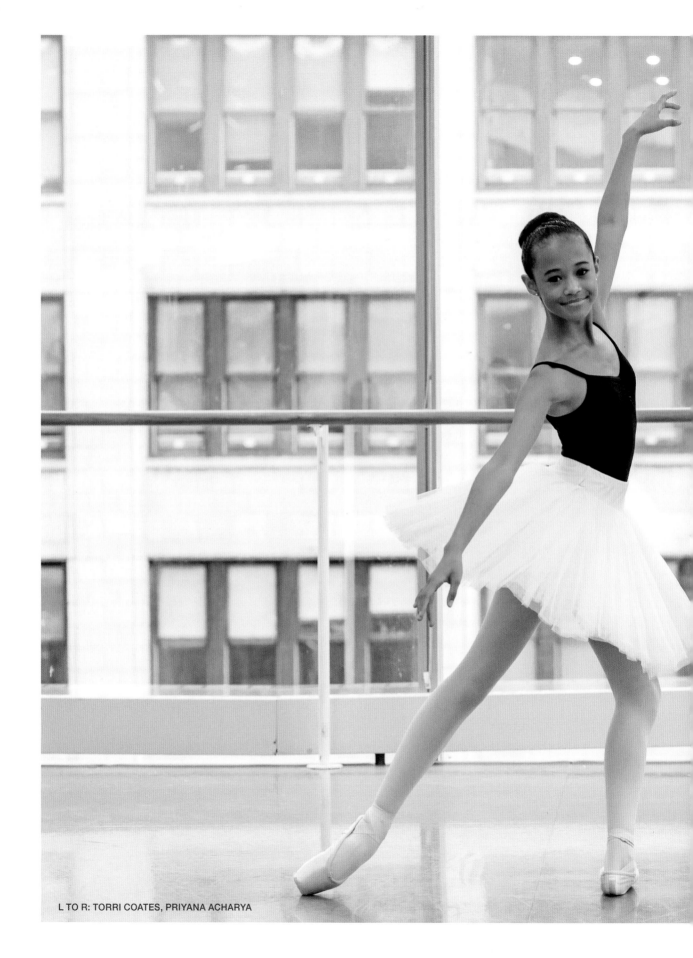

L TO R: TORRI COATES, PRIYANA ACHARYA

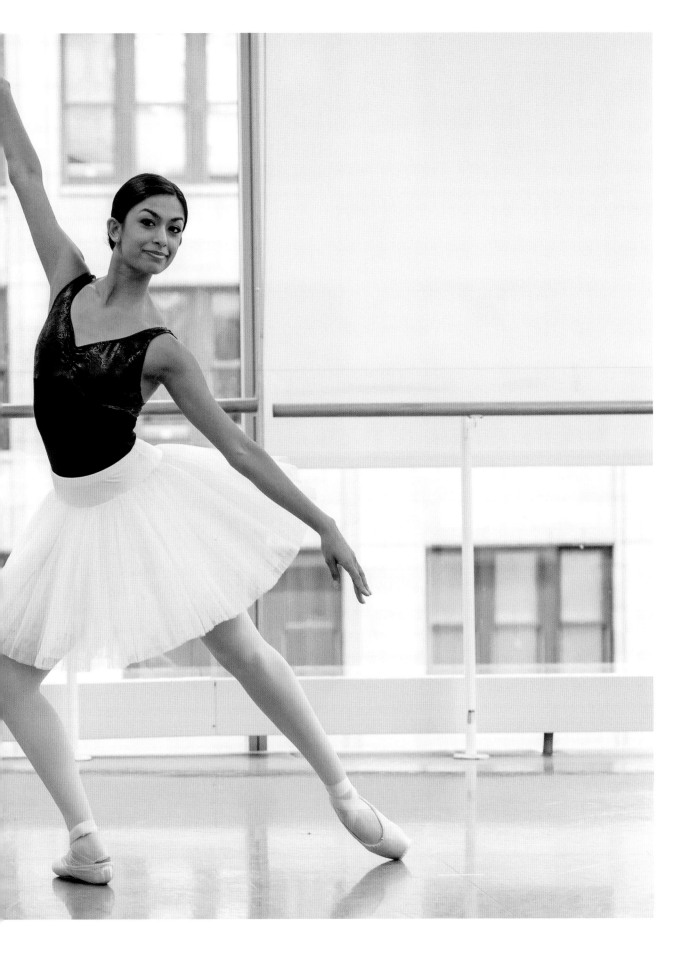

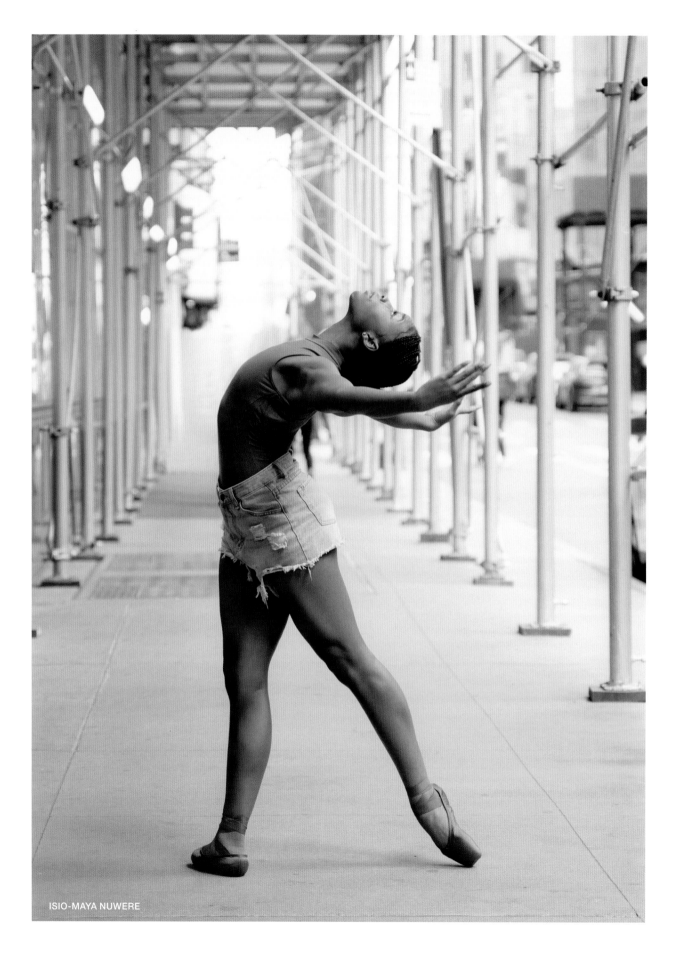

ISIO-MAYA NUWERE

I strive to be something greater than myself that'll inspire, represent, and amplify our voices.

—ISIO-MAYA NUWERE

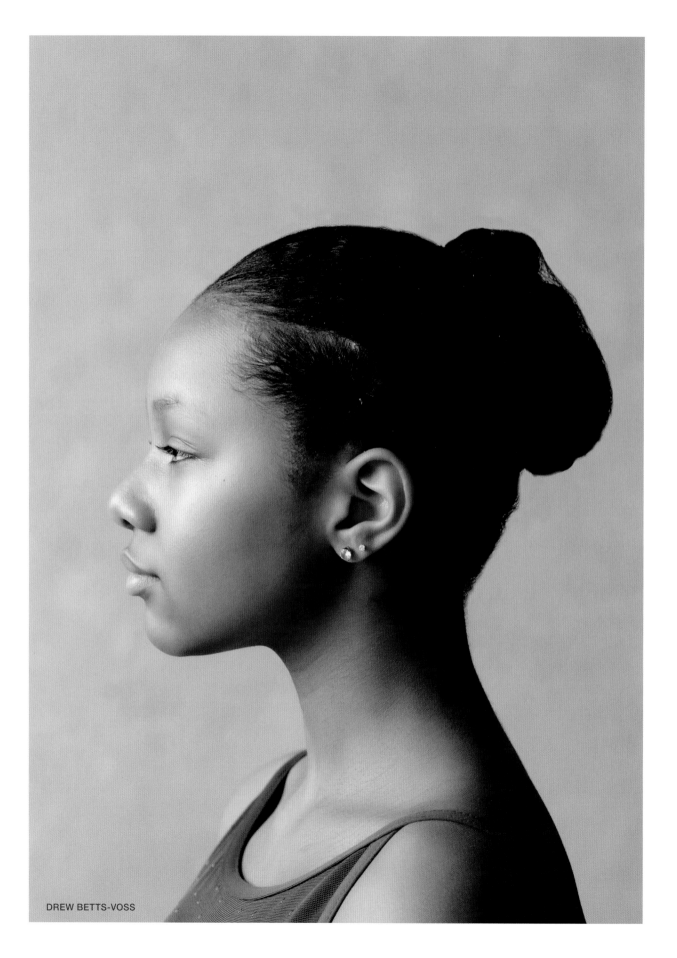

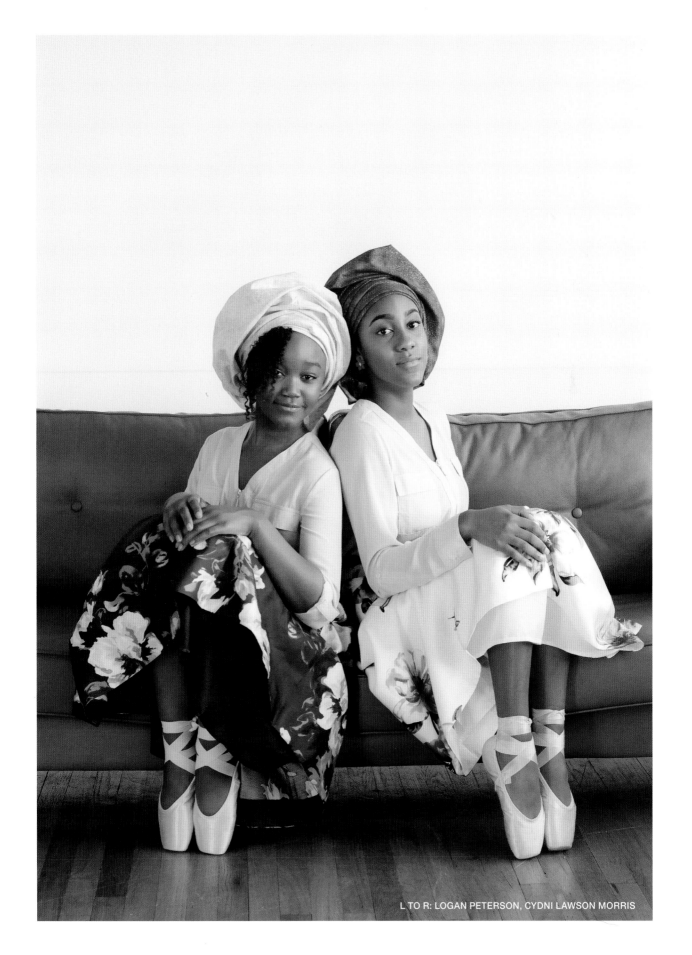

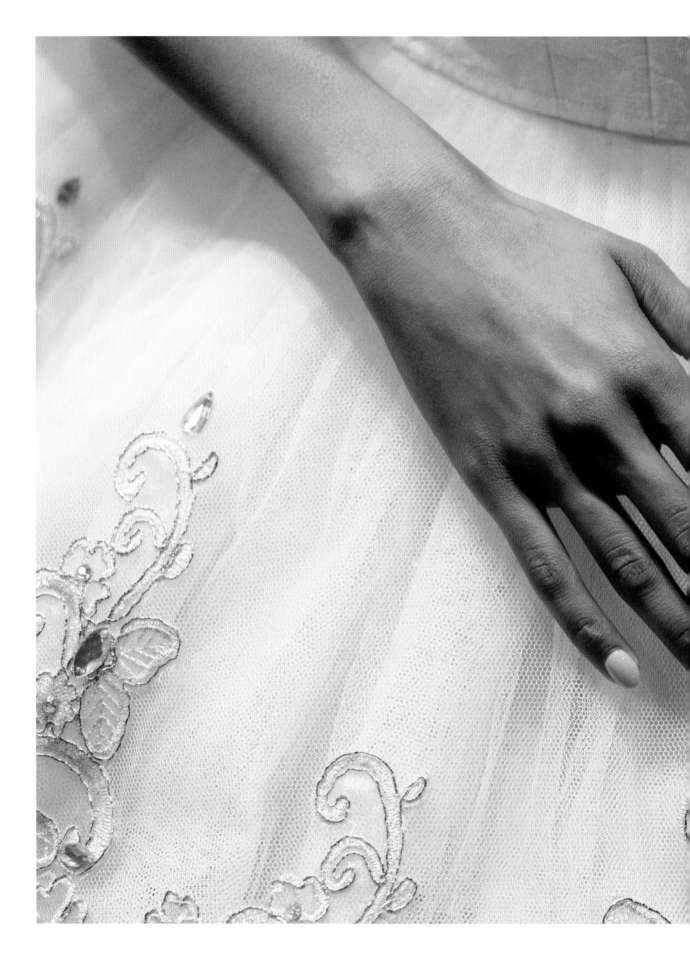

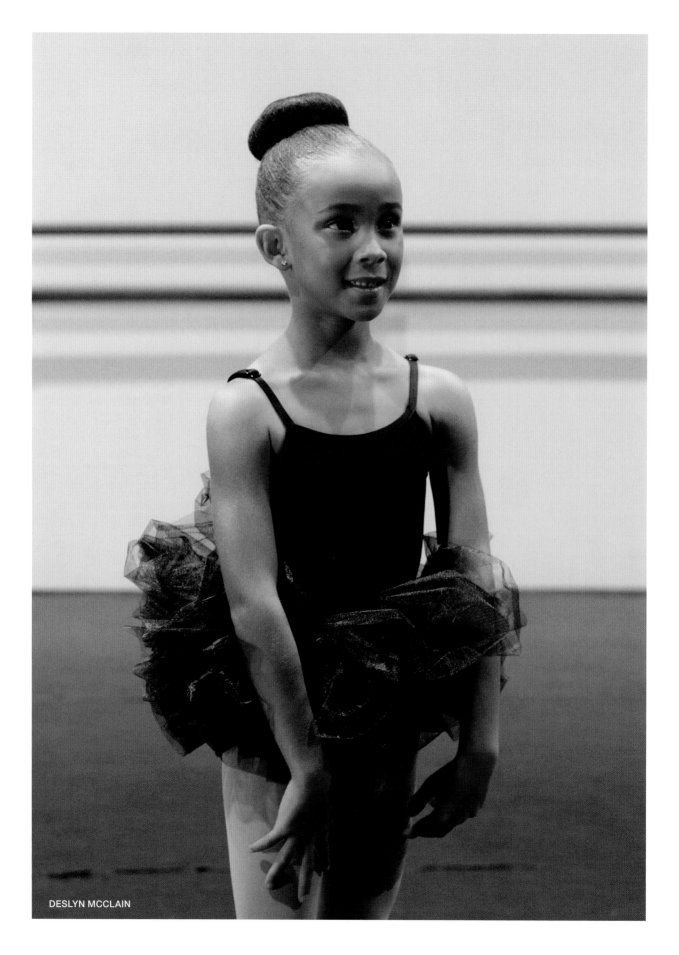

DESLYN MCCLAIN

The motion of dance is strength from my ancestors, the pride of my parents, and courage to face my future.

—DESLYN MCCLAIN

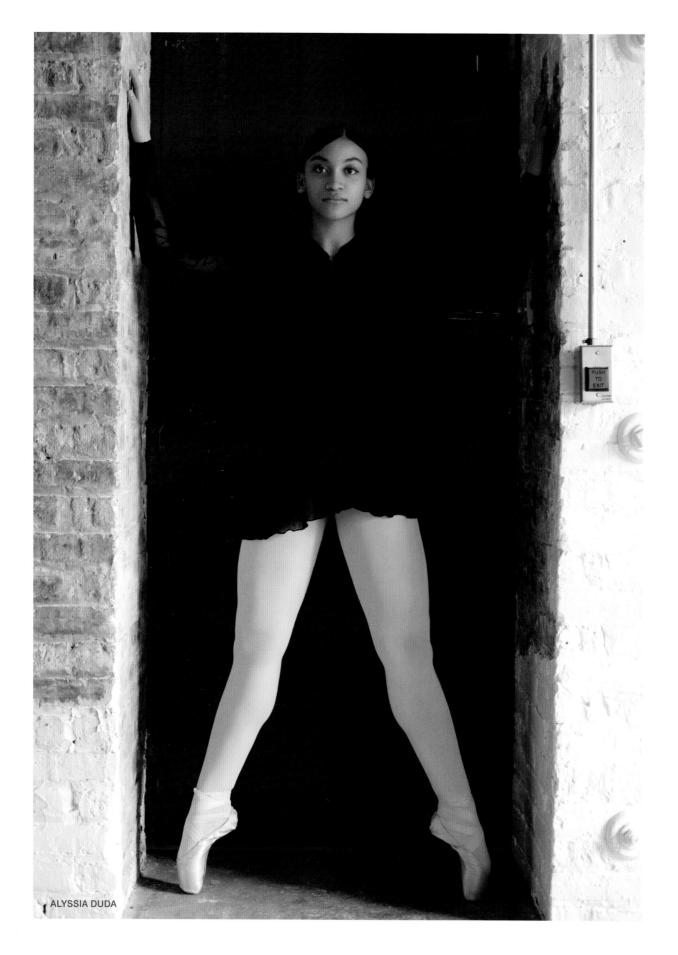

ALYSSIA DUDA

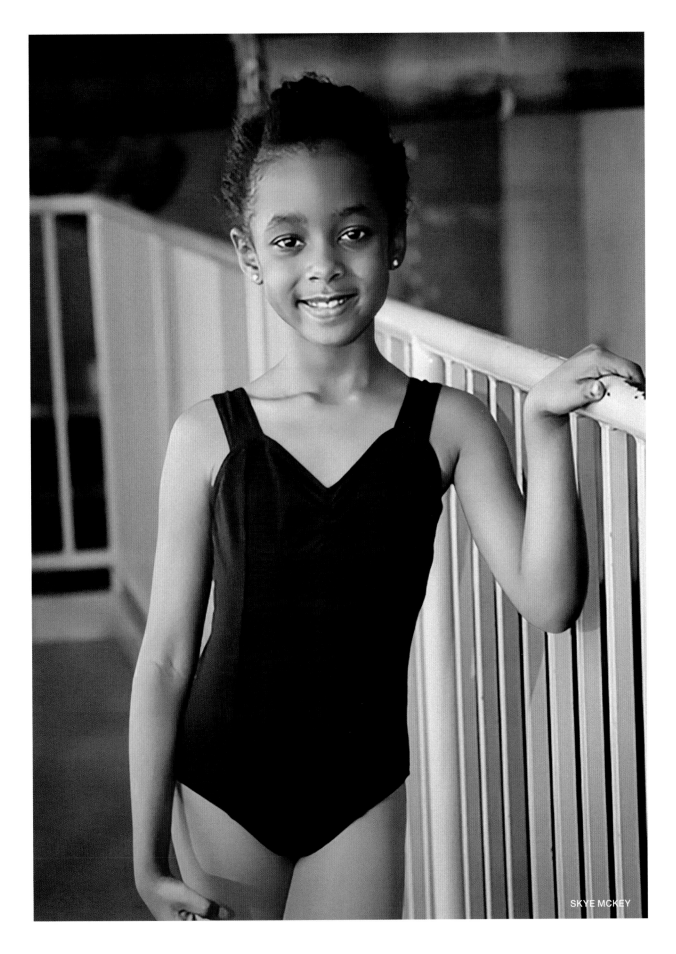

SKYE MCKEY

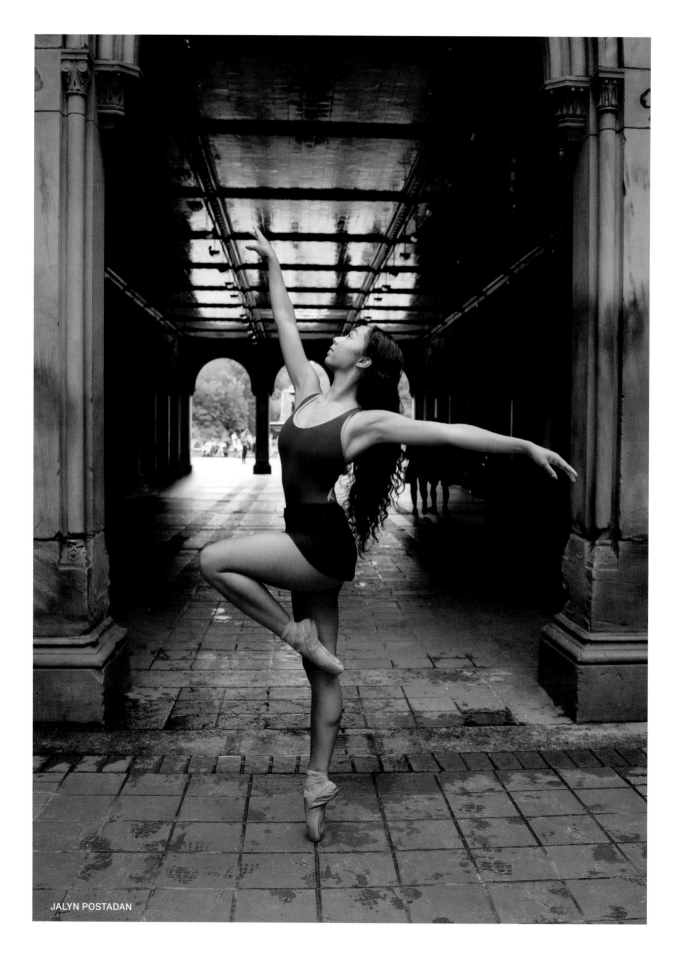

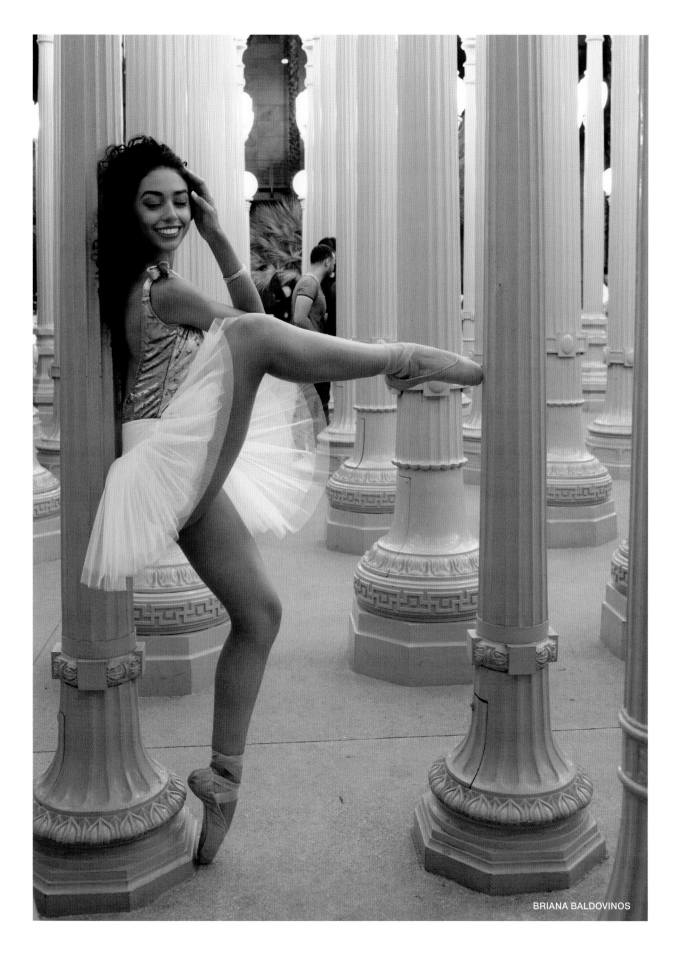

BRIANA BALDOVINOS

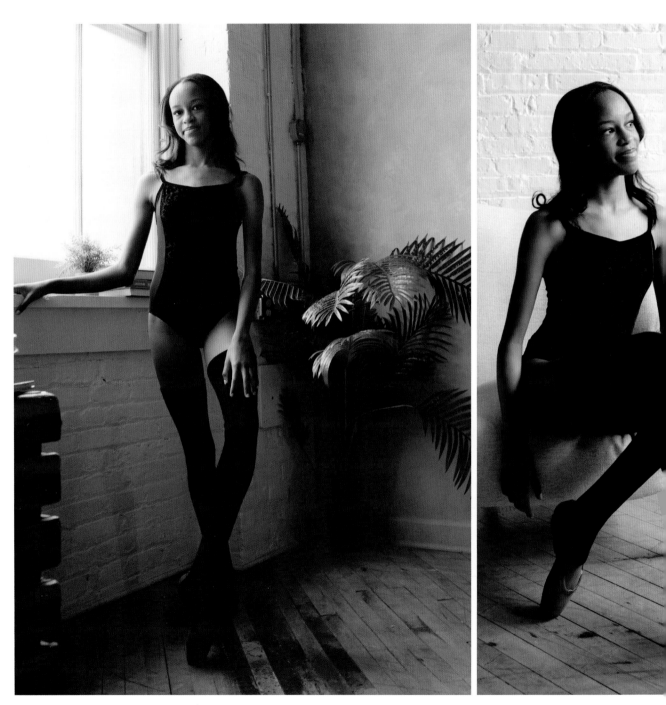

GRACE BUTLER

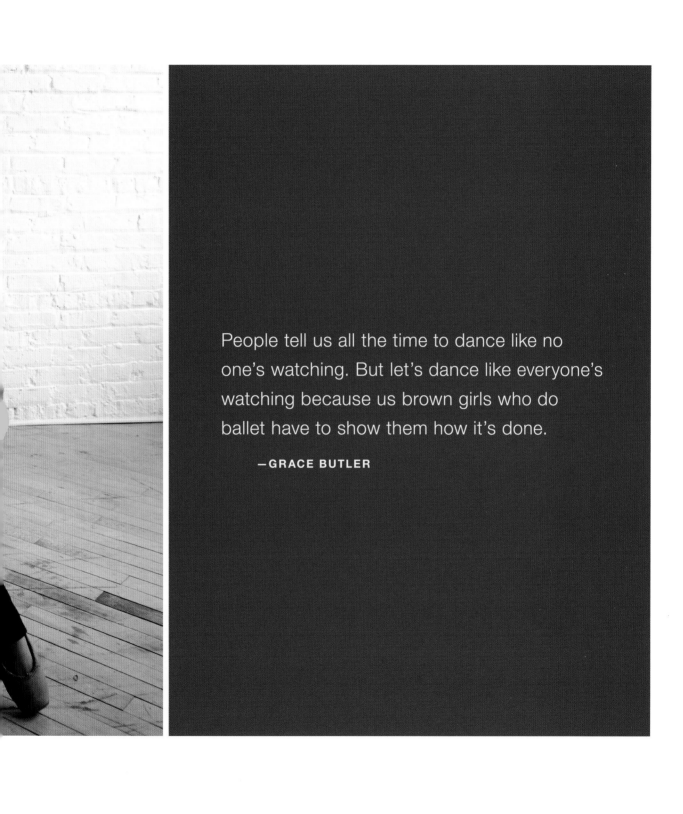

People tell us all the time to dance like no one's watching. But let's dance like everyone's watching because us brown girls who do ballet have to show them how it's done.

—GRACE BUTLER

JOELLE KIMBROUGH

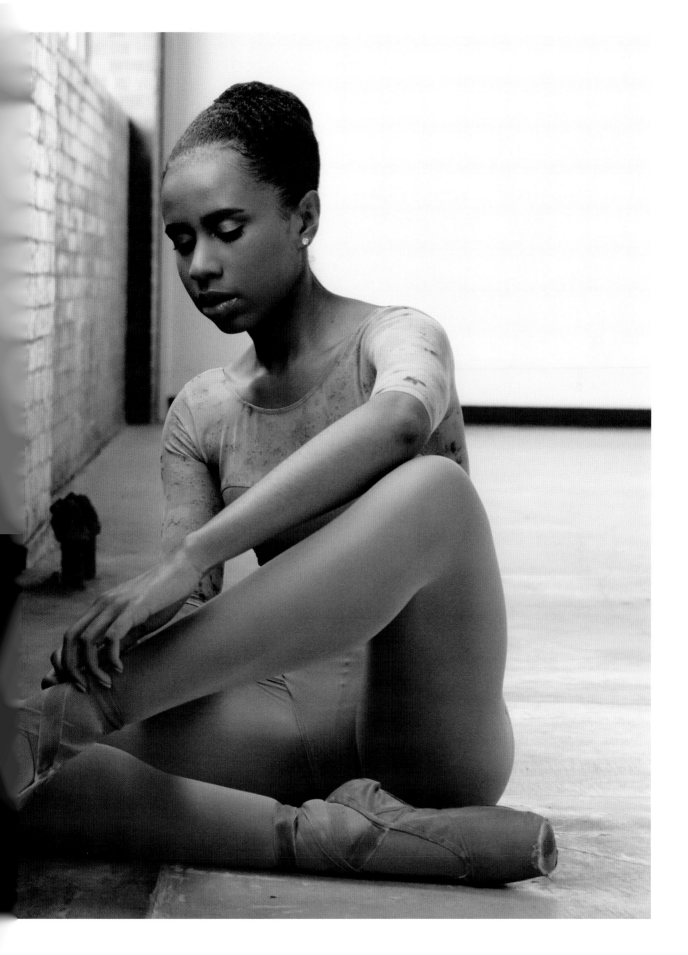

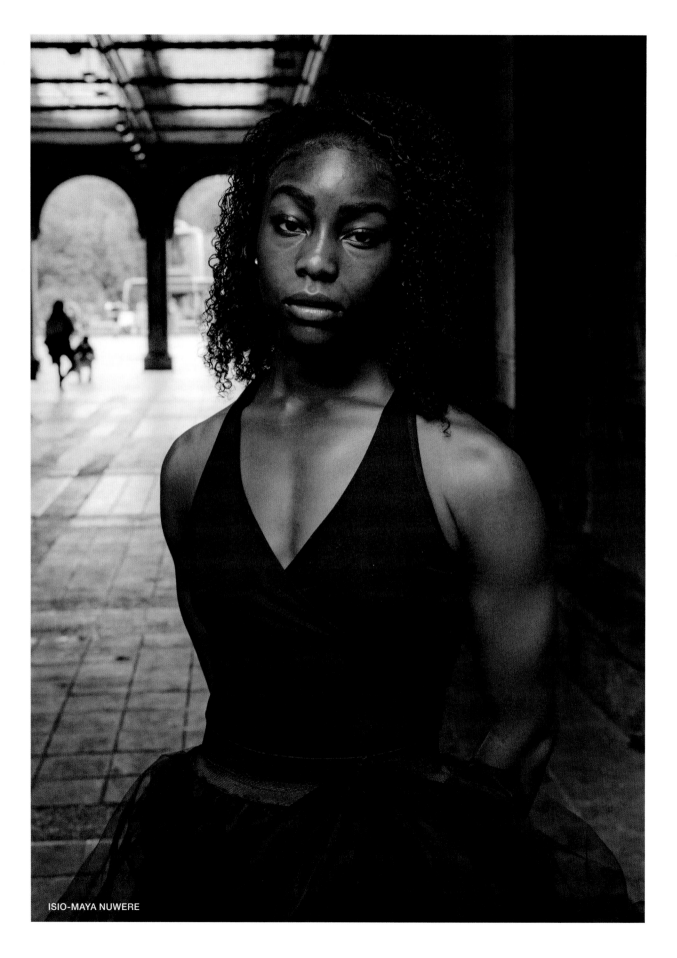

ISIO-MAYA NUWERE

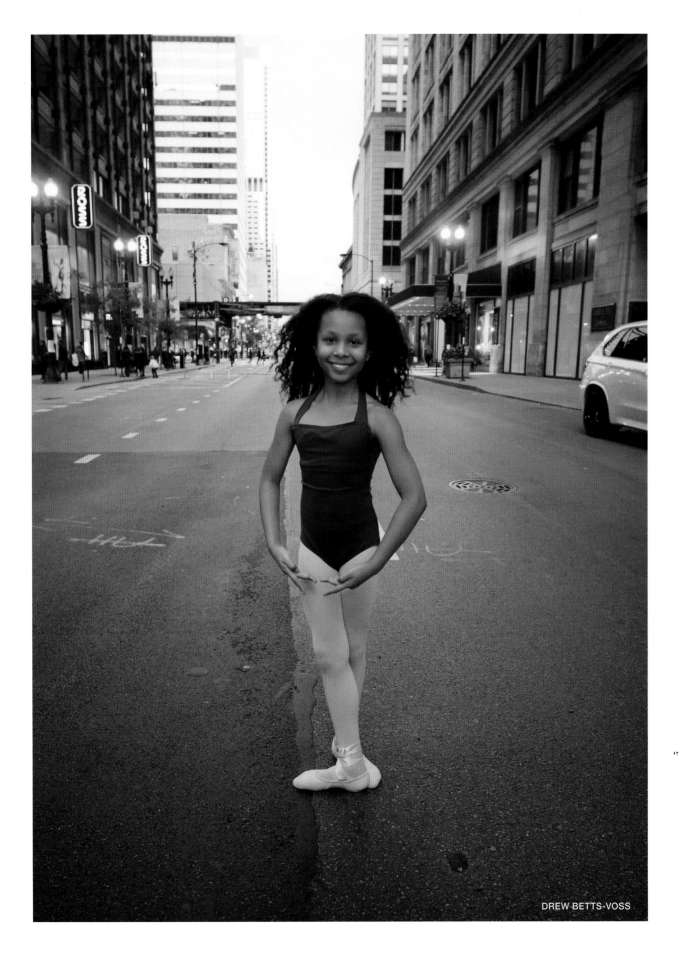

DREW BETTS-VOSS

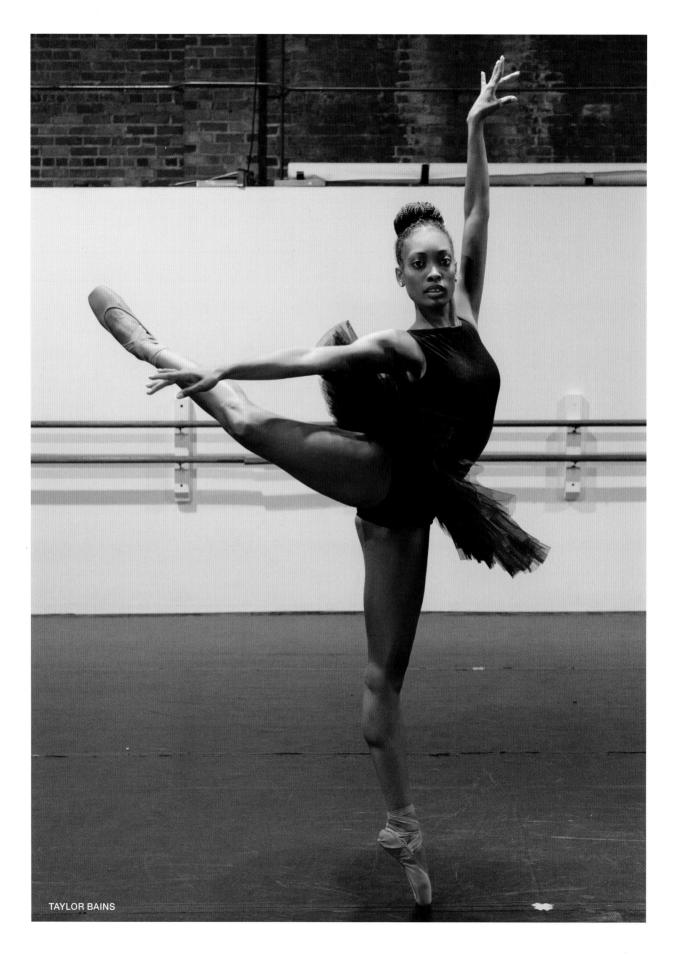

TAYLOR BAINS

George Bernard Shaw said, "Life isn't about finding yourself, it's about creating yourself." Creating new dance material is always a breath of fresh air when it's something that represents me to the fullest.

—TAYLOR BAINS

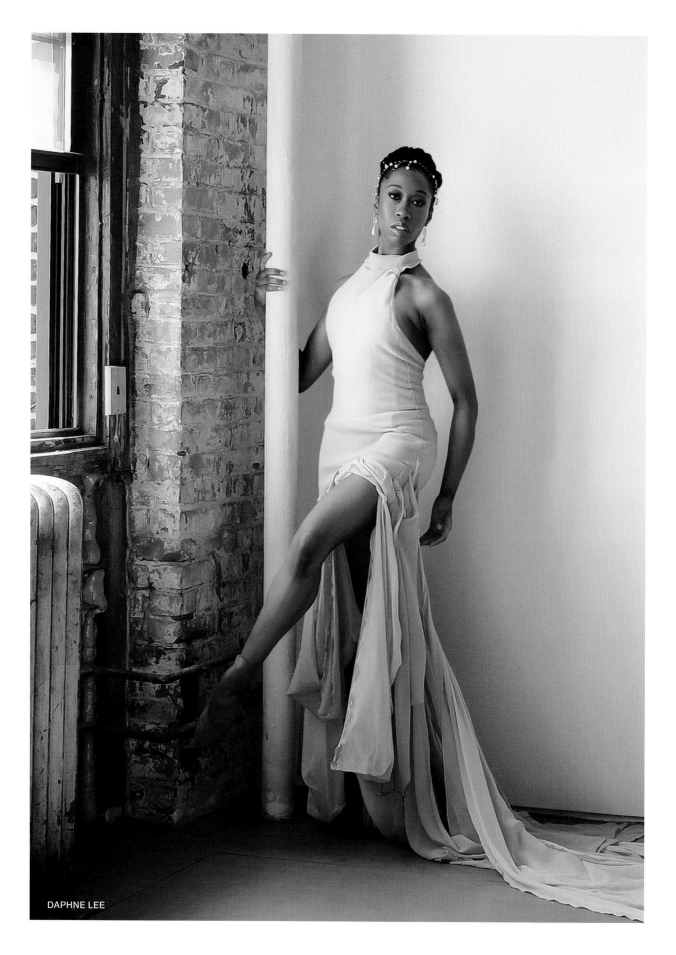

DAPHNE LEE

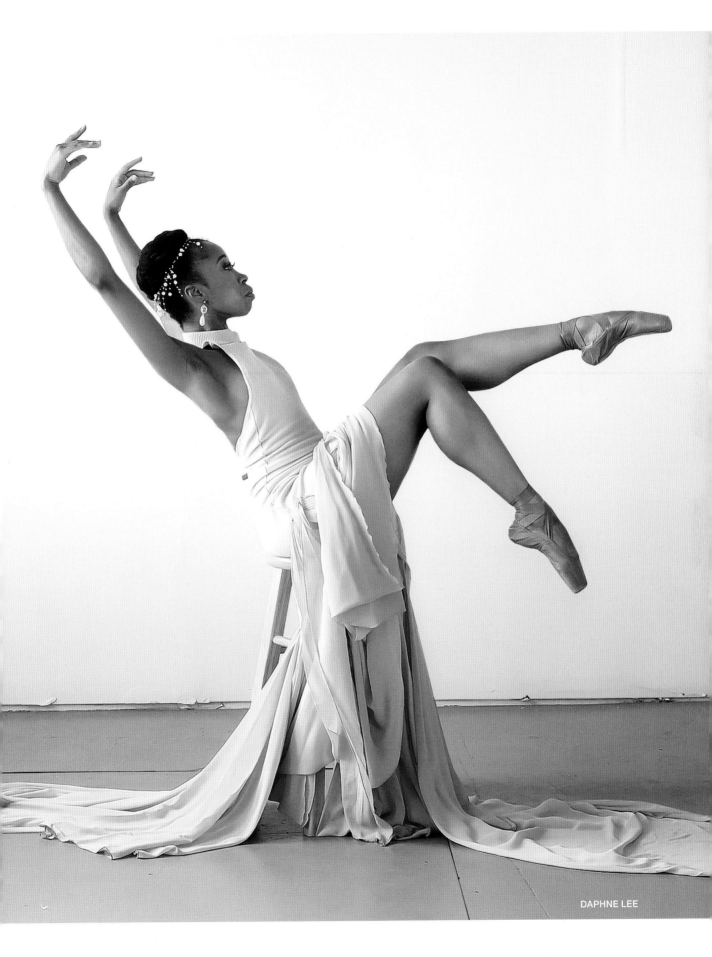

DAPHNE LEE

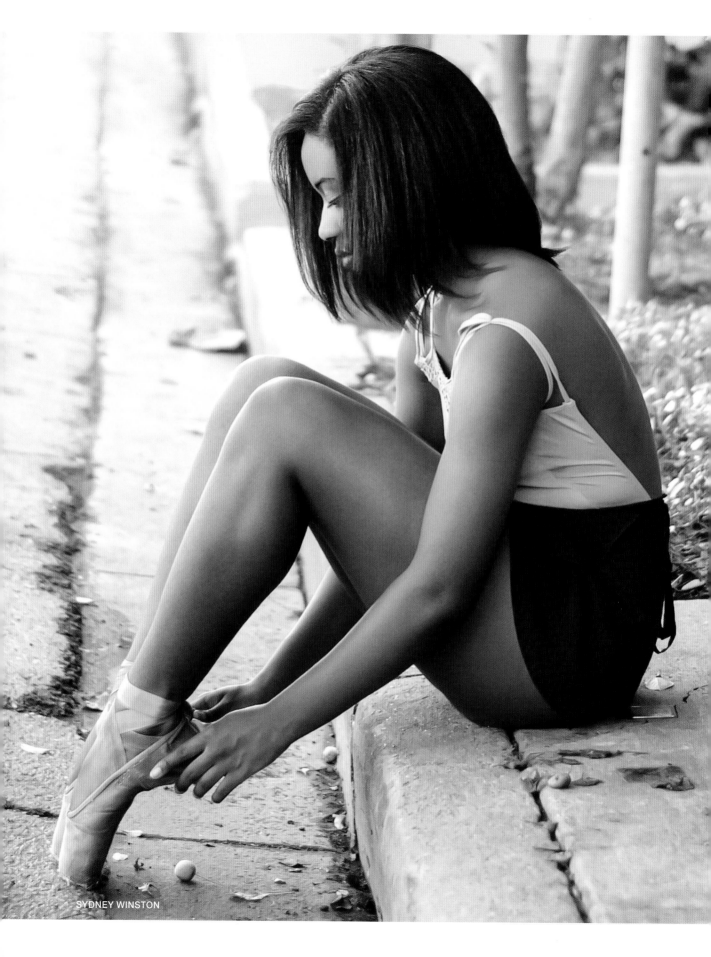

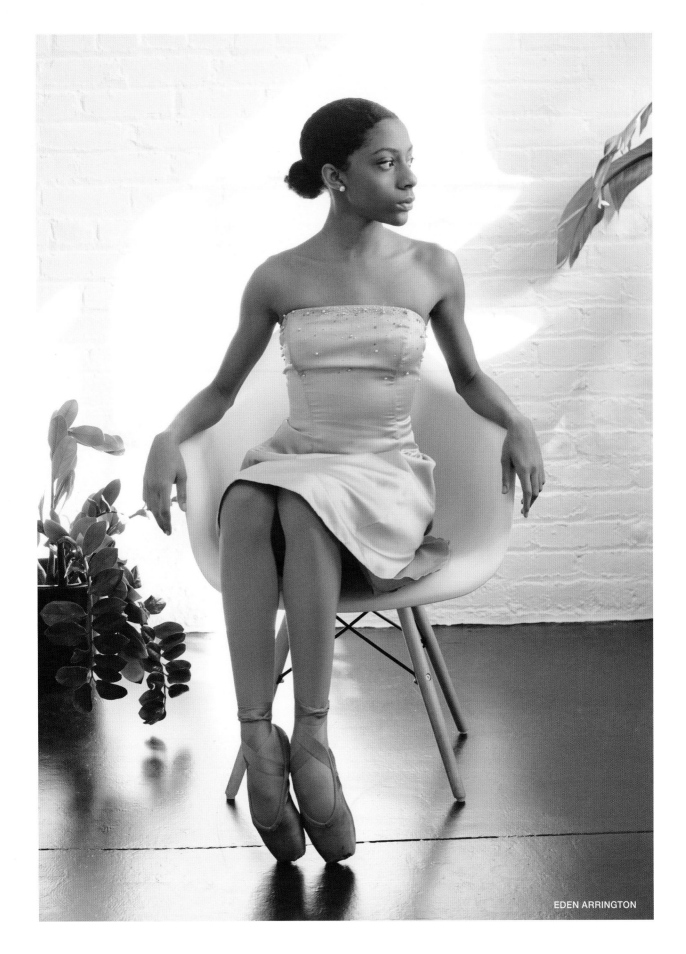

EDEN ARRINGTON

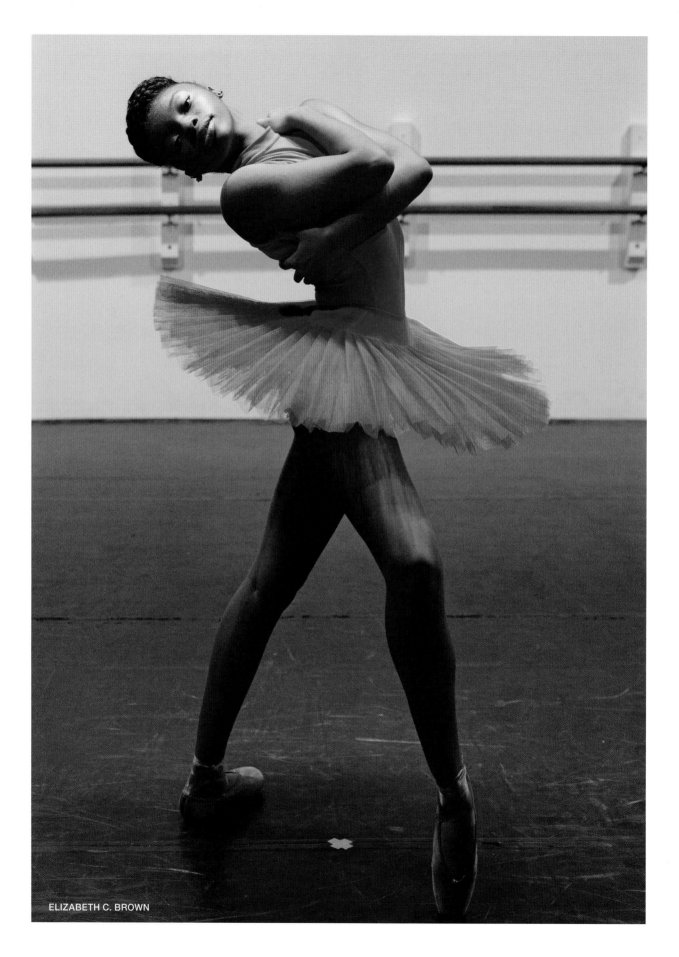

ELIZABETH C. BROWN

Everyone has a dream;
make that dream a reality.
—ELIZABETH C. BROWN

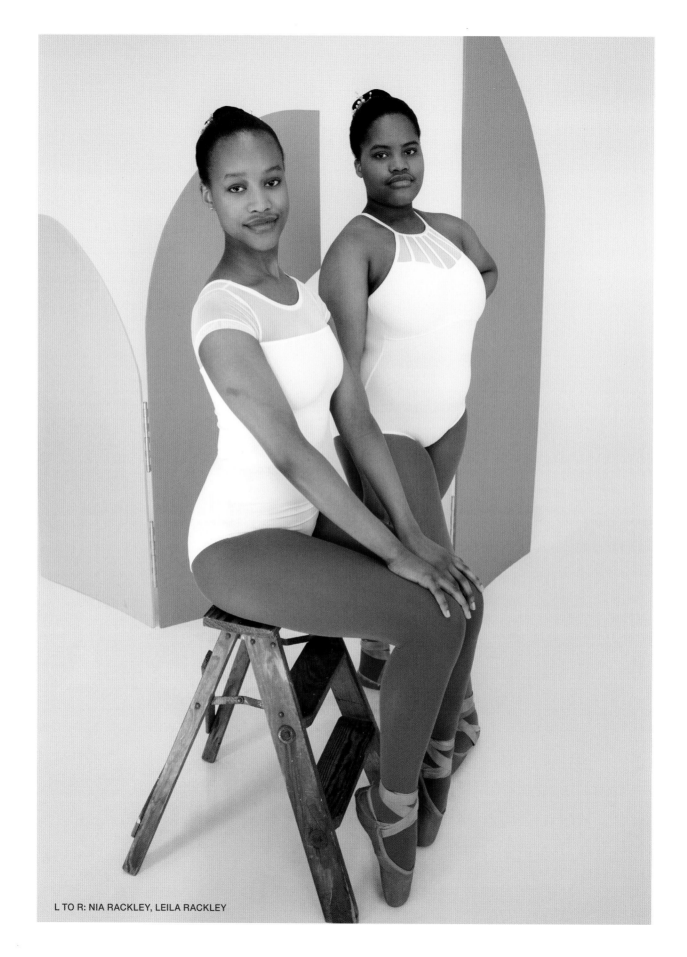

L TO R: NIA RACKLEY, LEILA RACKLEY

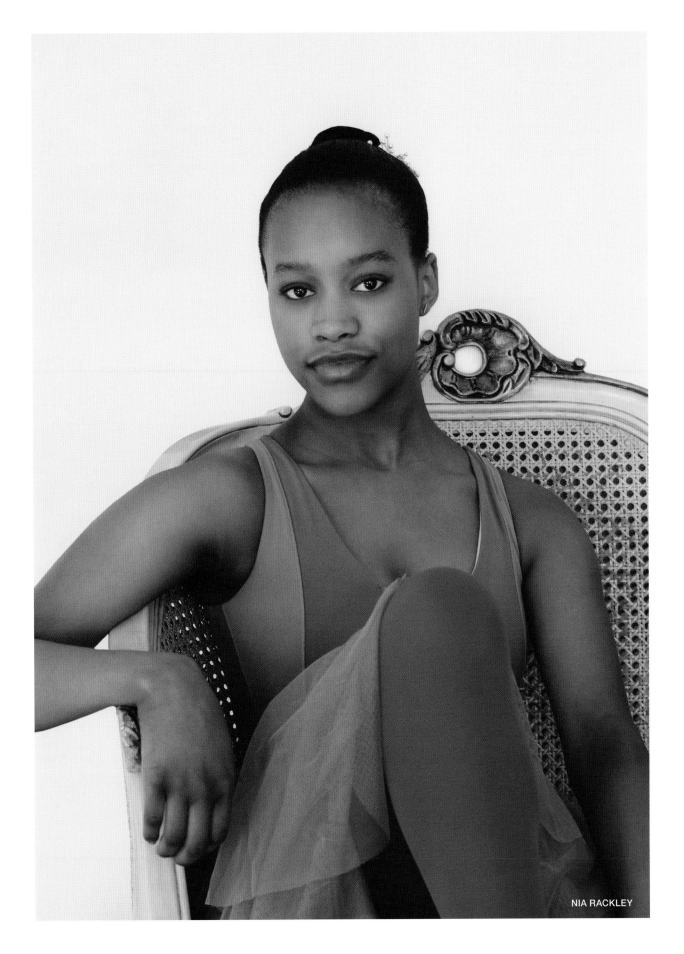

NIA RACKLEY

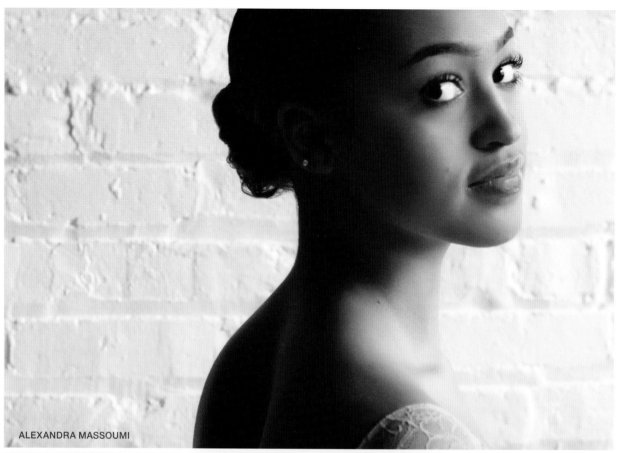

ALEXANDRA MASSOUMI

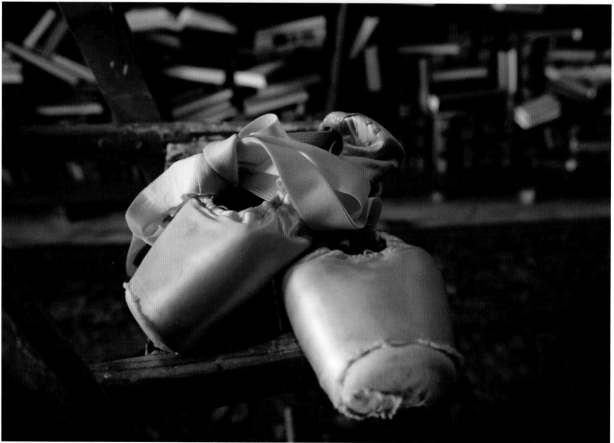

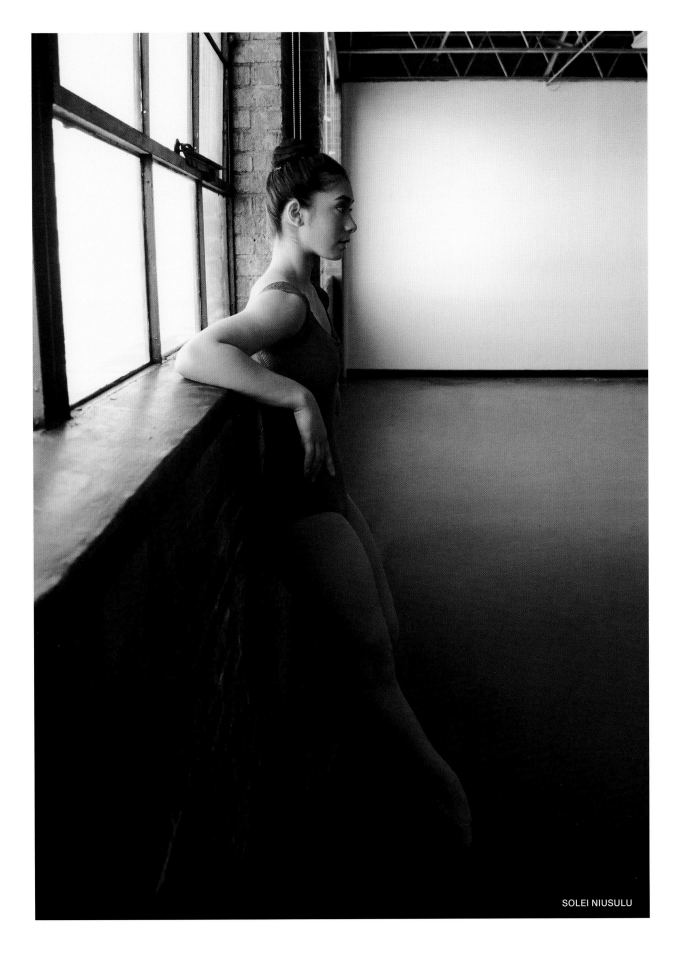

SOLEI NIUSULU

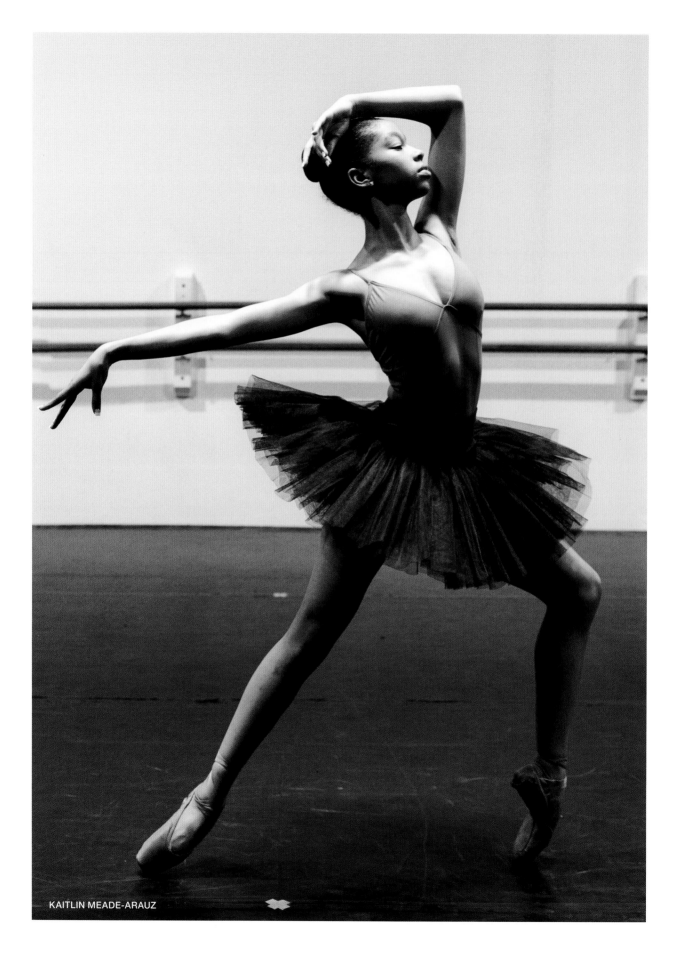

KAITLIN MEADE-ARAUZ

Dance is my
inspiration in motion.
—KAITLIN MEADE-ARAUZ

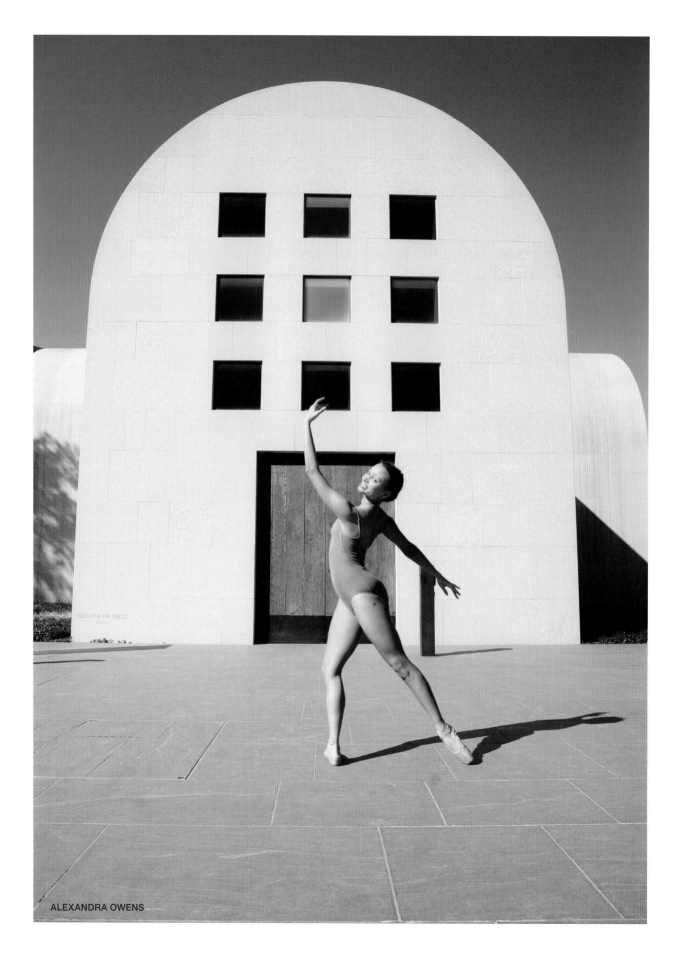

ALEXANDRA OWENS

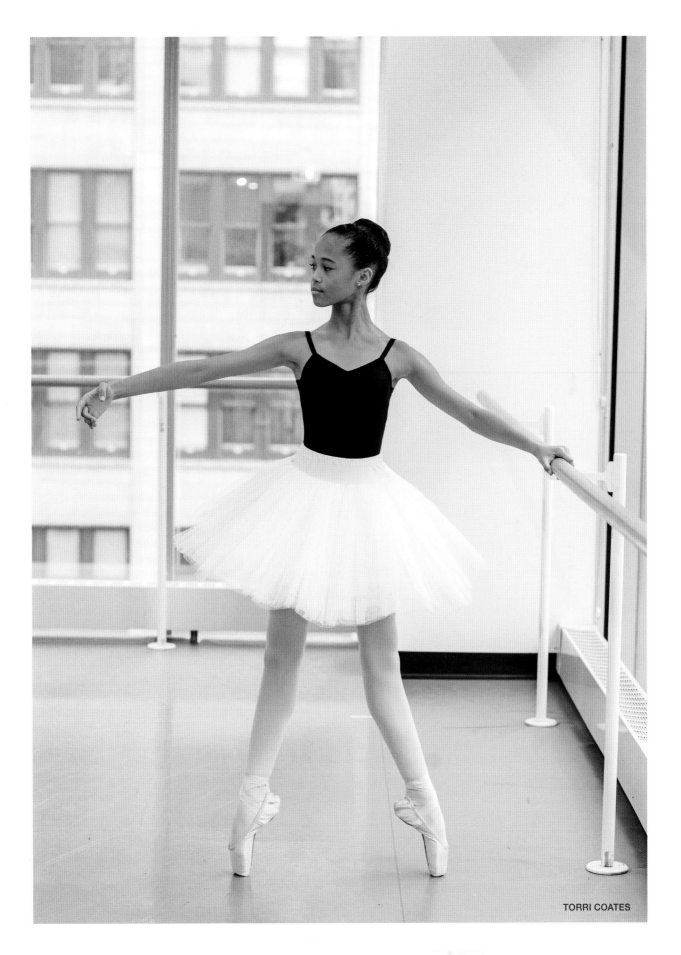

TORRI COATES

CASEY SELLERS

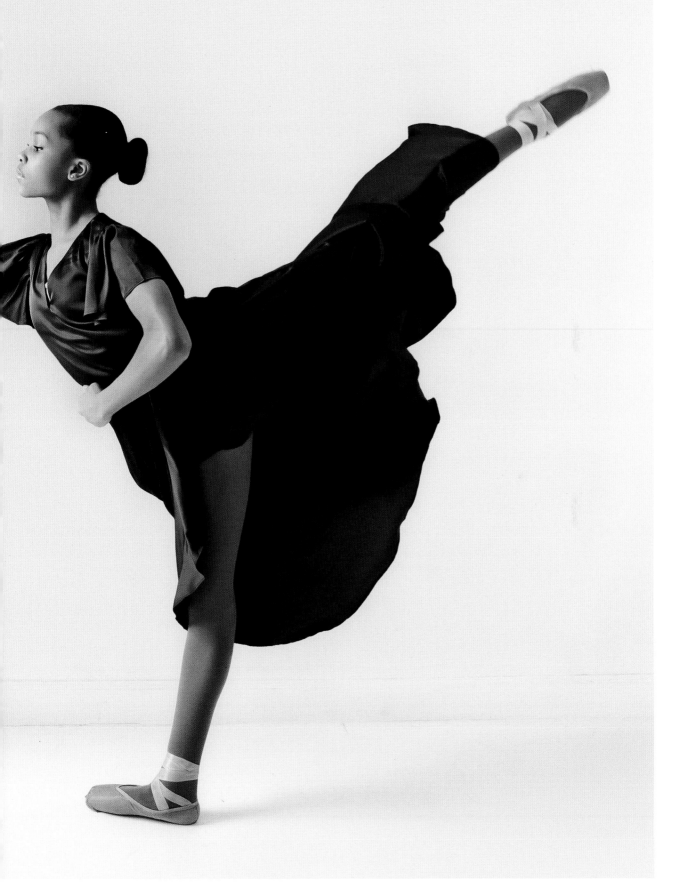

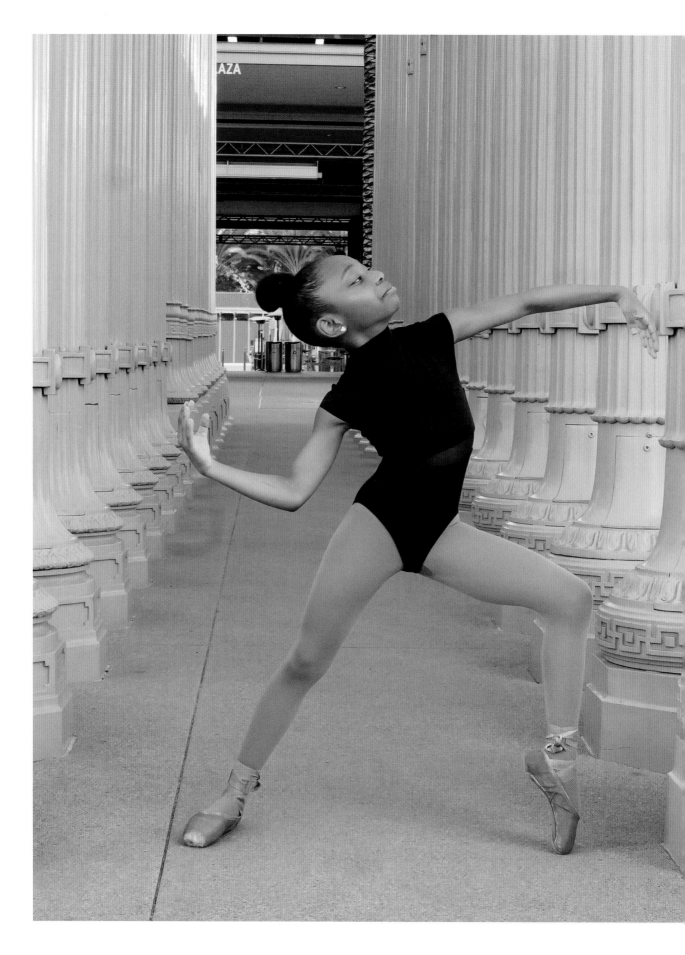

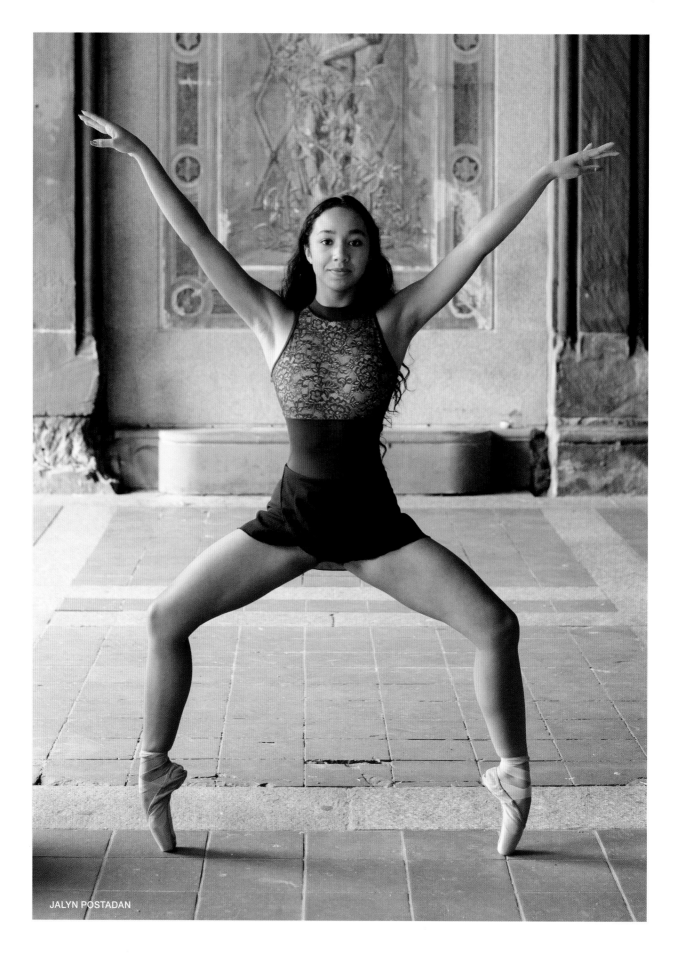

JALYN POSTADAN

I feel that dance is so special because my body is my instrument, which means that my movement and artistic expression will always be unique and authentic to me.

—JALYN POSTADAN

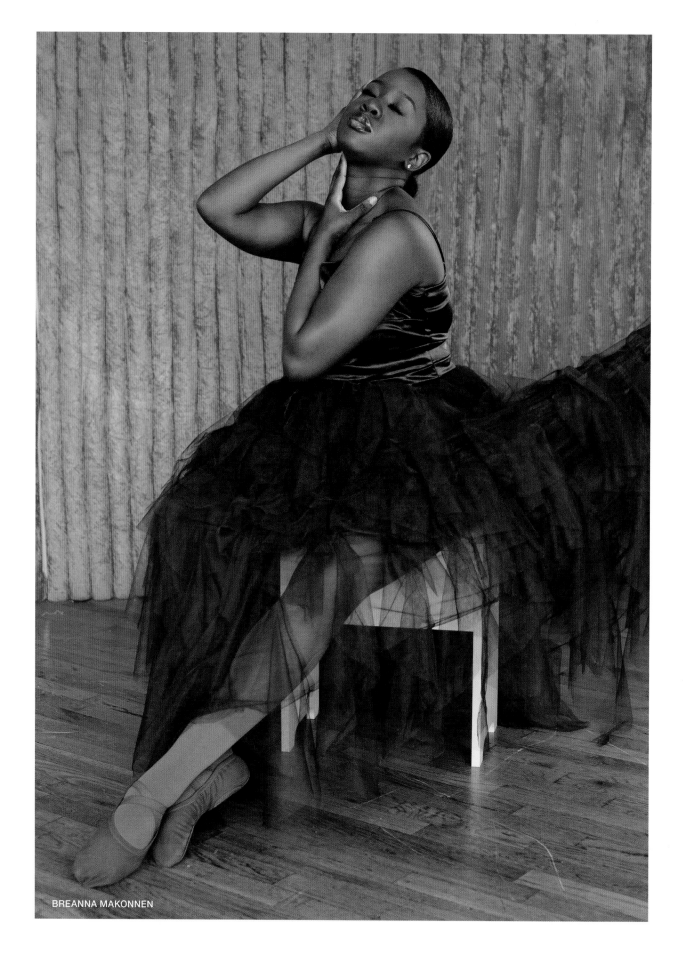

BREANNA MAKONNEN

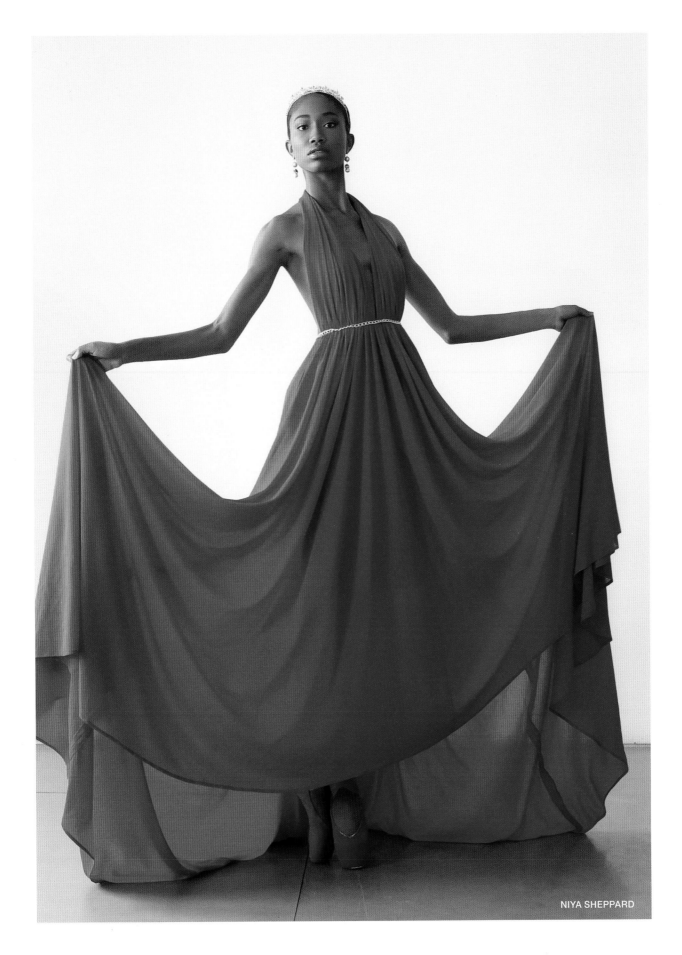

NIYA SHEPPARD

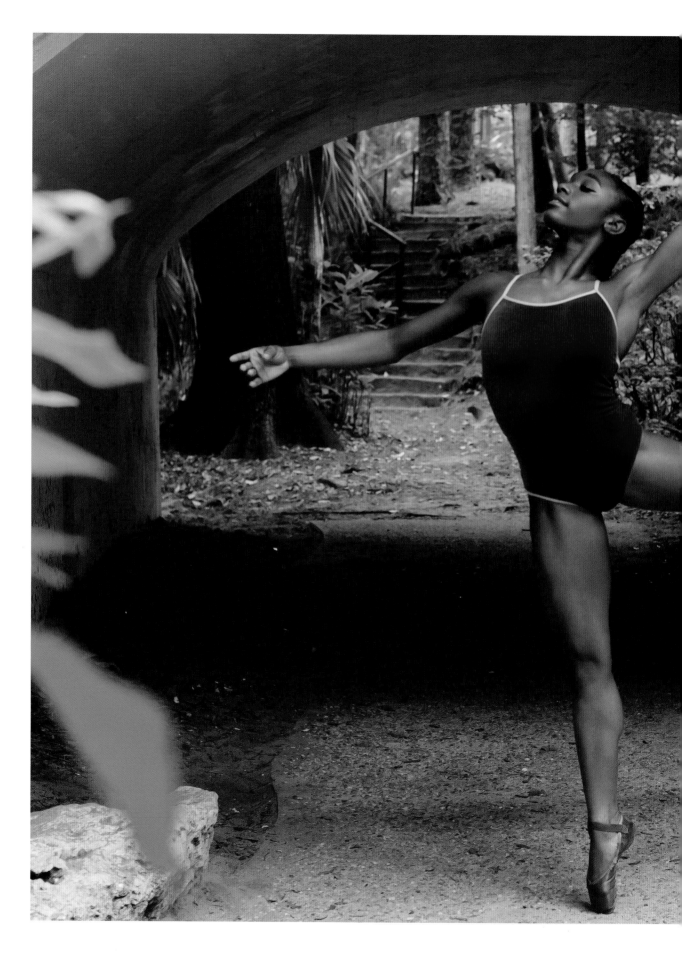

AMAYA JOSEPH

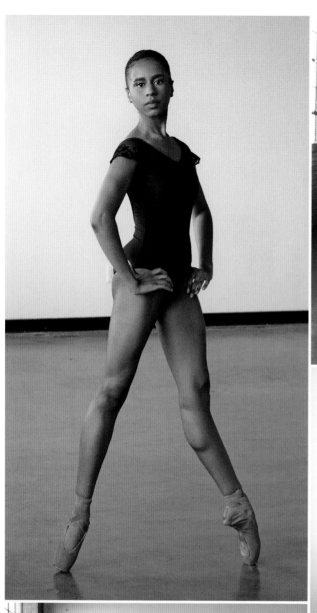

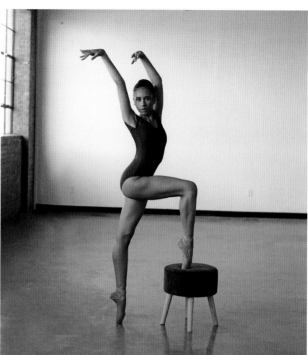

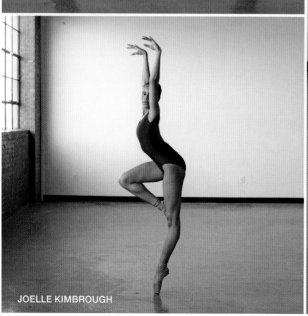

JOELLE KIMBROUGH

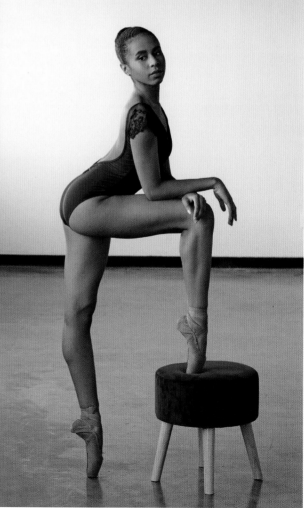

Ballet gives me my voice. It allows me to say so much without having to say anything. I am so grateful for organizations like Brown Girls Do Ballet that help amplify my voice and of others who look like me.

—JOELLE KIMBROUGH

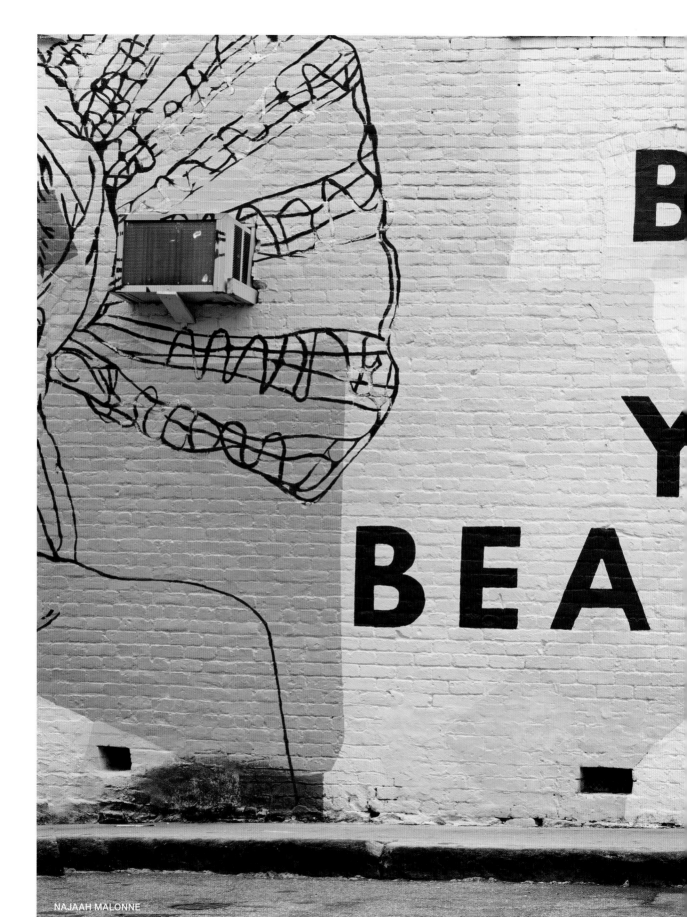

NAJAAH MALONNE

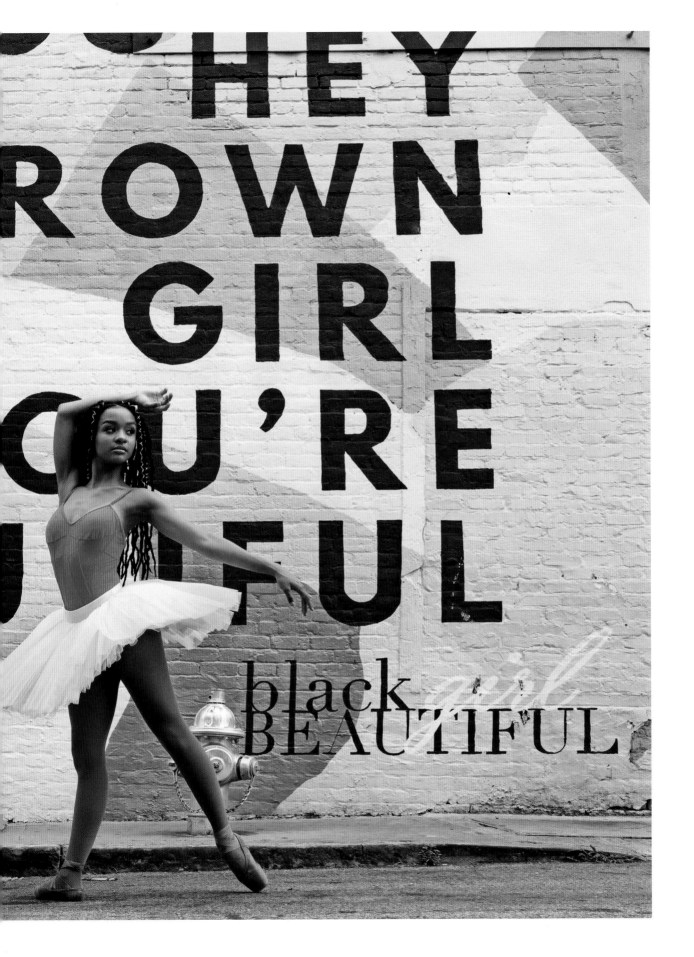

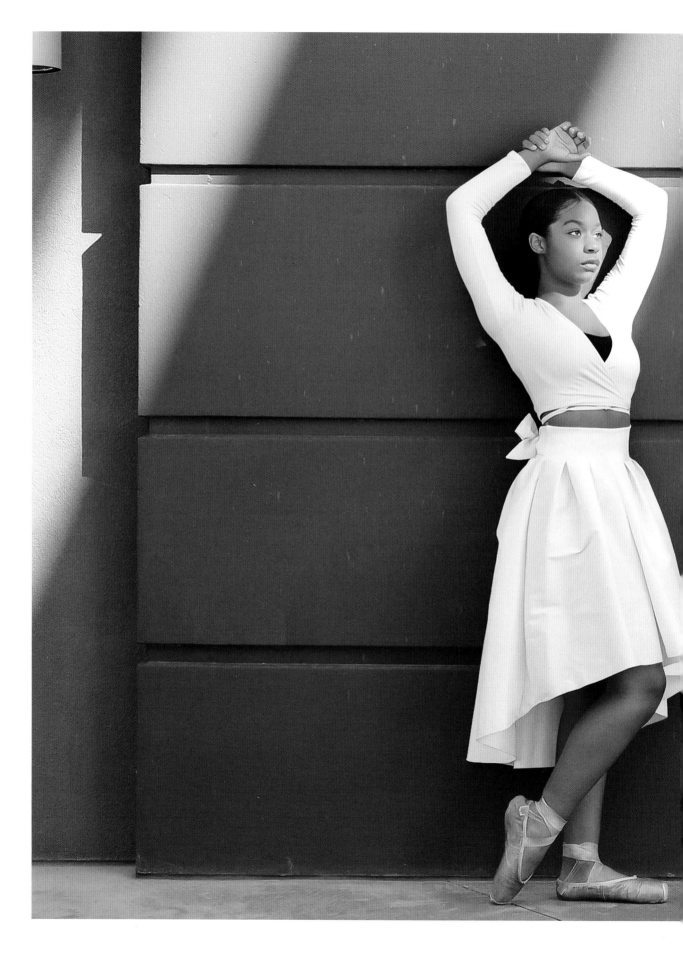

CAT JAMES

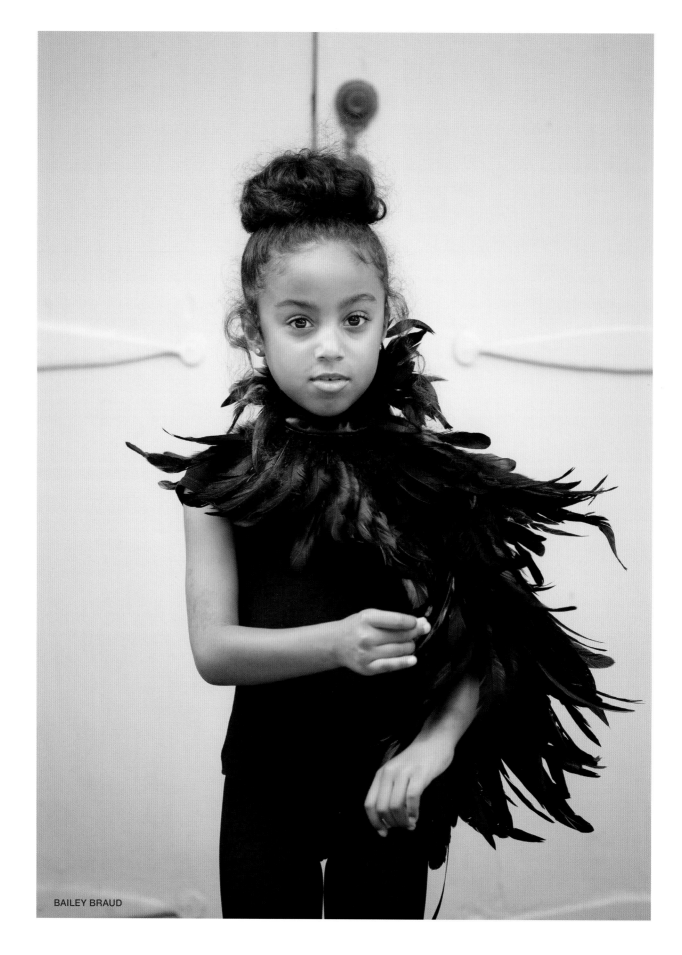

BAILEY BRAUD

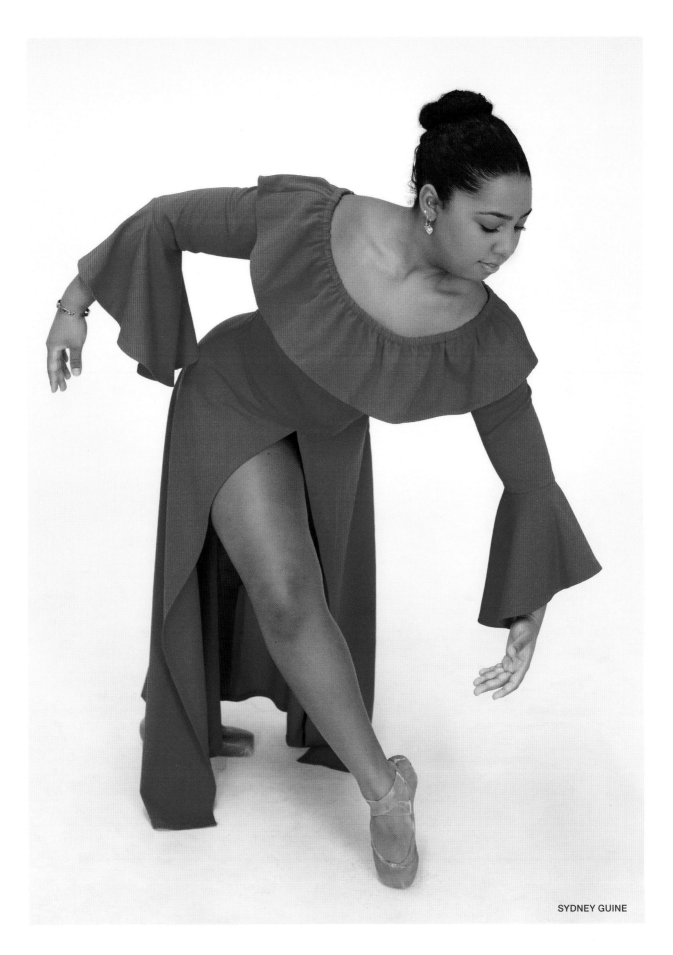

SYDNEY GUINE

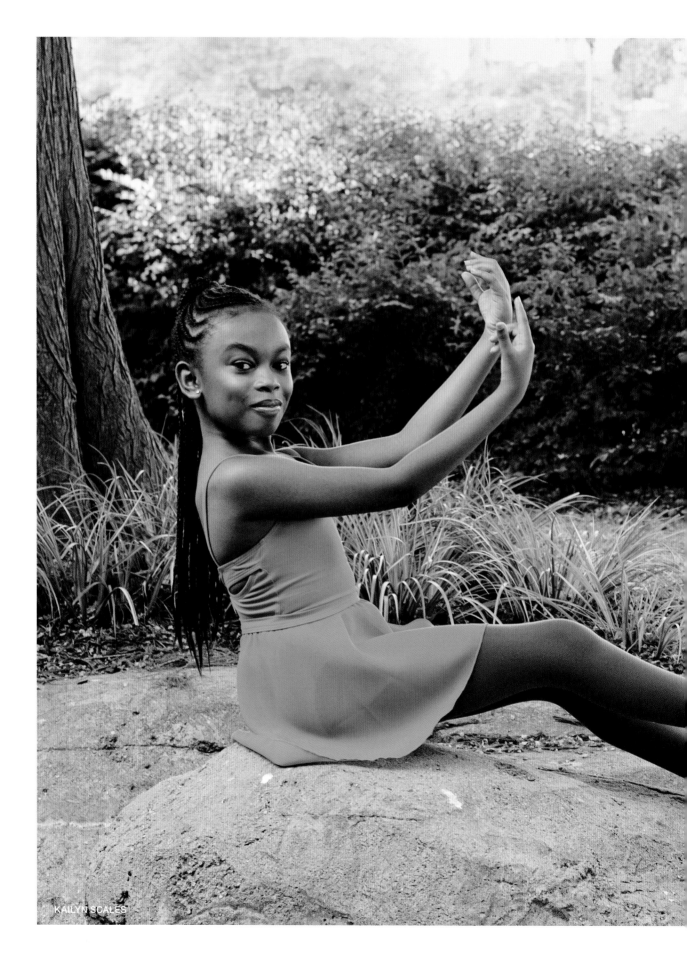
KAILYN SCALES

I am small but mighty. When
I dance, I feel powerful. I don't
feel like the smallest person
in the room.

—KAILYN SCALES

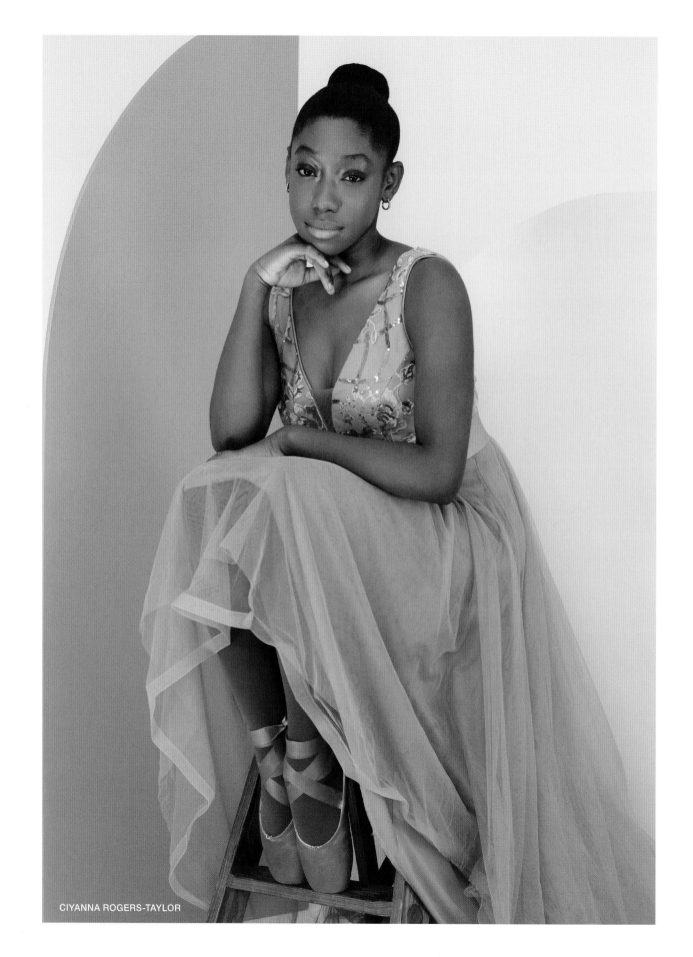
CIYANNA ROGERS-TAYLOR

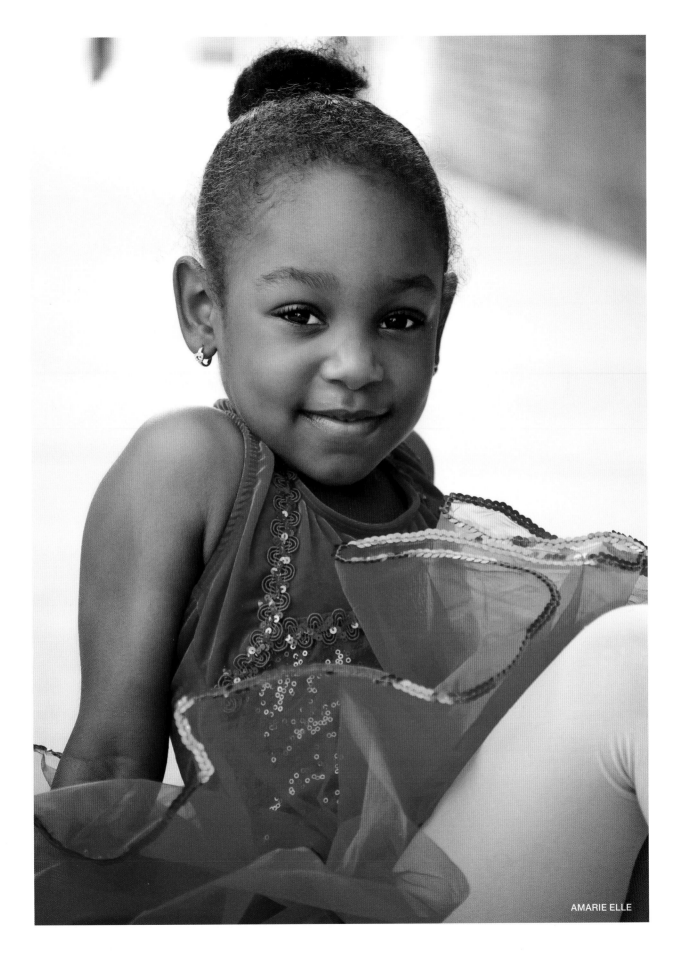
AMARIE ELLE

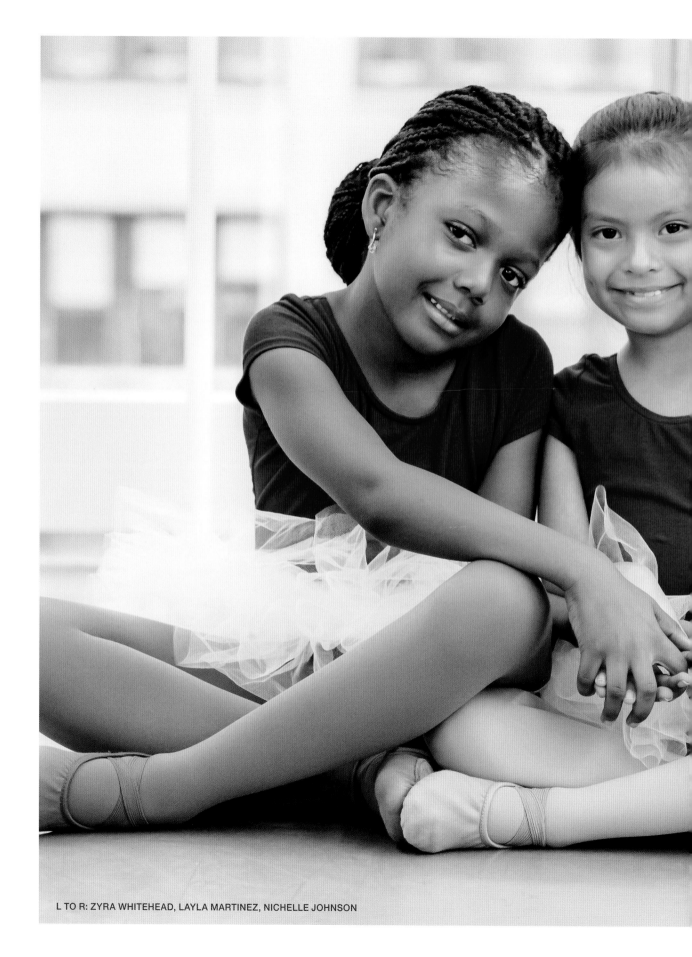

L TO R: ZYRA WHITEHEAD, LAYLA MARTINEZ, NICHELLE JOHNSON

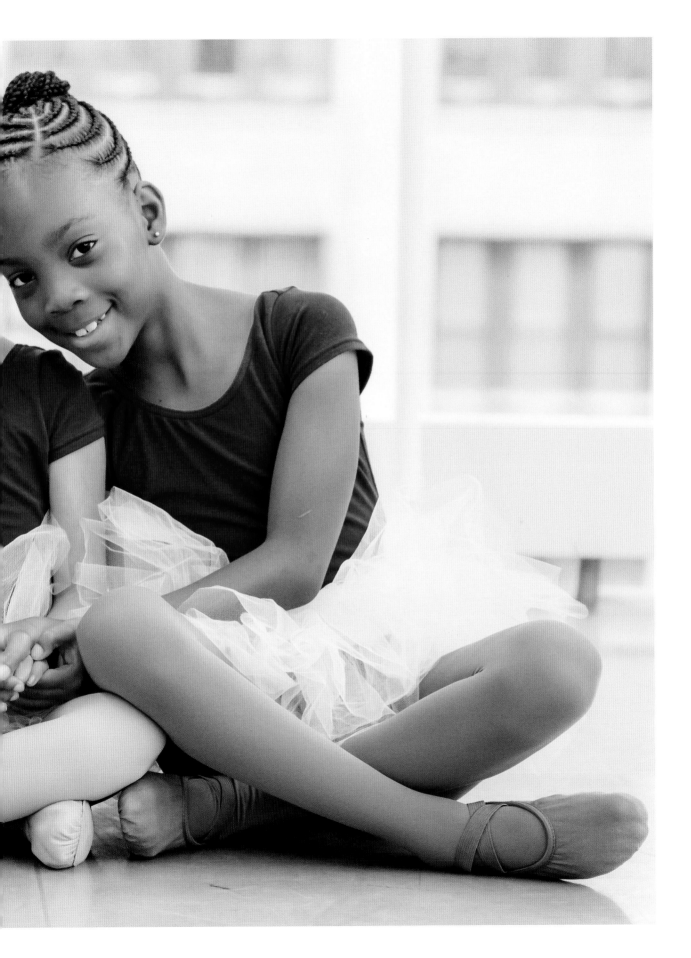

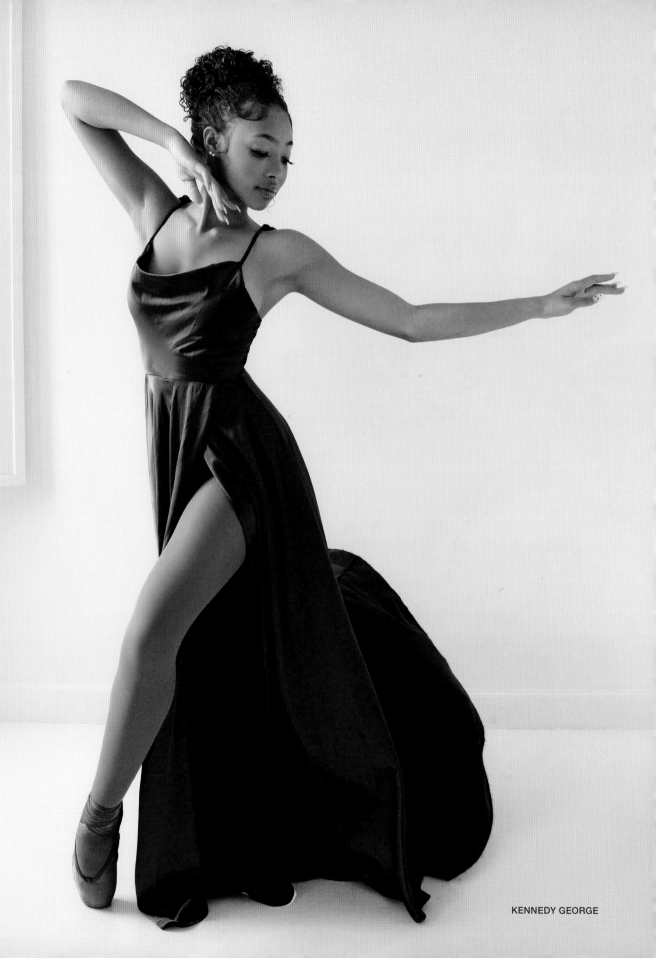

KENNEDY GEORGE

When what you love to do isn't just entertainment but art, it makes the world a more beautiful place to live in.

—KENNEDY GEORGE

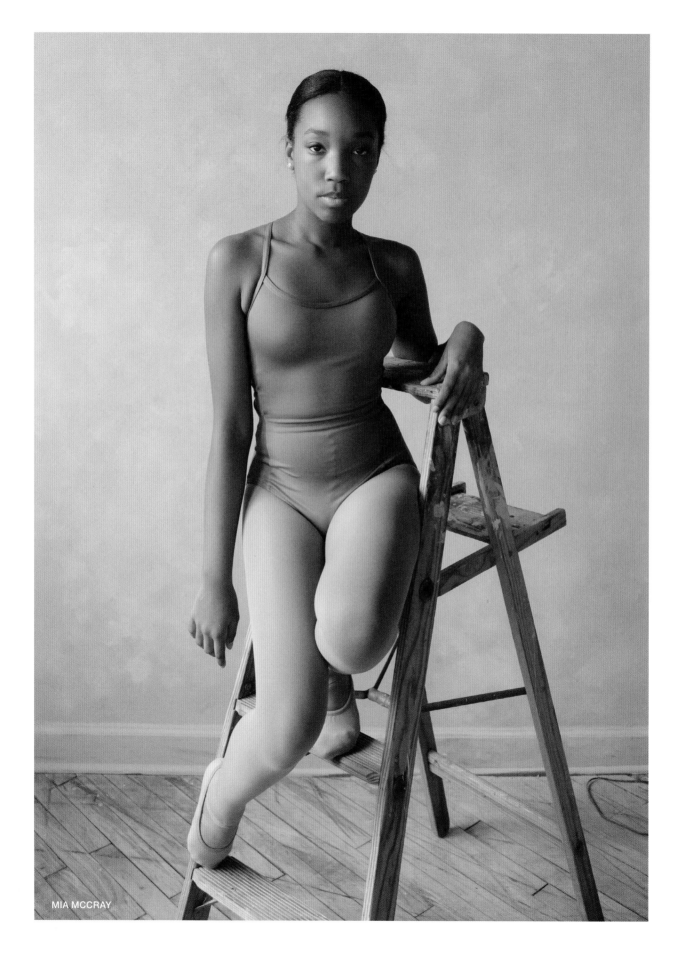

MIA MCCRAY

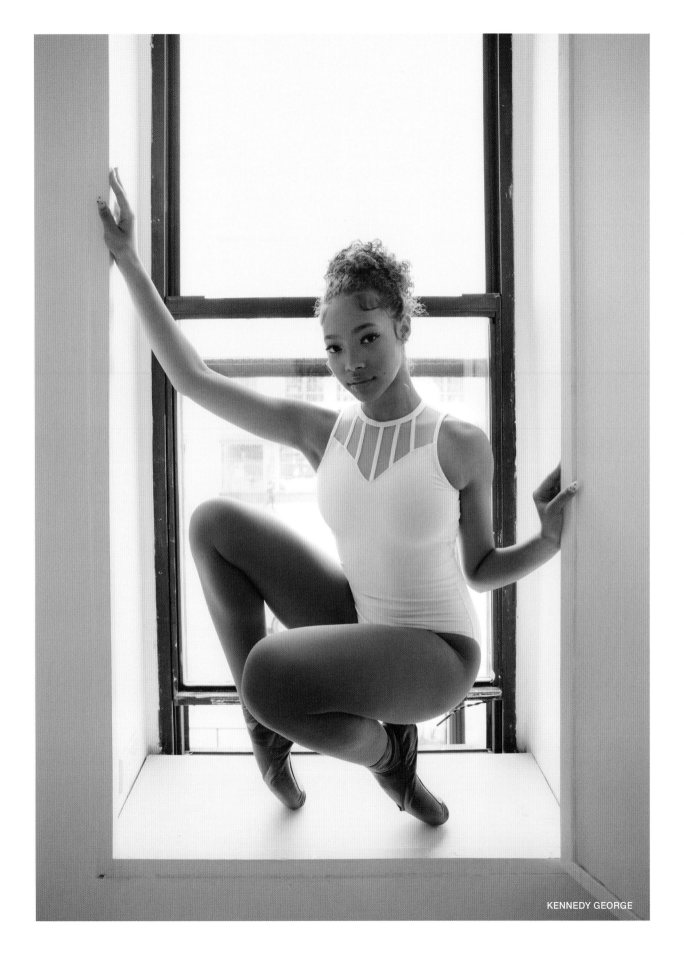

KENNEDY GEORGE

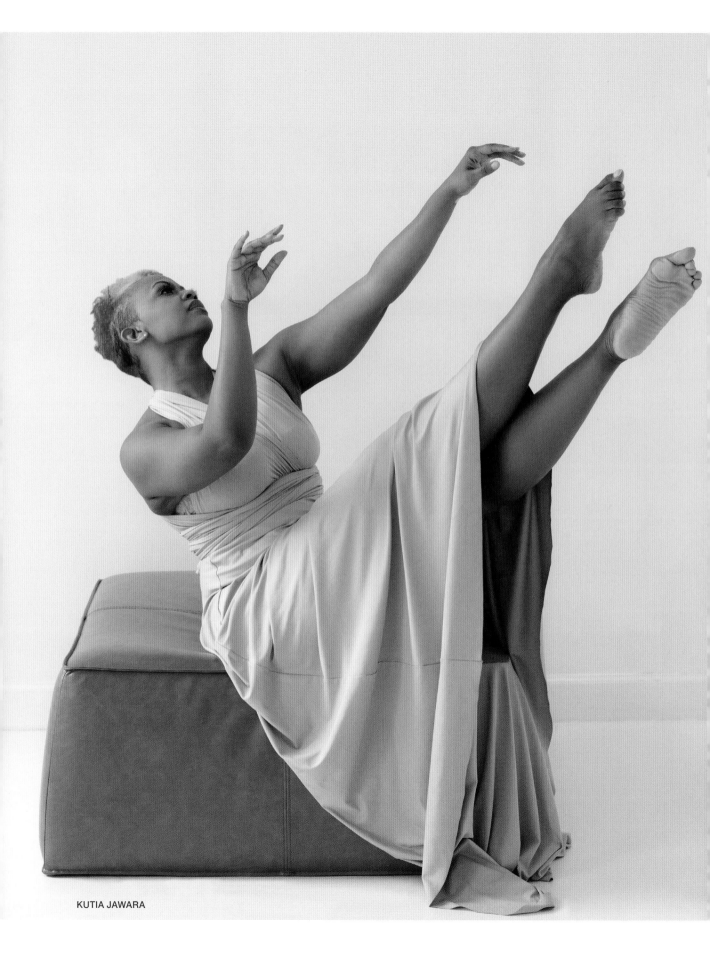

KUTIA JAWARA

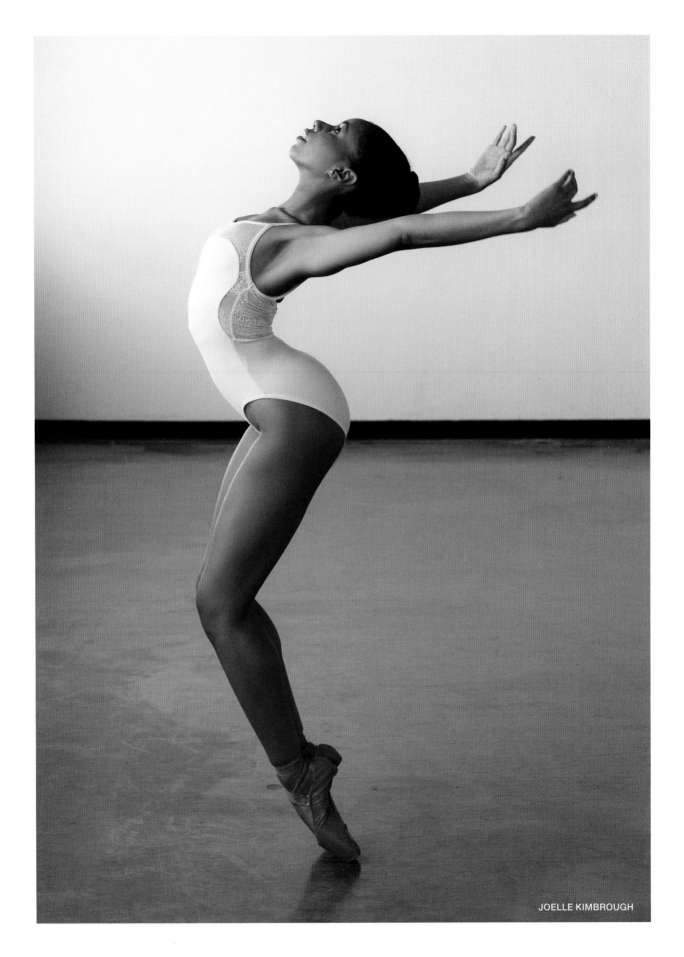

JOELLE KIMBROUGH

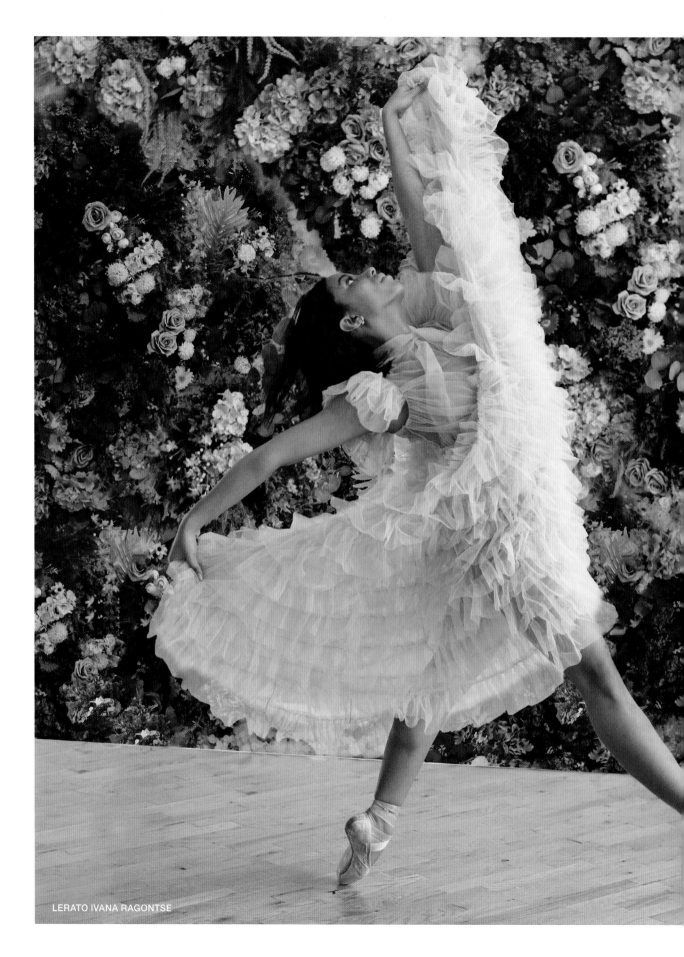

LERATO IVANA RAGONTSE

To dance is to embody what it means to be human. Telling stories in my own brown skin, hair, and strong body. To freely express who I am through movement.

—LERATO IVANA RAGONTSE

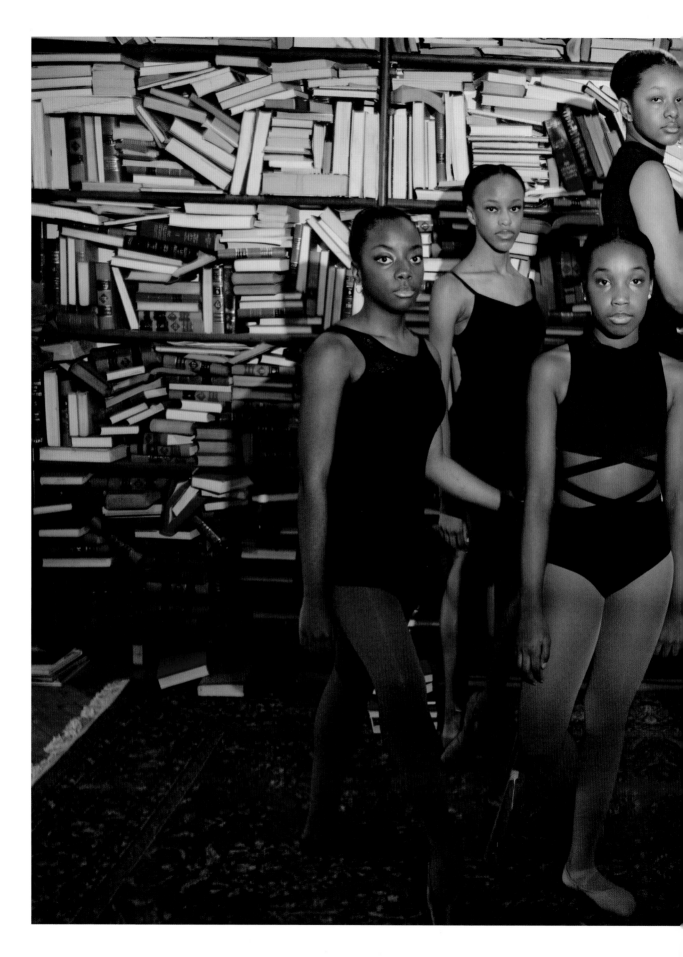

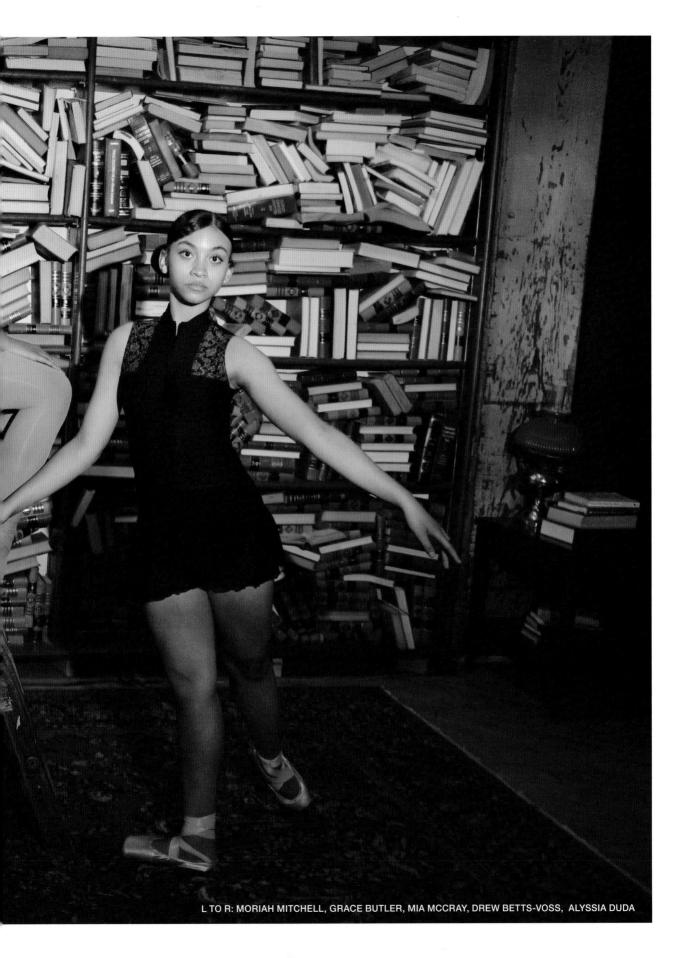

L TO R: MORIAH MITCHELL, GRACE BUTLER, MIA MCCRAY, DREW BETTS-VOSS, ALYSSIA DUDA

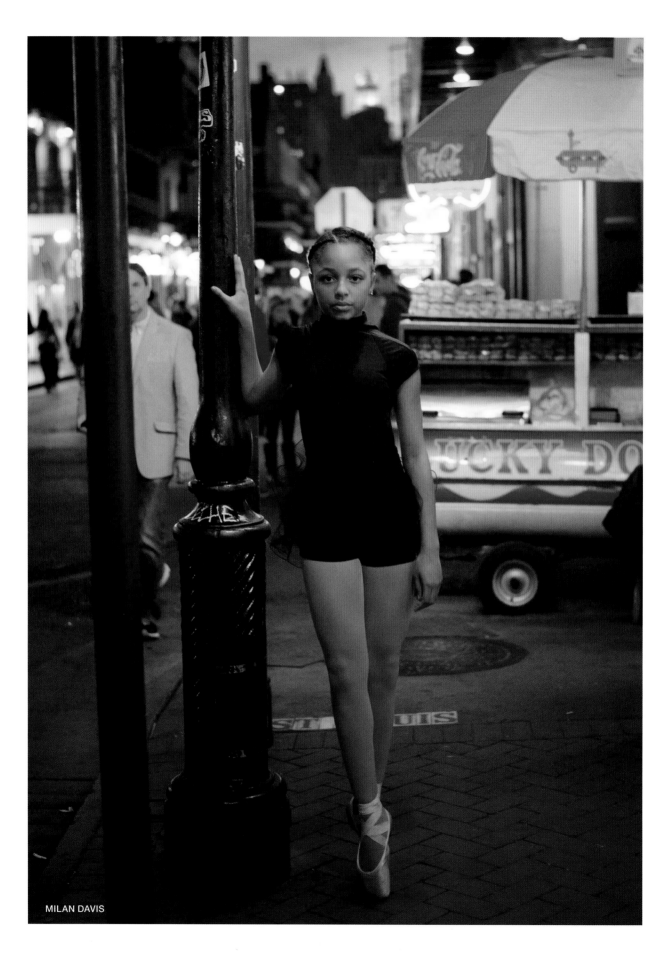

MILAN DAVIS

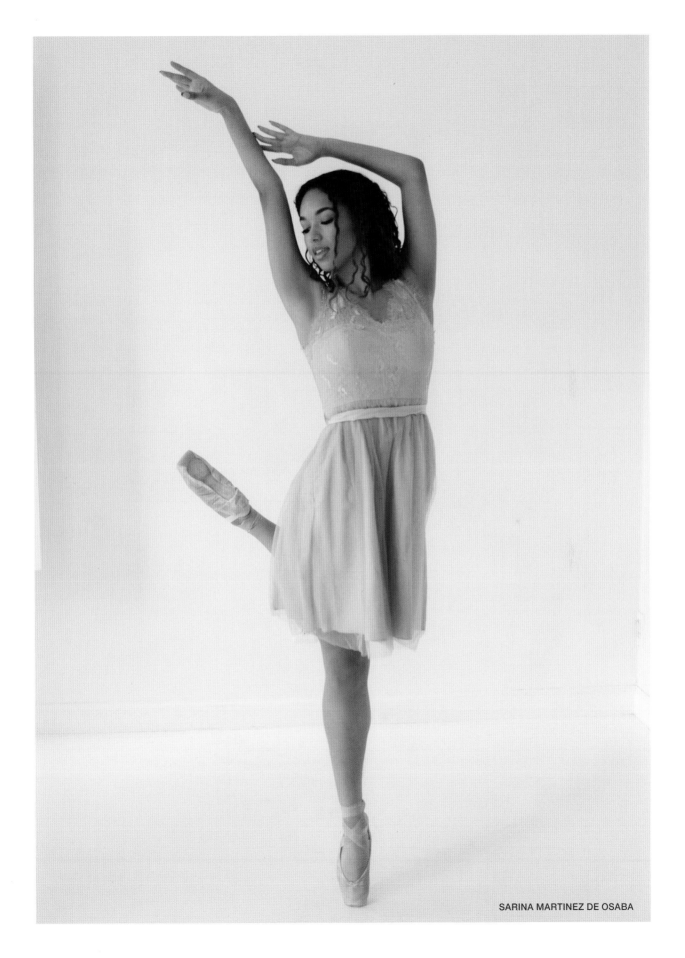

SARINA MARTINEZ DE OSABA

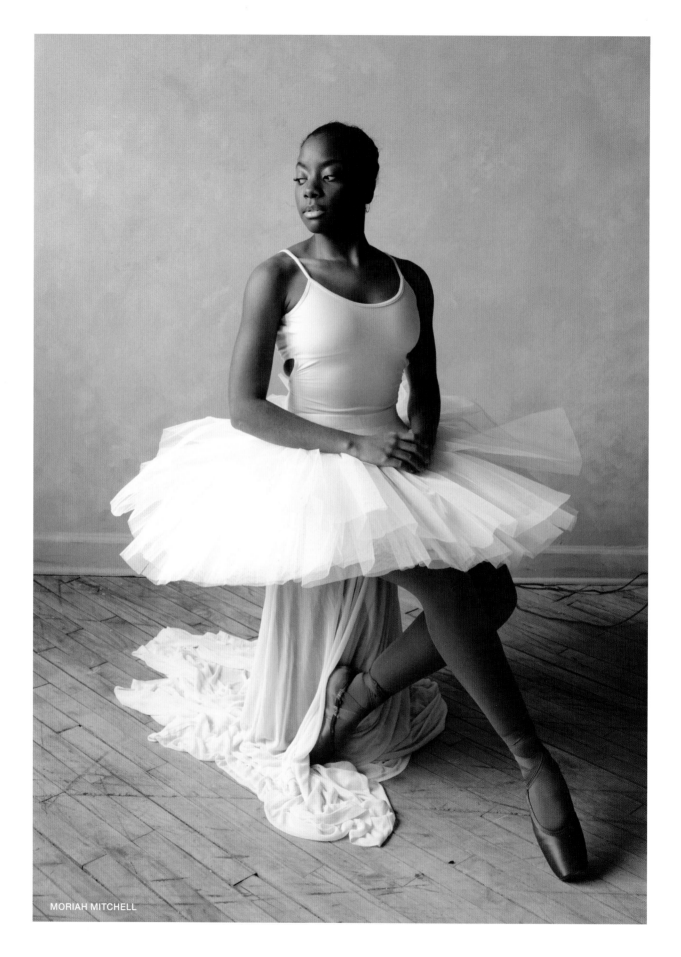

MORIAH MITCHELL

Dance is not an
activity. It is a lifestyle,
and an experience
that makes me feel
so free and confident.

—MORIAH MITCHELL

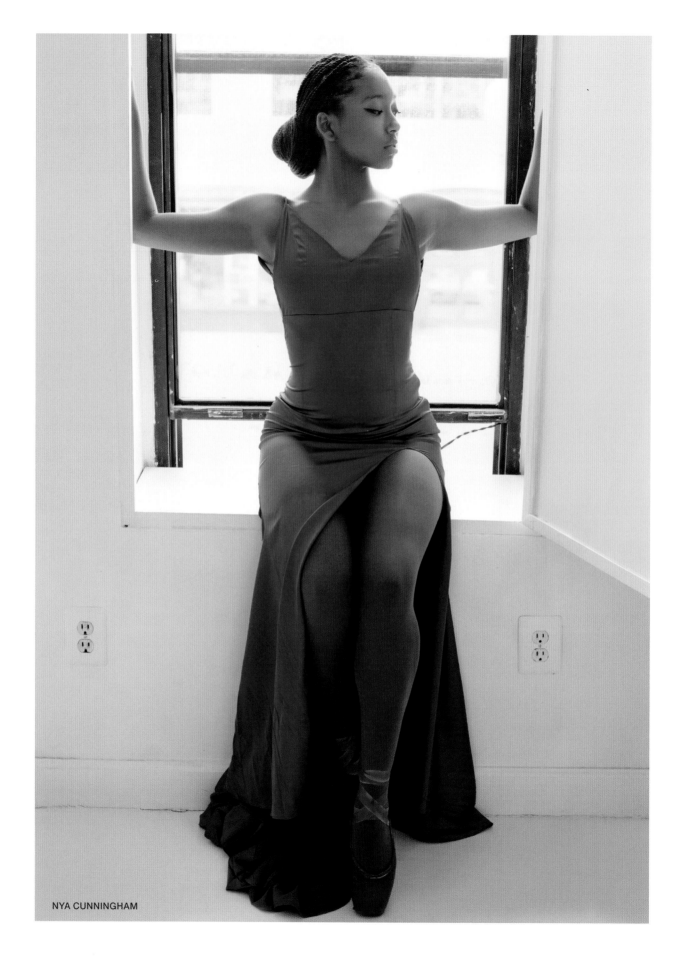

NYA CUNNINGHAM

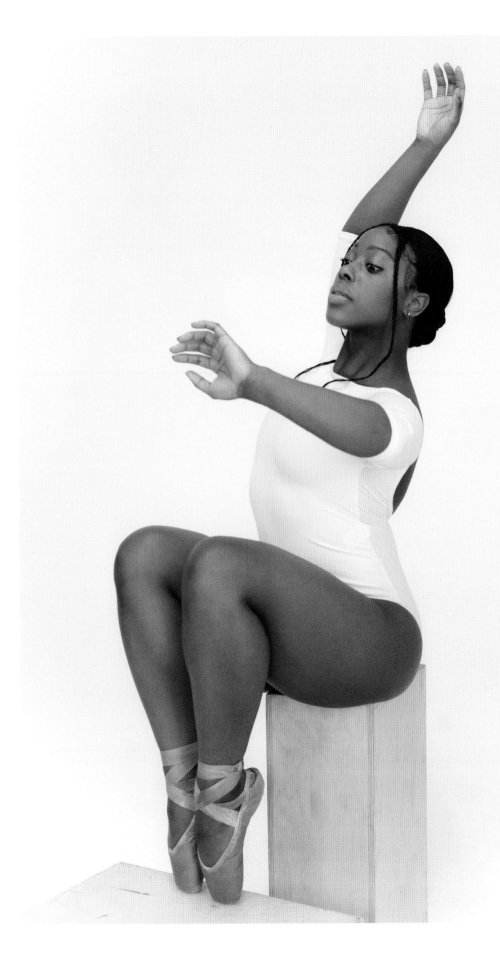

DYMON SAMARA

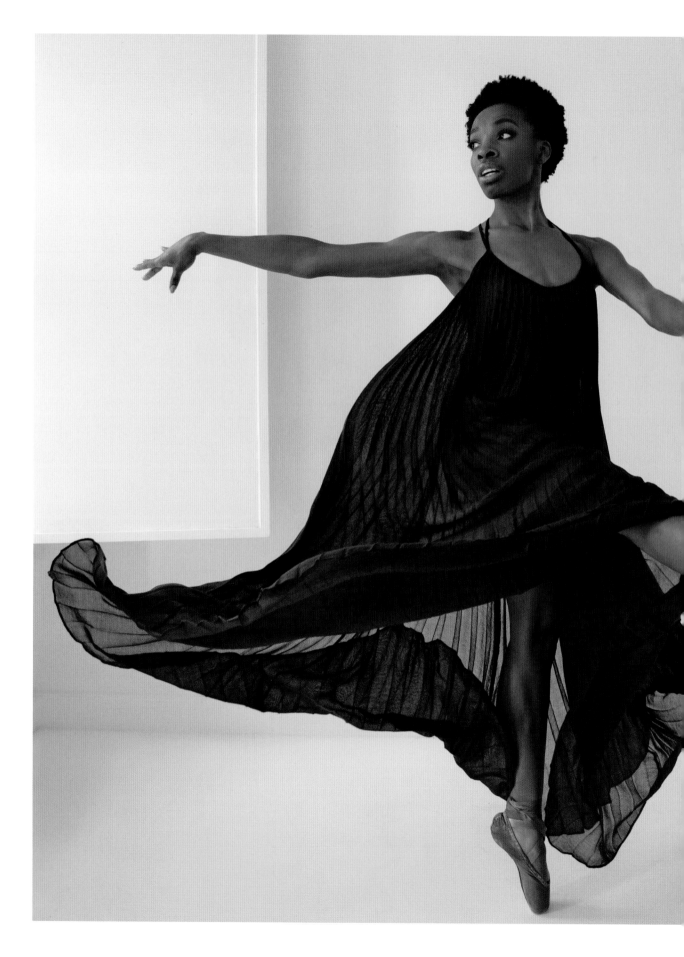

NOELLE ANCHES

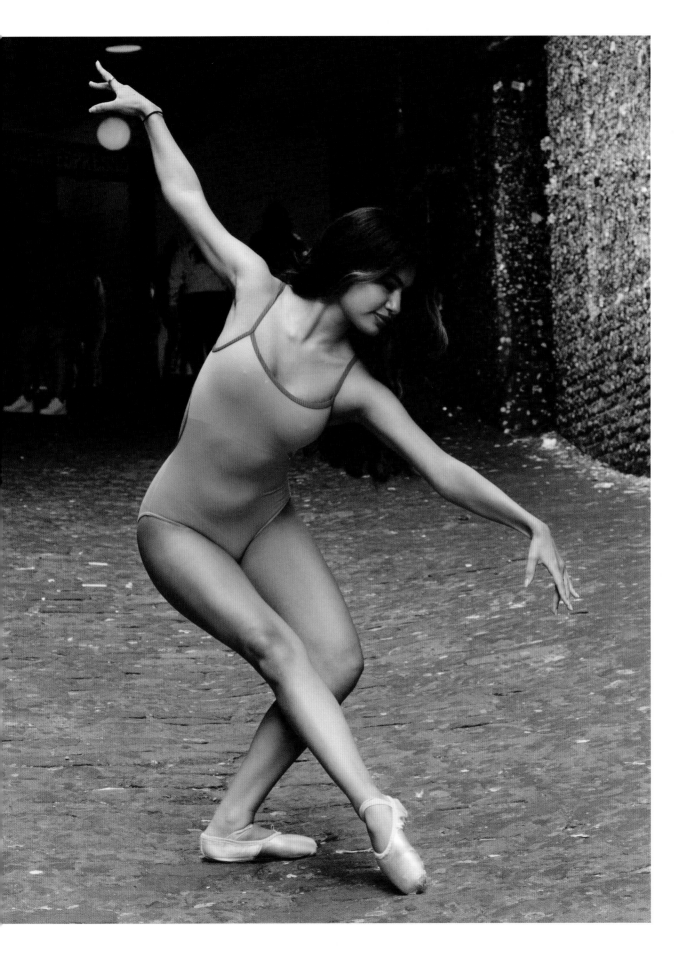

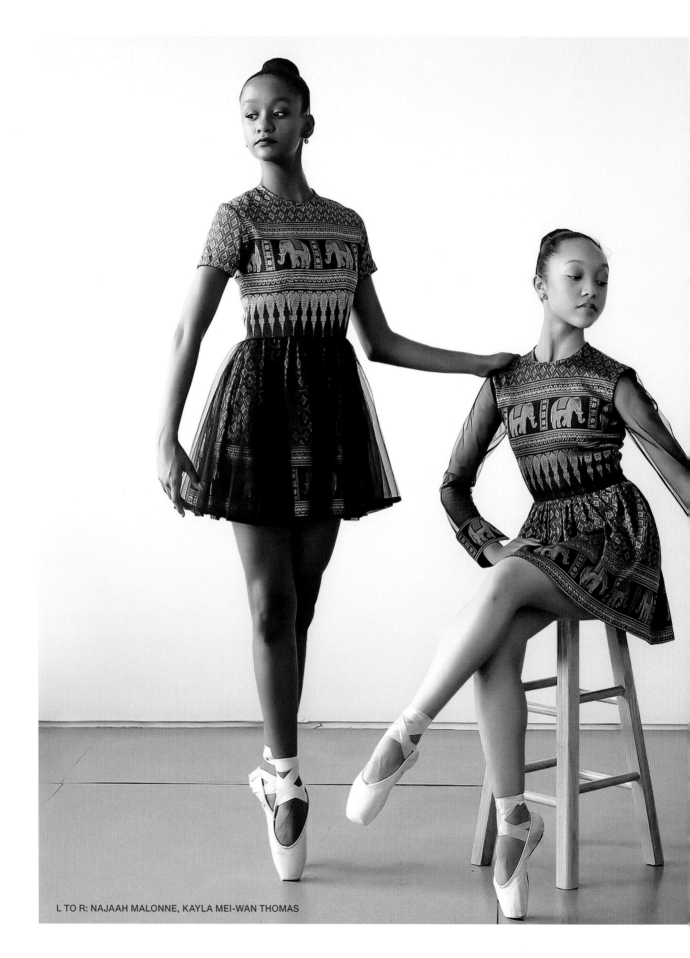

L TO R: NAJAAH MALONNE, KAYLA MEI-WAN THOMAS

Never be afraid to exude confidence
and be your unique self when you
dance because no one can take that
away from you.

—NAJAAH MALONNE

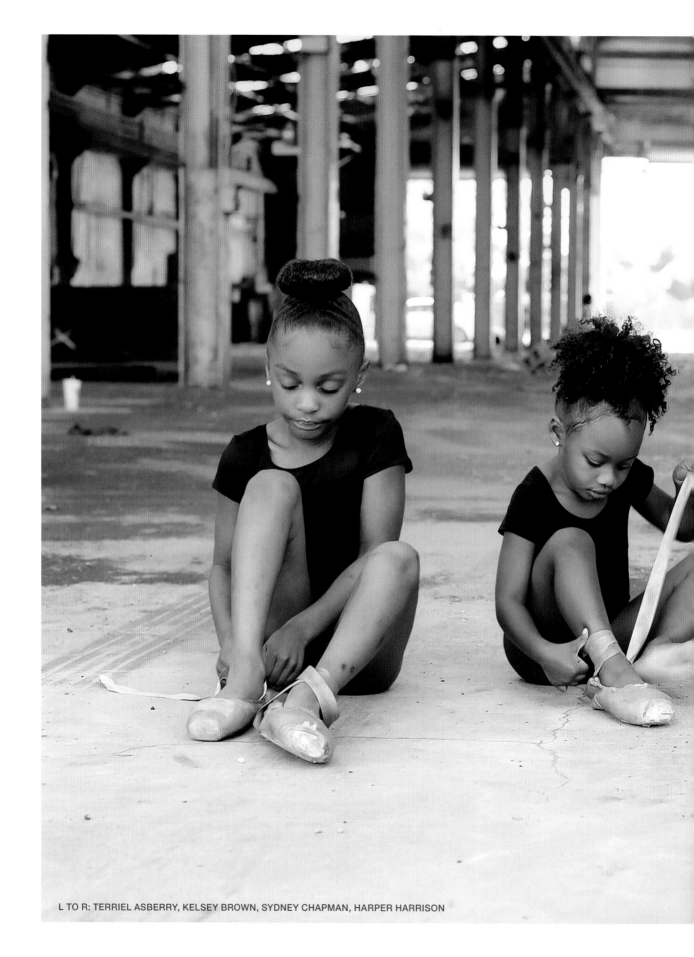

L TO R: TERRIEL ASBERRY, KELSEY BROWN, SYDNEY CHAPMAN, HARPER HARRISON

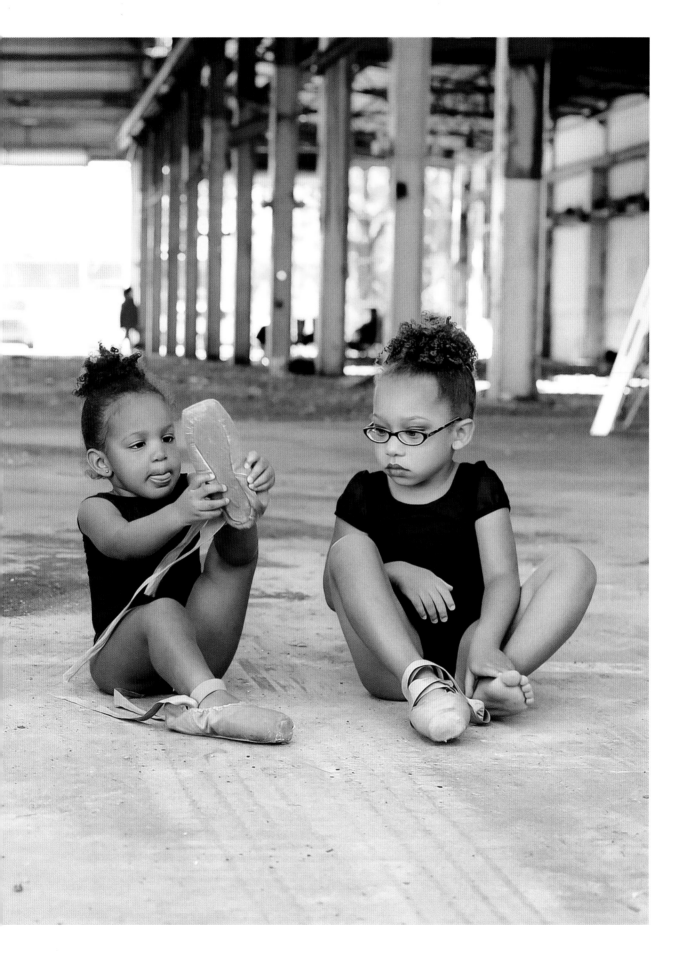

SYDNEY GUINE

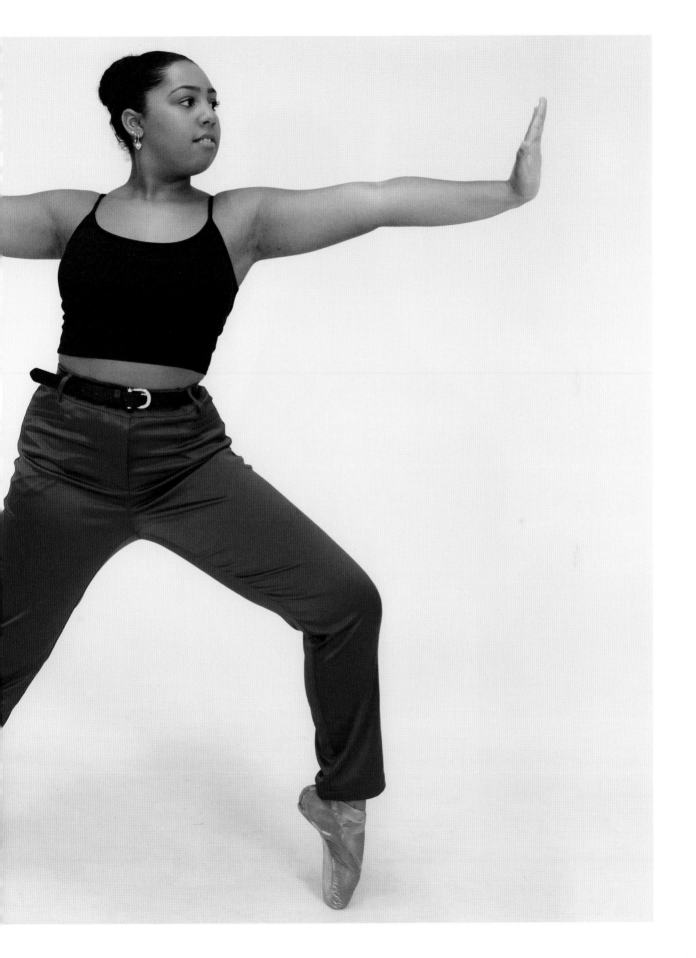

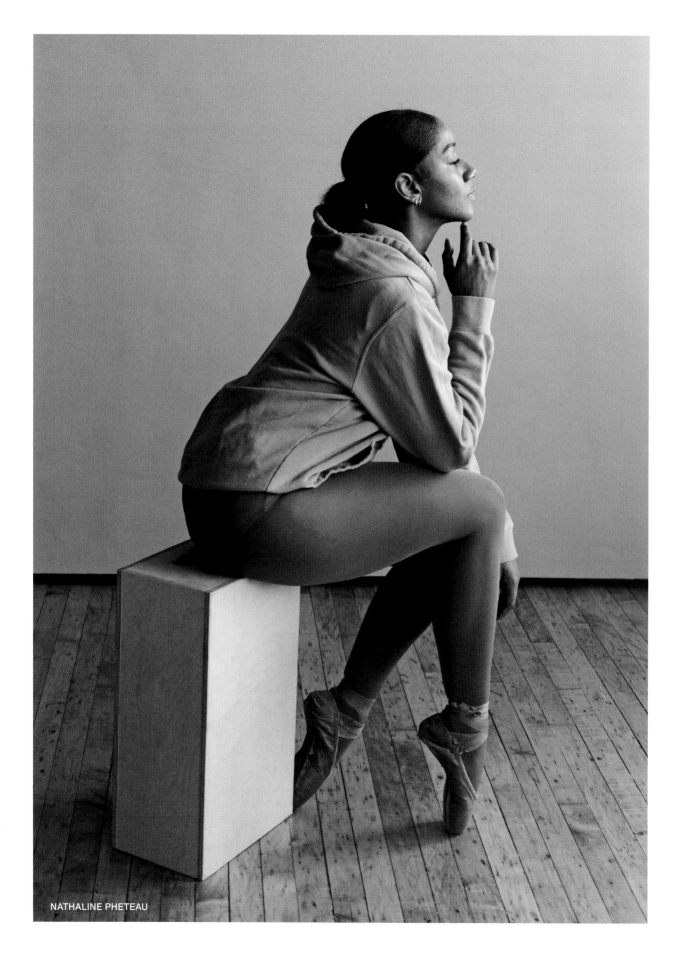
NATHALINE PHETEAU

As we make the
dance world more
inclusive, we also
need to push
the boundaries on
what it means to
look like a dancer.

—NATHALINE PHETEAU

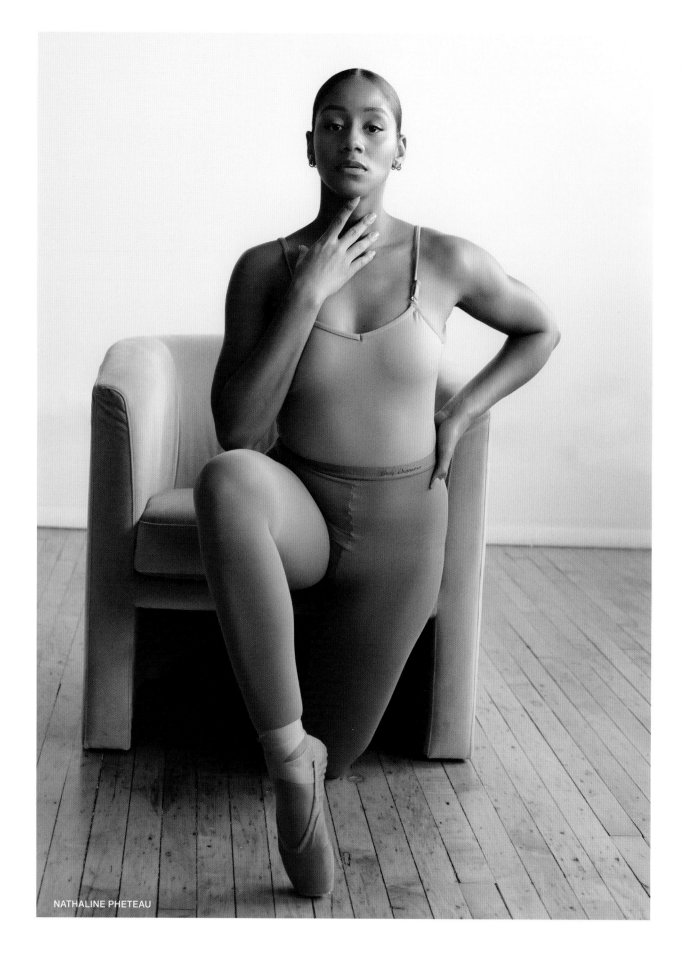

NATHALINE PHETEAU

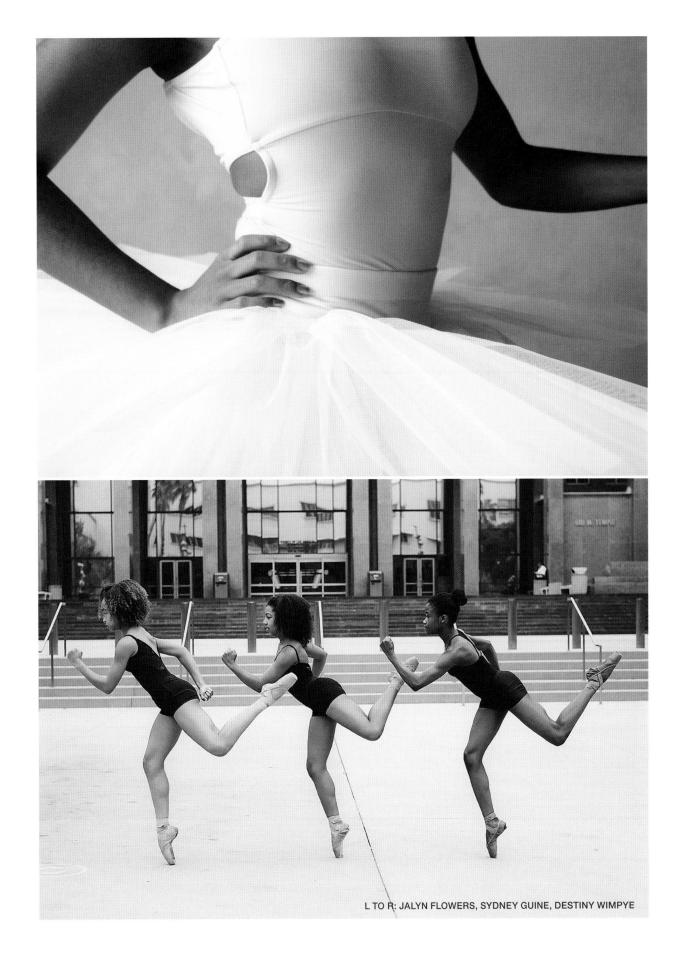

L TO R: JALYN FLOWERS, SYDNEY GUINE, DESTINY WIMPYE

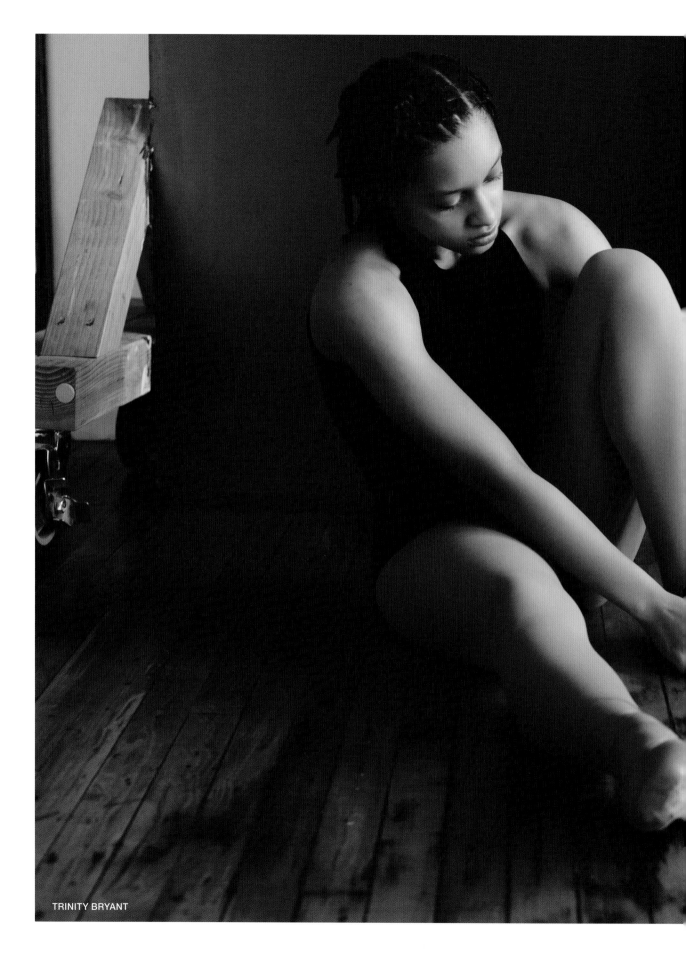

TRINITY BRYANT

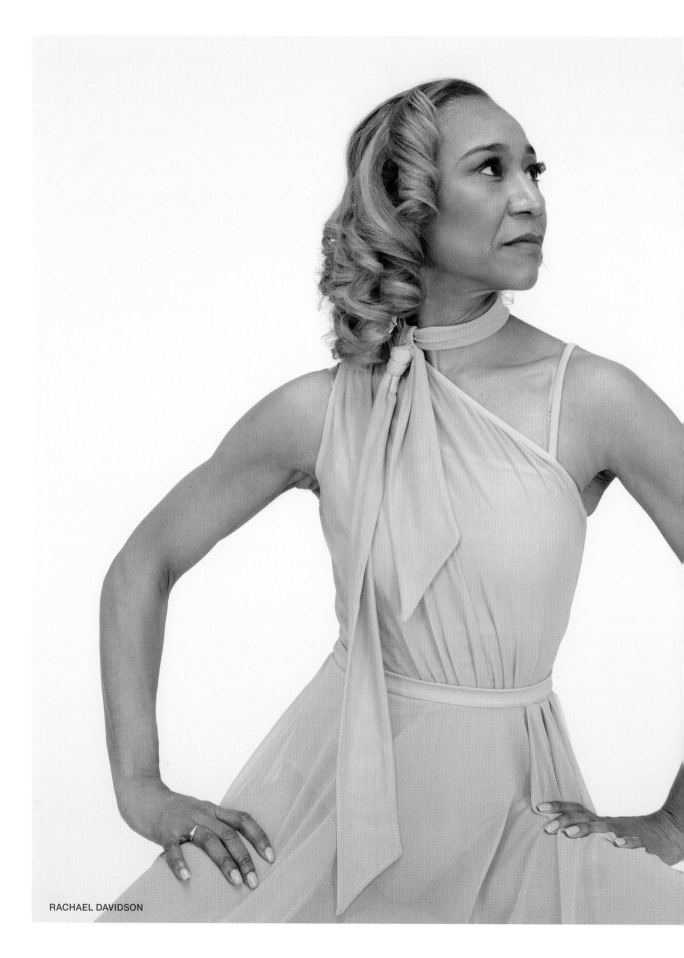
RACHAEL DAVIDSON

How does it feel to be a dancer? You're constantly challenging yourself to make each day, each movement, better than the last while pushing toward your purpose. As you mature, disappointments and defeats will be markers for success and building blocks in developing one's character.

—RACHAEL DAVIDSON

CORTNEY TAYLOR-KEY

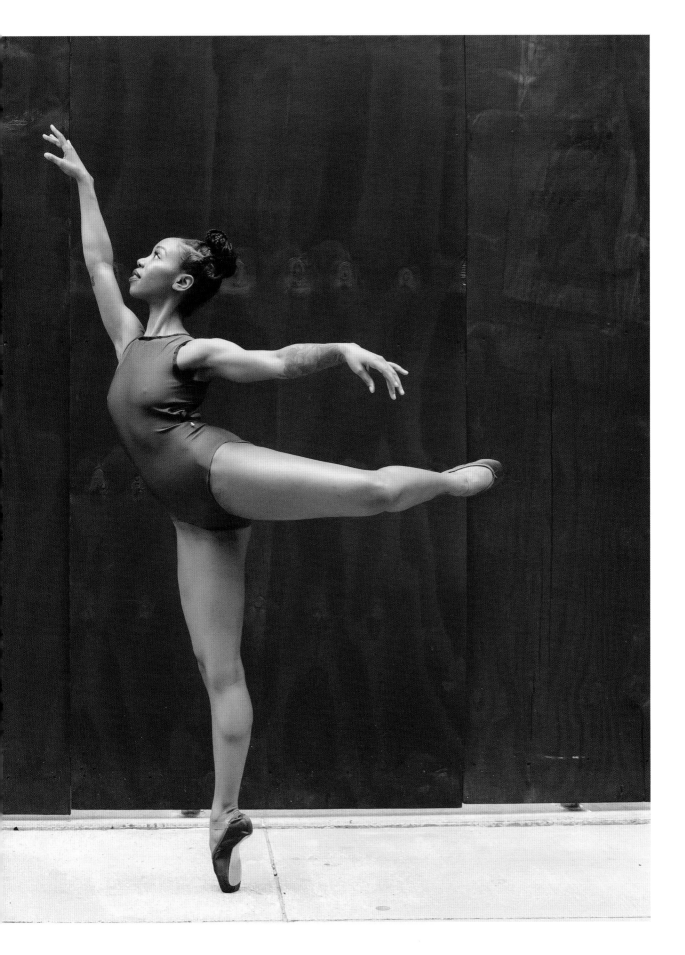

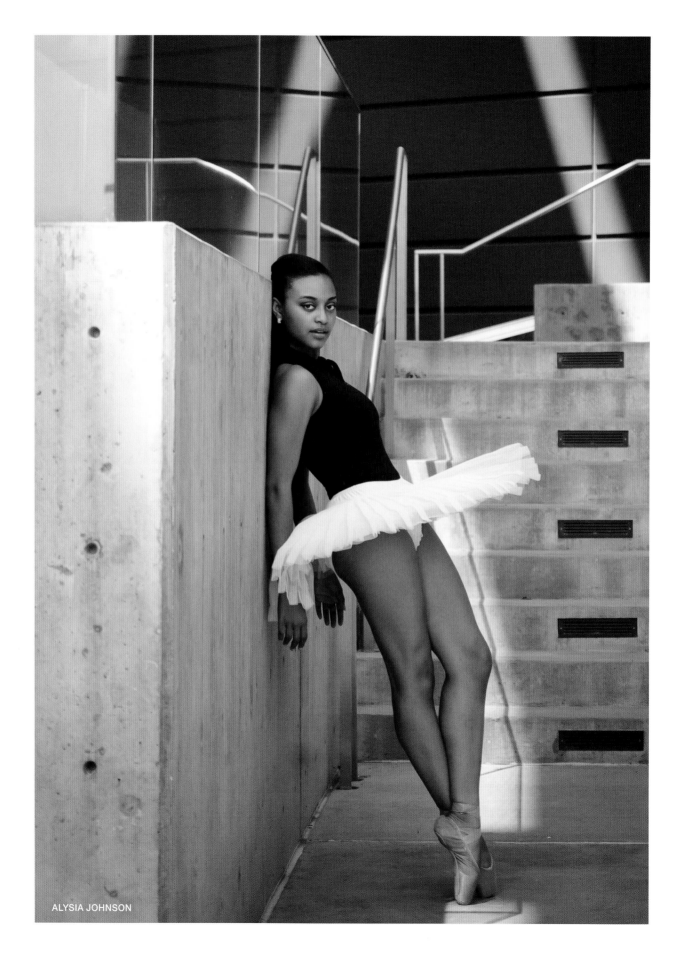

ALYSIA JOHNSON

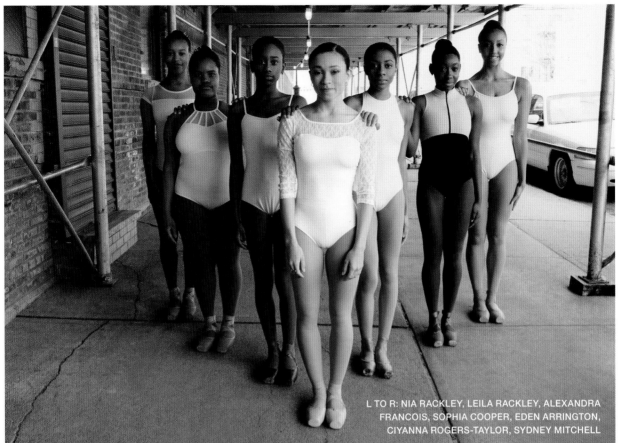

L TO R: NIA RACKLEY, LEILA RACKLEY, ALEXANDRA FRANCOIS, SOPHIA COOPER, EDEN ARRINGTON, CIYANNA ROGERS-TAYLOR, SYDNEY MITCHELL

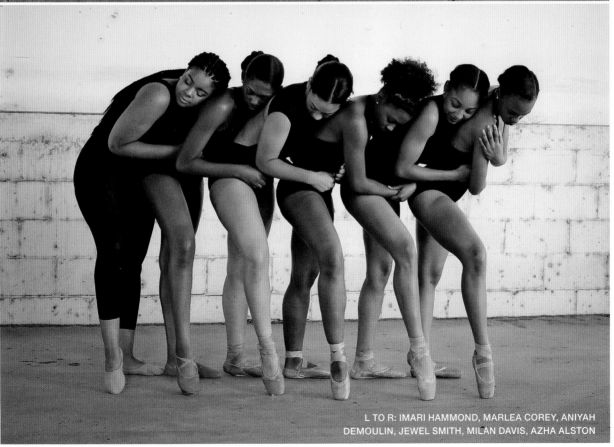

L TO R: IMARI HAMMOND, MARLEA COREY, ANIYAH DEMOULIN, JEWEL SMITH, MILAN DAVIS, AZHA ALSTON

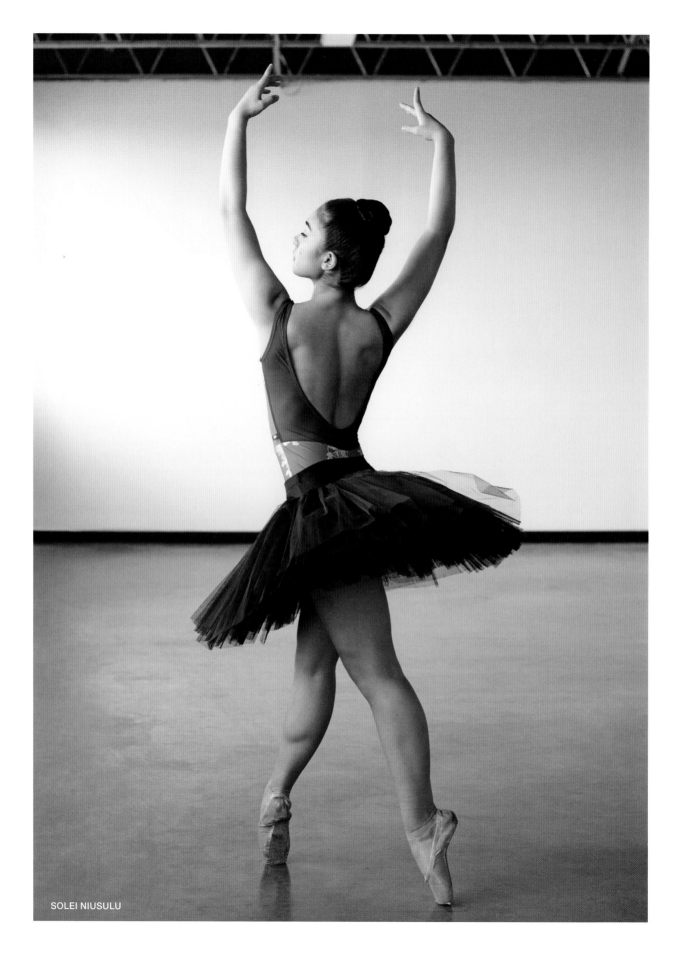

SOLEI NIUSULU

Being an ambassador
for Brown Girls Do
Ballet has helped
me learn to embrace
my differences, and
to be confident in
them. I'm proud to be
a Samoan ballerina
and can't wait to see
more diversity in the
ballet world.

—SOLEI NIUSULU

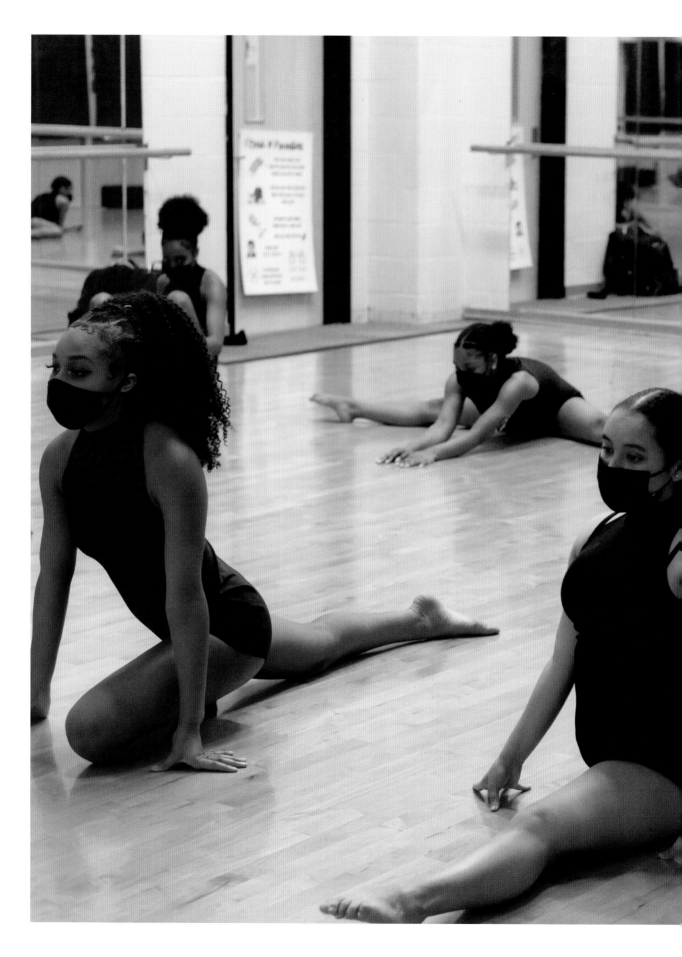

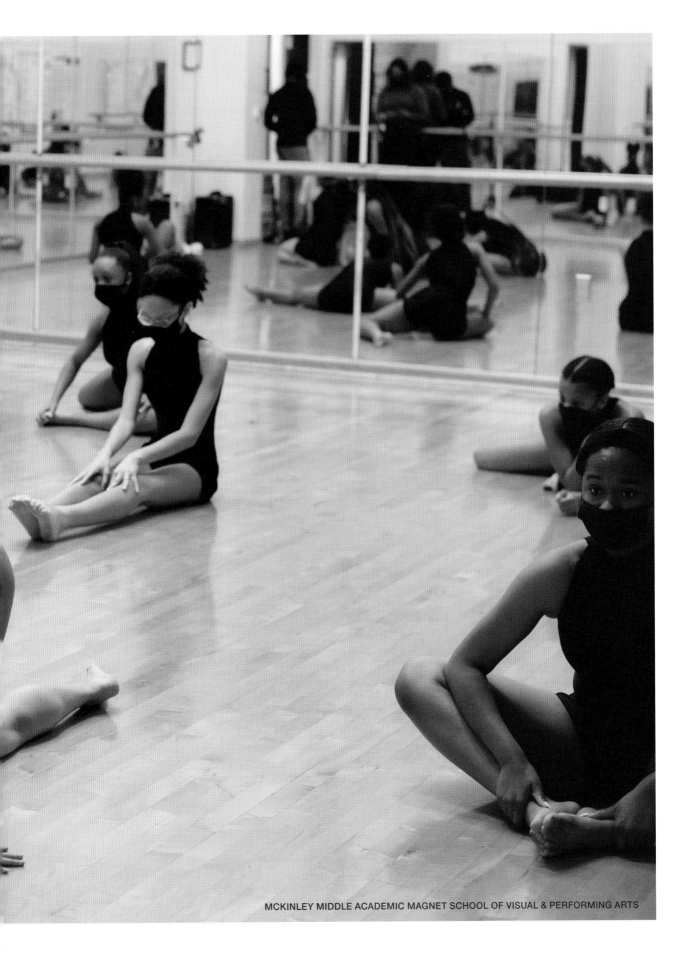

MCKINLEY MIDDLE ACADEMIC MAGNET SCHOOL OF VISUAL & PERFORMING ARTS

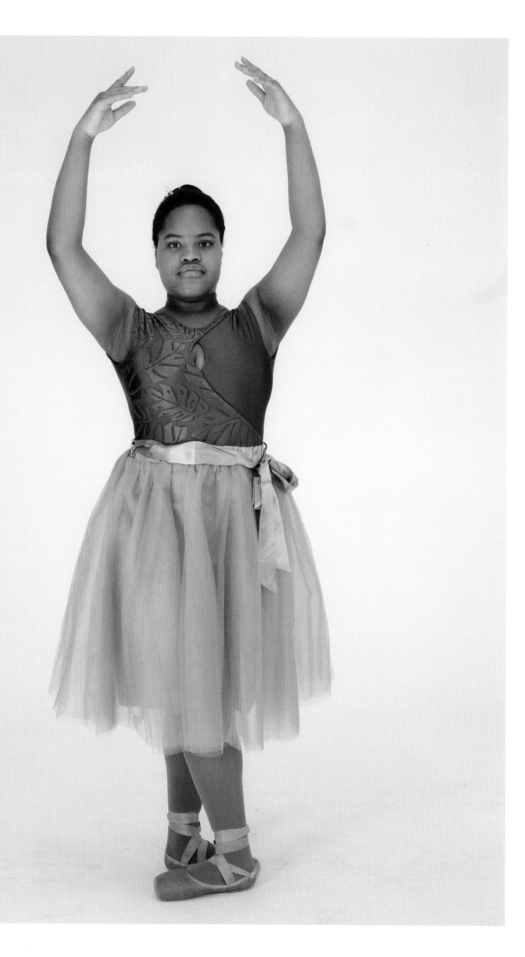

LEILA RACKLEY

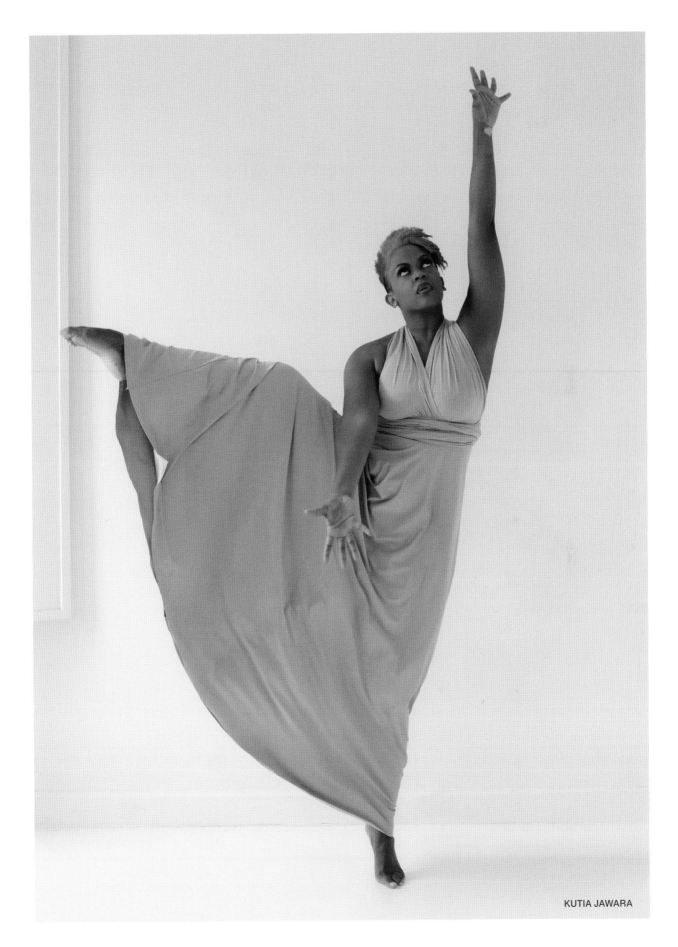

KUTIA JAWARA

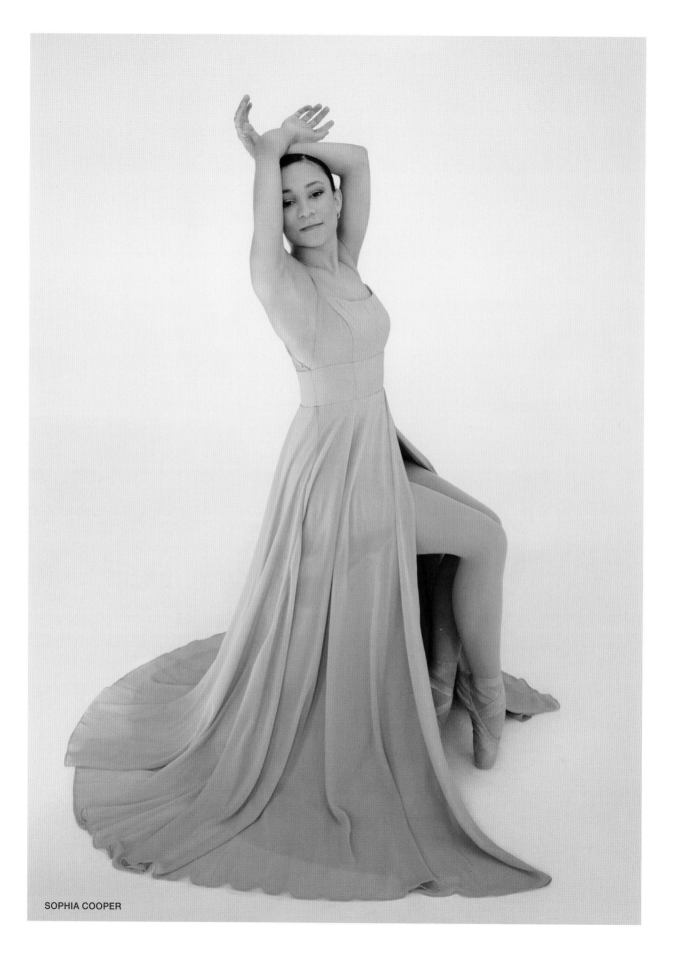

SOPHIA COOPER

Being a dancer has always been a special thing for me, but it wasn't until I got older that I realized how much more special it is to be a dancer of color.

—SOPHIA COOPER

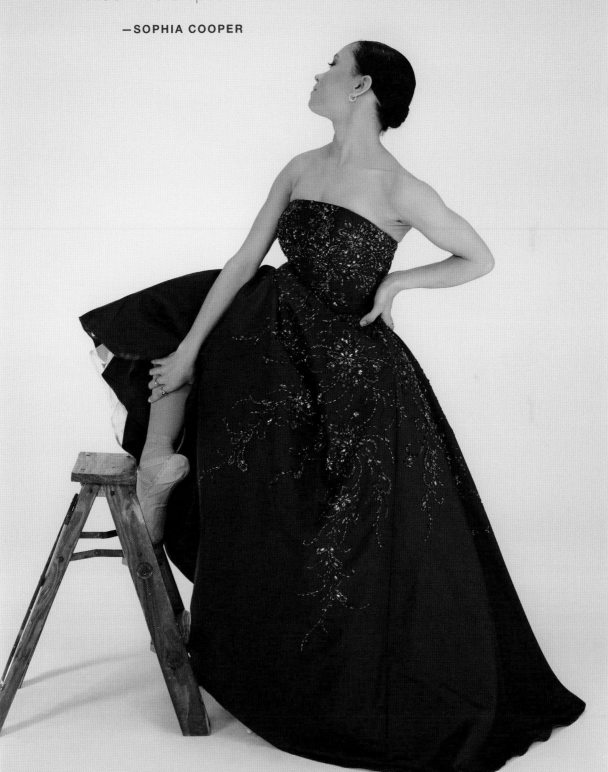

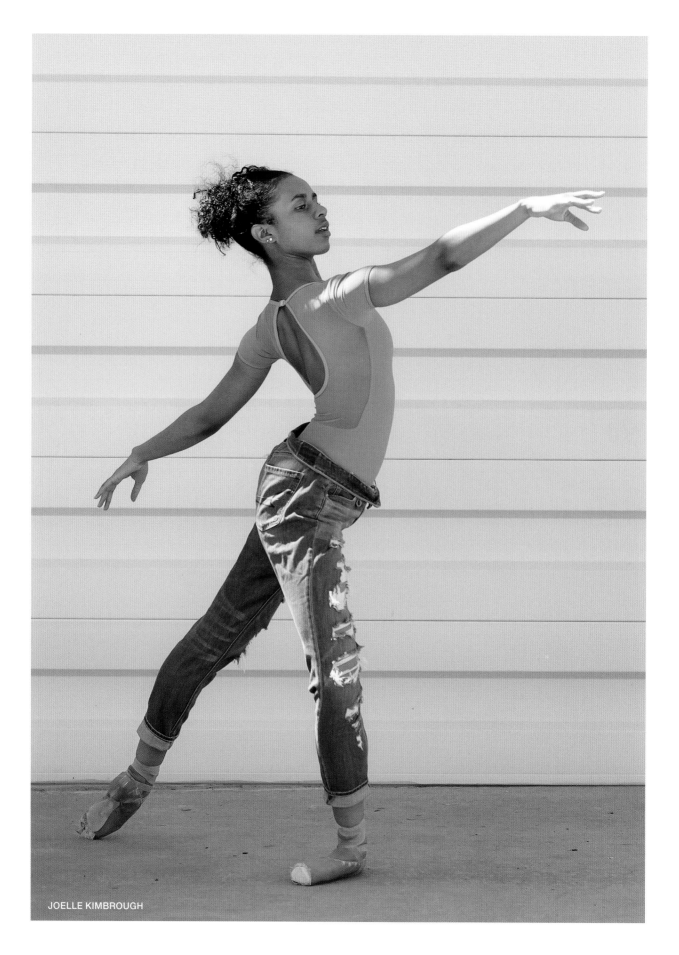

JOELLE KIMBROUGH

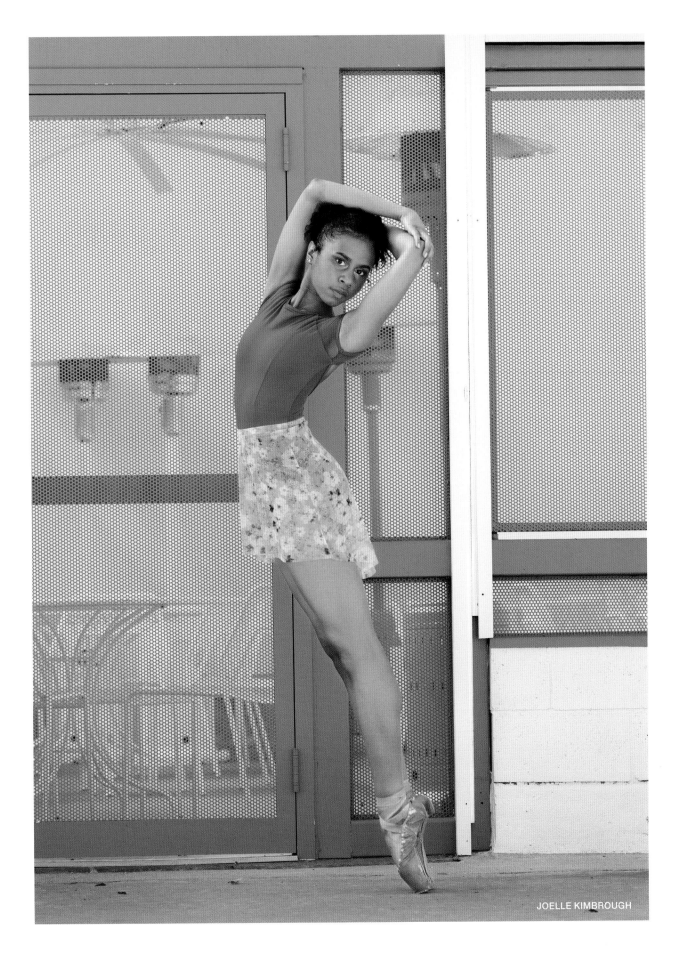

JOELLE KIMBROUGH

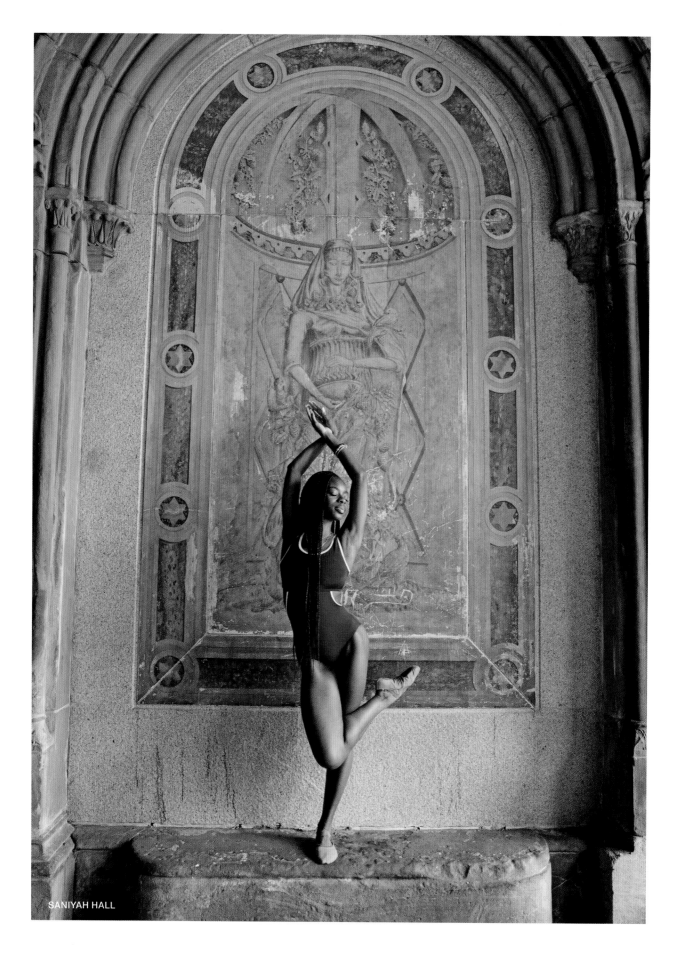

SANIYAH HALL

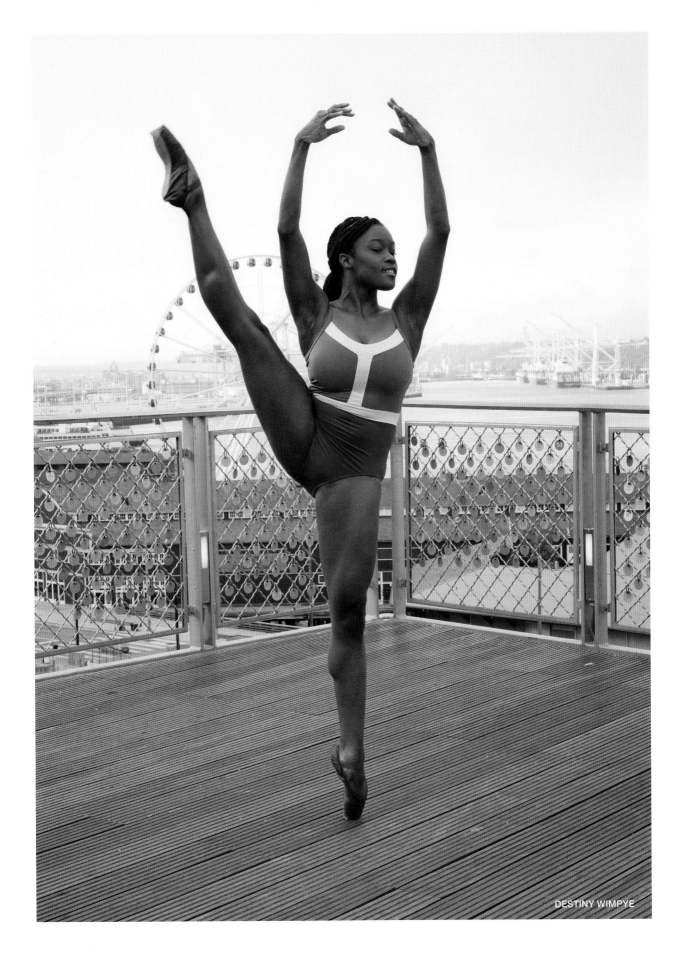

DESTINY WIMPYE

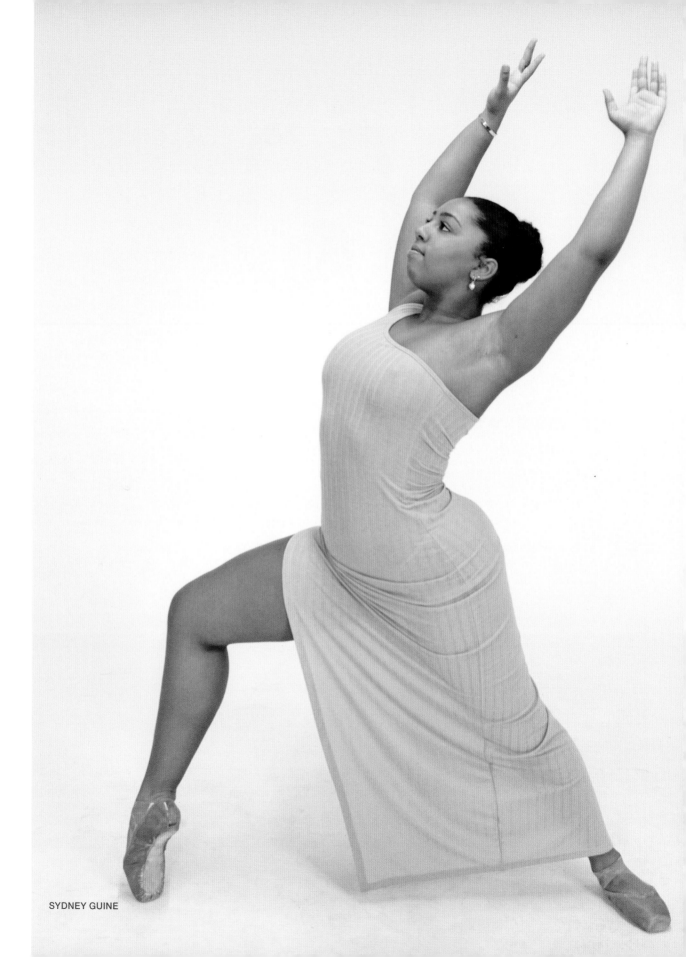

SYDNEY GUINE

The dance world is very judgmental, but as long
as I don't judge myself, that's the most important
step. Loving yourself is much more important than
leaning on others to love you. This has been one
of the most important lessons I have had to learn
as a Black dancer.

—SYDNEY GUINE

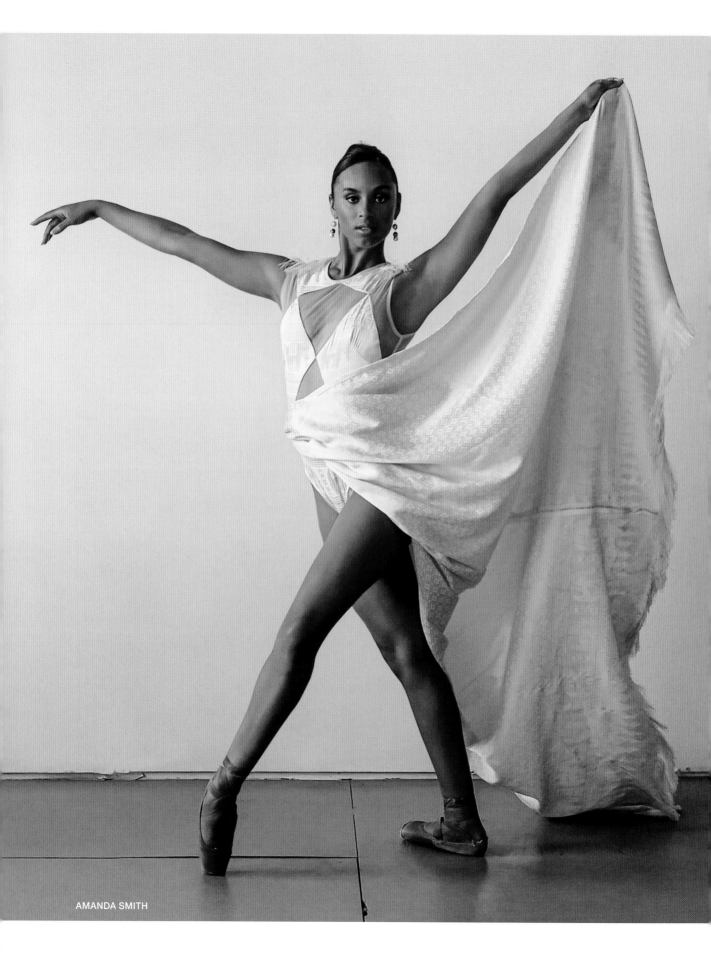

AMANDA SMITH

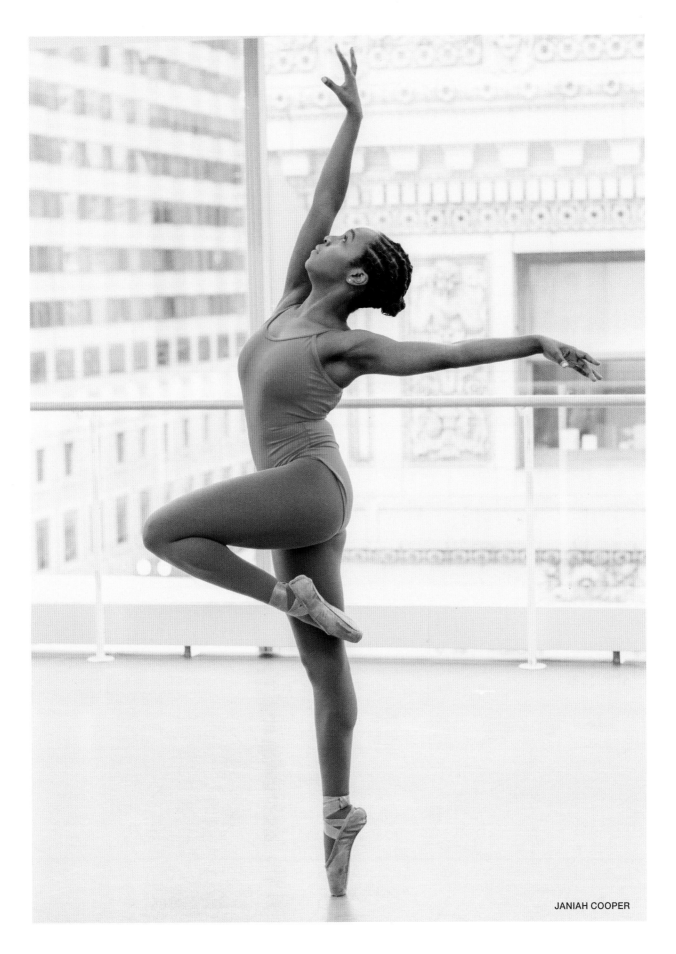

JANIAH COOPER

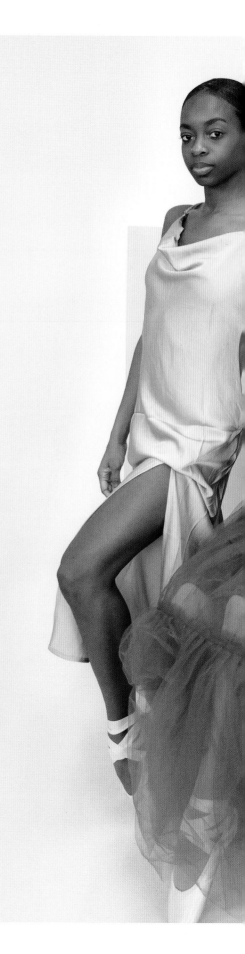

L TO R: SANIYAH HALL, ARLENE LIZARES, RACHAEL DAVIDSON, DYMON SAMARA

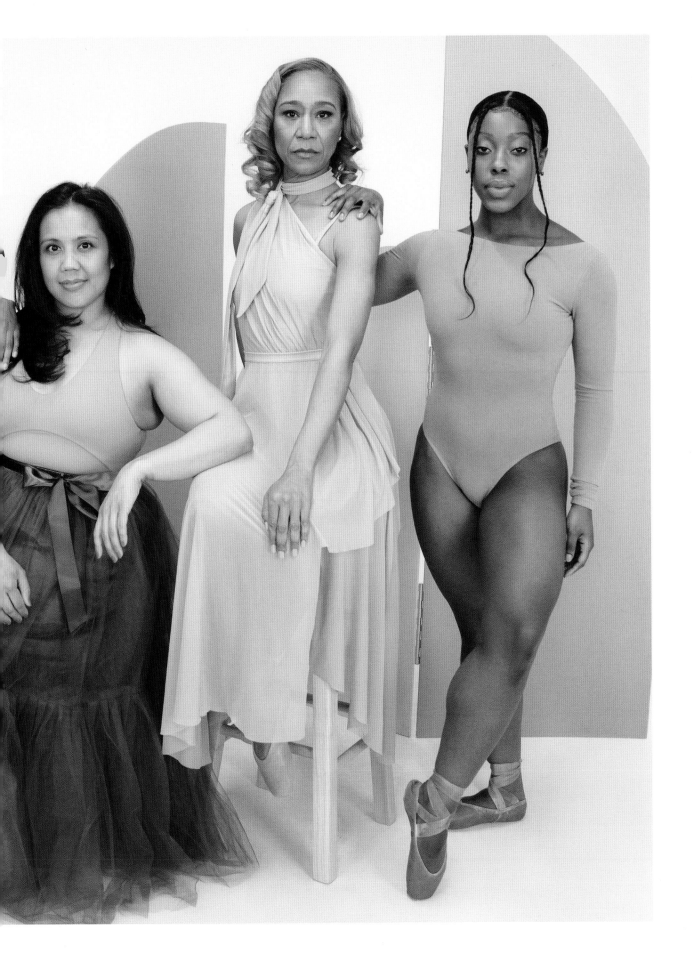

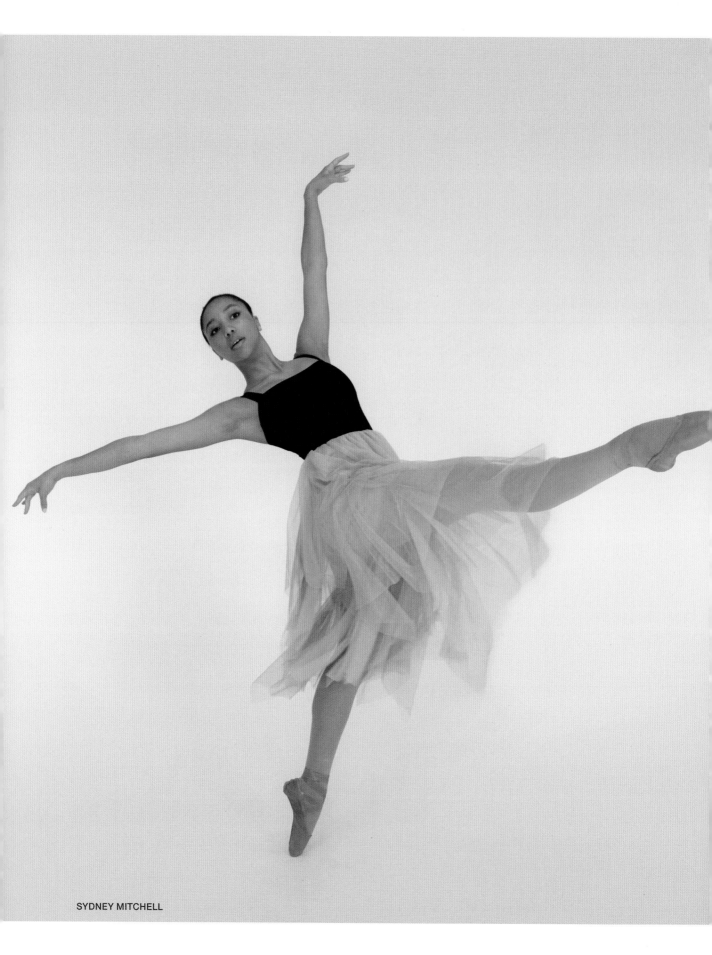

SYDNEY MITCHELL

I love dancing because it allows me to create an expressive energy, and I think that process is challenging yet beautiful.

—SYDNEY MITCHELL

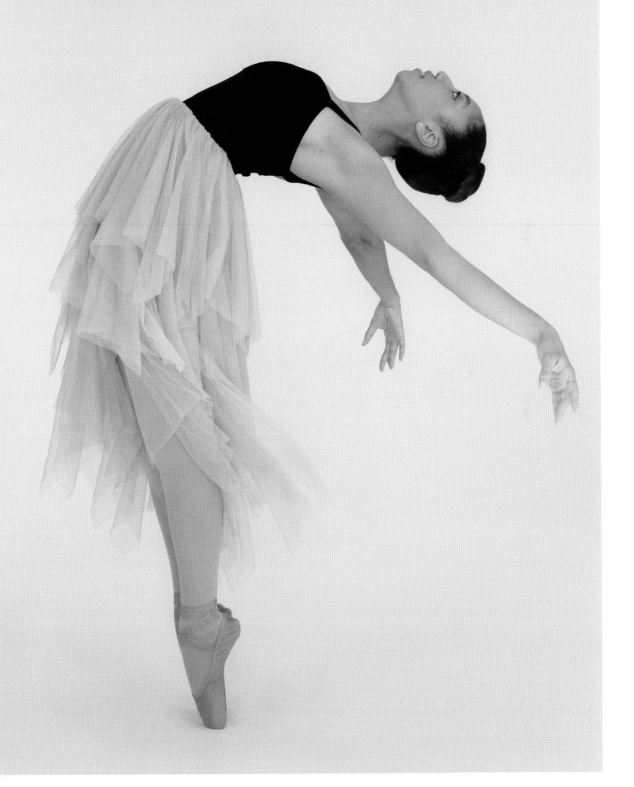

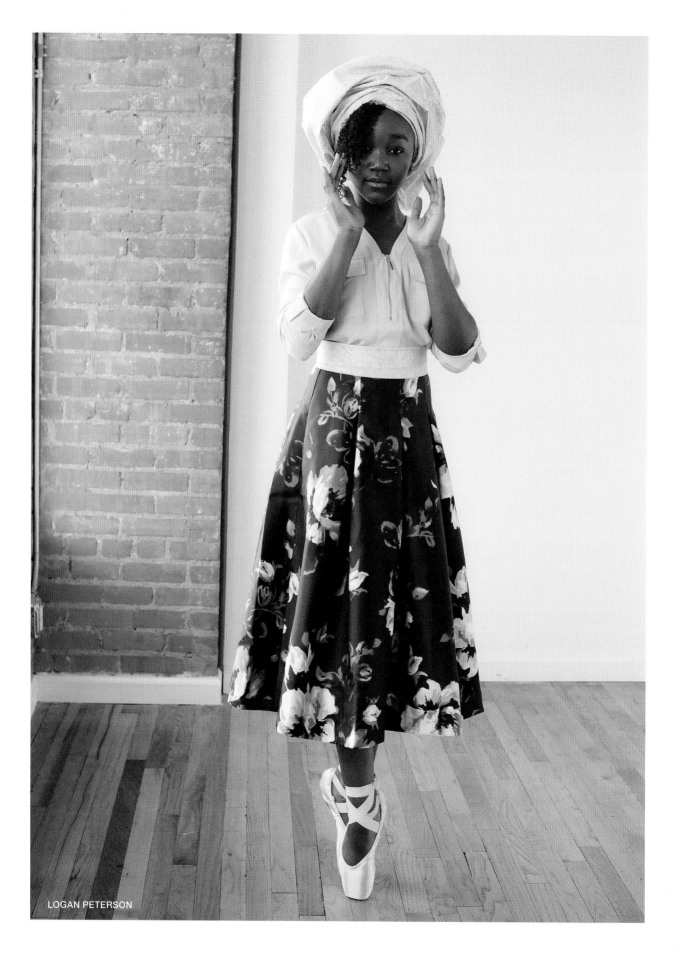

LOGAN PETERSON

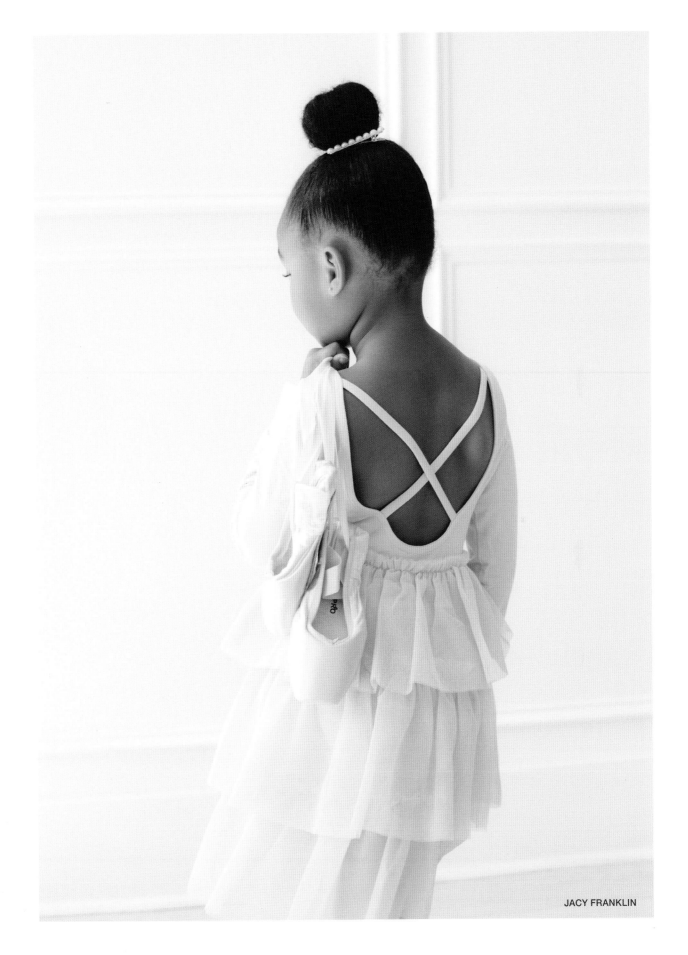

JACY FRANKLIN

NAJAAH MALONNE

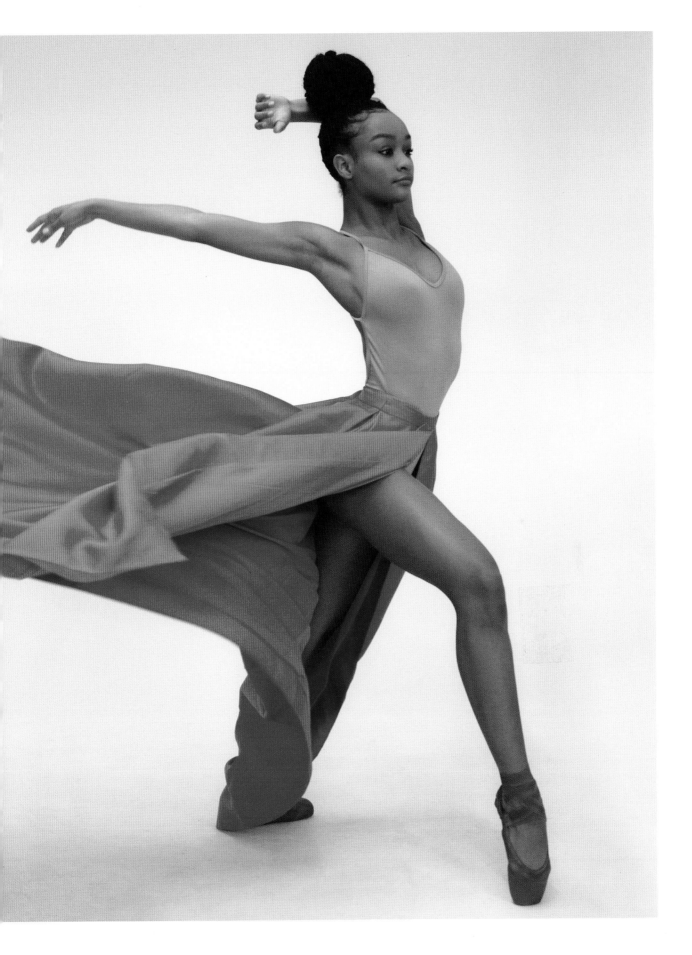

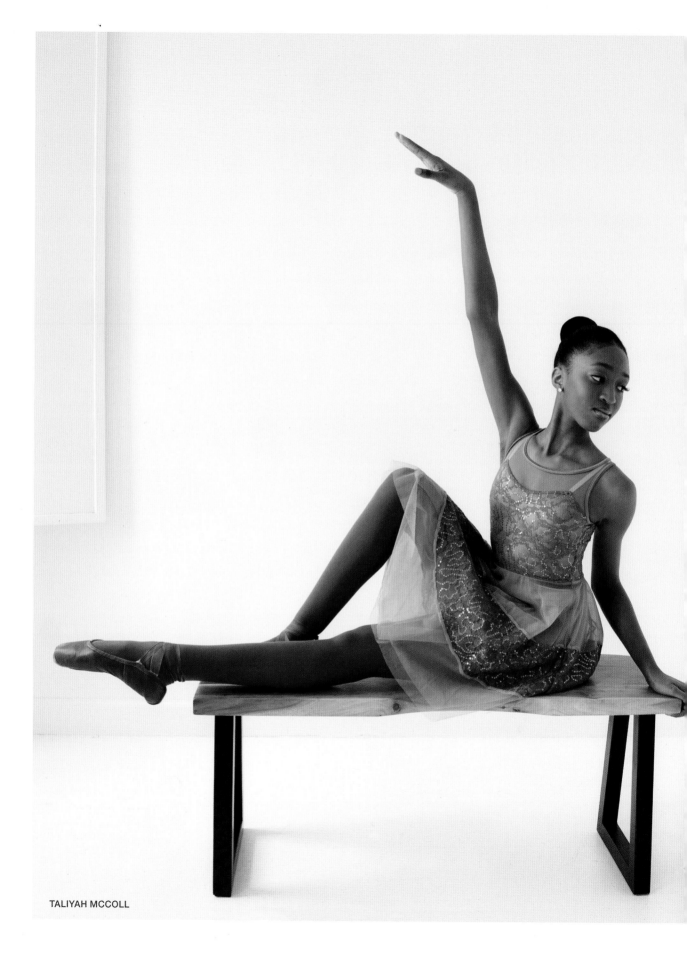

TALIYAH MCCOLL

Being a dancer means a lot to me. Dance is a way that I can stay healthy mentally and physically, while still doing something that I love. It also means that I can speak my emotions without having to say a word.

—TALIYAH MCCOLL

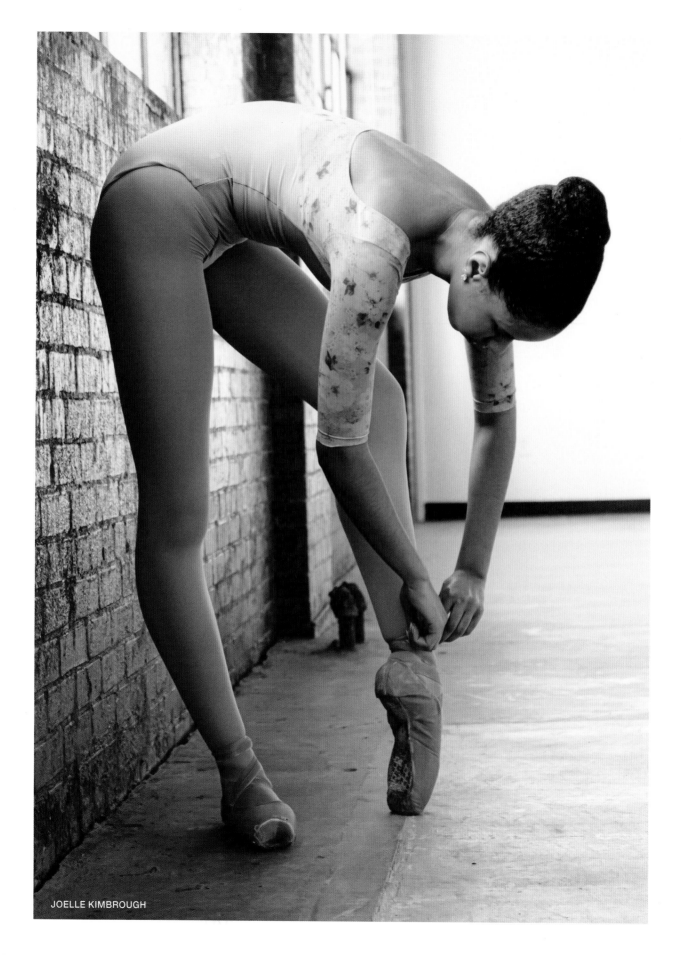

JOELLE KIMBROUGH

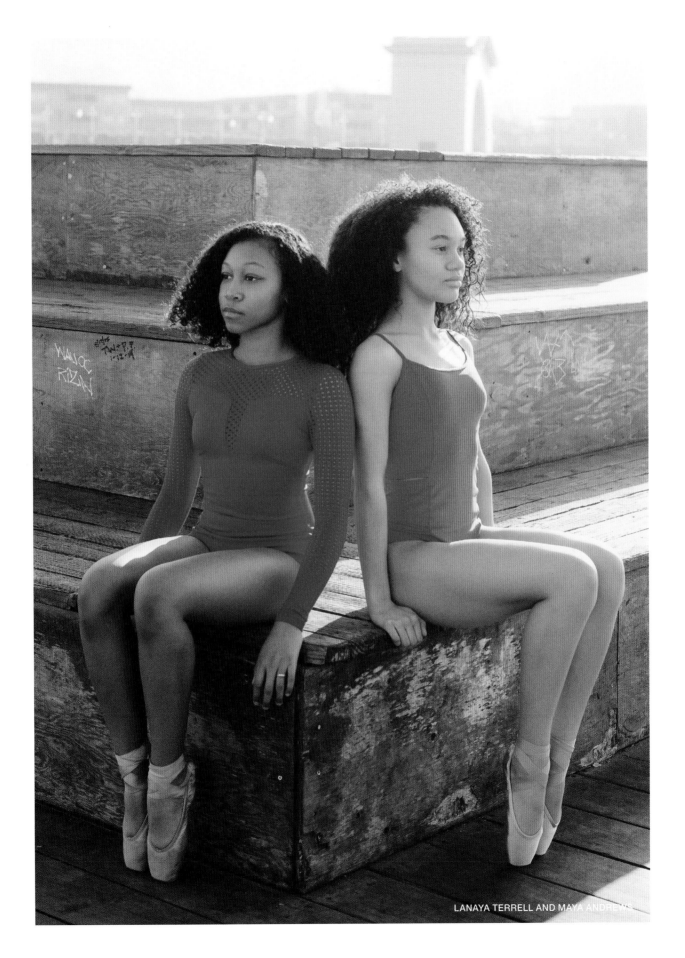

LANAYA TERRELL AND MAYA ANDREWS

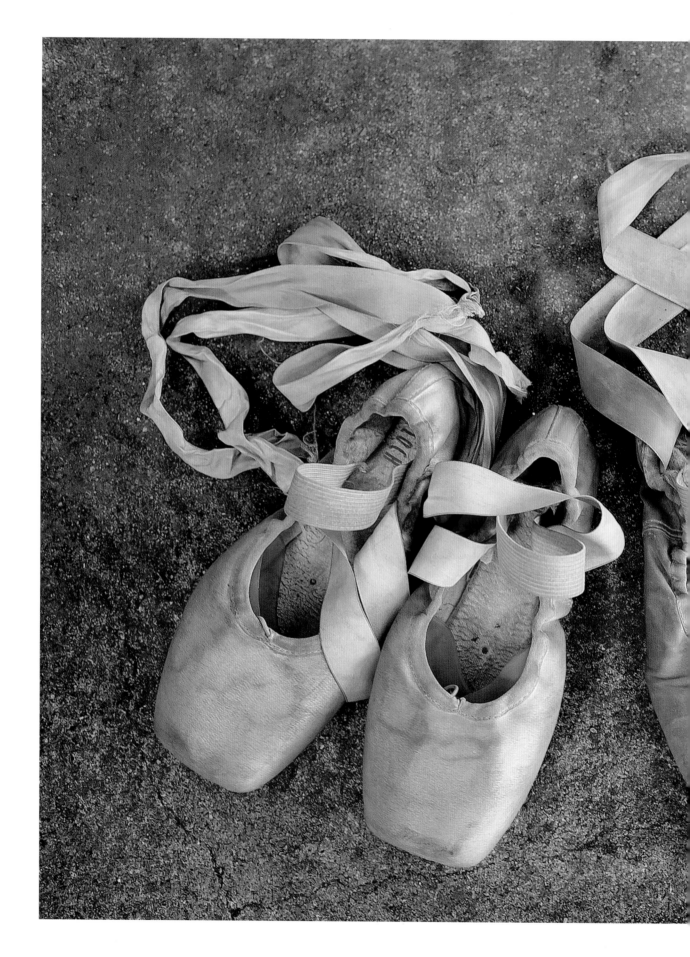

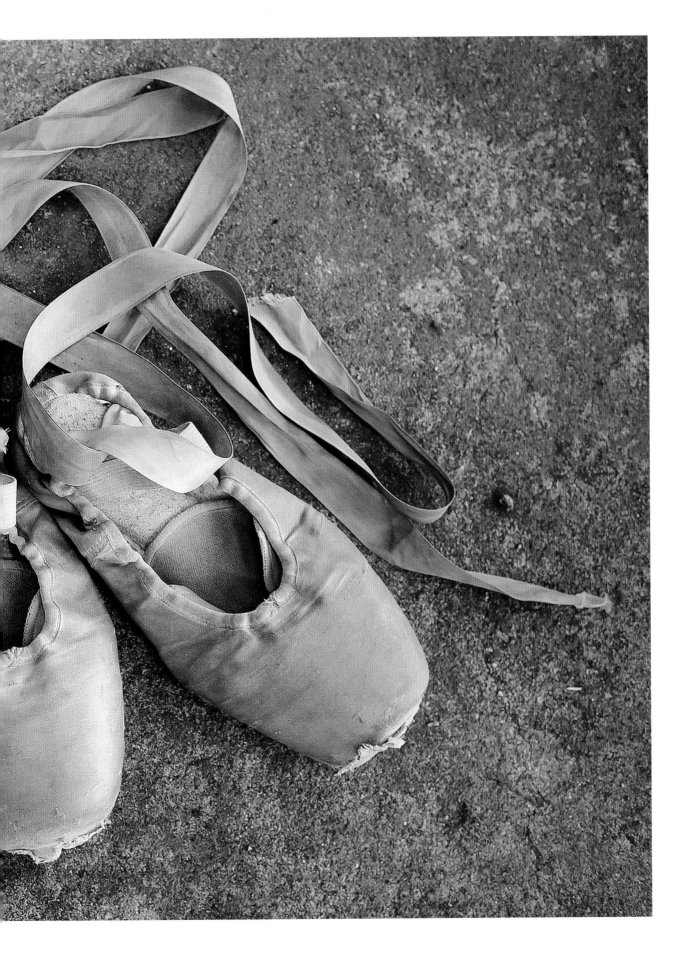

Black Dog & Leventhal Publishers
Hachette Book Group
1290 Avenue of the Americas
New York, NY 10104

www.hachettebookgroup.com
www.blackdogandleventhal.com

First Edition: September 2023

Brown Girls Do Ballet® is a registered trademark.

Black Dog & Leventhal Publishers is an imprint of Perseus Books, LLC, a subsidiary of Hachette Book Group, Inc. The Black Dog & Leventhal Publishers name and logo are trademarks of Hachette Book Group, Inc.

The publisher is not responsible for websites (or their content) that are not owned by the publisher.

The Hachette Speakers Bureau provides a wide range of authors for speaking events. To find out more, go to www.HachetteSpeakersBureau.com or email HachetteSpeakers@hbgusa.com.

Black Dog & Leventhal books may be purchased in bulk for business, educational, or promotional use. For more information, please contact your local bookseller or the Hachette Book Group Special Markets Department at Special.Markets@hbgusa.com.

Print book interior design by Frances J. Soo Ping Chow

LCCN: 2022940892

ISBNs: 978-0-7624-7955-9 (hardcover); 978-0-7624-7956-6 (ebook)

Printed in China

APS

10 9 8 7 6 5 4 3 2 1